Publisher's Acknowledgements
Special thanks to **Maureen Paley/ Interim Art**, London. We would also like to thank the following for lending reproductions: **Michael Apted**, Los Angeles; The Estate of **André Boiffard**, Paris; **Christian Boltanski**, Paris; **Emi Fontana**, Milan; **The Estate of Douglas Huebler**, Valencia, California; **Sherrie Levine**, New York; **The Metropolitan Museum of Art**, New York; **National Gallery of Art**, Washington DC; **Richard Prince**, New York; **August Sander Archive**, Cologne; **Cindy Sherman**, New York; **Tate Gallery**, London; **Paul Watson**, London; **William Wegman**, New York. We regret that images of Diane Arbus' work cited in the texts have not been illustrated, to respect the wishes of the Diane Arbus Estate. Photographers: **Wolfgang Tilmans**; **Gillian Wearing**; **Justin Westover**; **Stephen White**. We are also grateful to **Jay Gorney**, New York; **James Lavender**, Maureen Paley/Interim Art, and **Kathy Kenny**, London, for their contribution to this project.

Artist's Acknowledgements
I would like to thank Gilda Williams for commissioning this monograph; Maureen Paley for her support and advice; my video editor, Kathy Kenny, for her work on the digital images for this book; James Lavender, Maureen Paley/Interim Art, and Nigel, Omega Colour, London. Thanks also to Ian Farr, Clair Joy, Veronica Price, Stuart Smith and John Stack at Phaidon Press.

All works are in private collections unless otherwise stated.

Phaidon Press Limited
Regent's Wharf
All Saints Street
London N1 9PA

First published 1999
© Phaidon Press Limited 1999
All works of Gillian Wearing are
© Gillian Wearing
Courtesy, Maureen Paley/Interim
Art, London

ISBN 0 7148 3824 1

A CIP catalogue record of this book is available from the British Library.

Printed in Hong Kong

cover, **Sixty Minute Silence**
1996
Video projection
60 mins., colour, sound
Dimensions variable
Video still

page 4, **Untitled**
1998
Colour photograph
25.5 × 25.5 cm

page 6, **Gillian Wearing** with
Simon
1992
Colour Polaroid photograph
10 × 10 cm
Photograph by Simon, participant
in the *Signs* ... series, from the
artist's archive

page 32, From **The Garden**
1993
C-type colour photograph
124 × 90 cm

page 72, **10–16**
1997
Video projection
Approx. 15 mins., colour, sound
Dimensions variable
Video still

page 86, **Untitled**
1998
Black and white photograph
25.5 × 25.5 cm

page 144, **Gillian Wearing**,
Birmingham
c. 1978
Colour photograph from the
artist's archive

Russell Ferguson Donna De Salvo John Slyce

Gillian Wearing

Φ

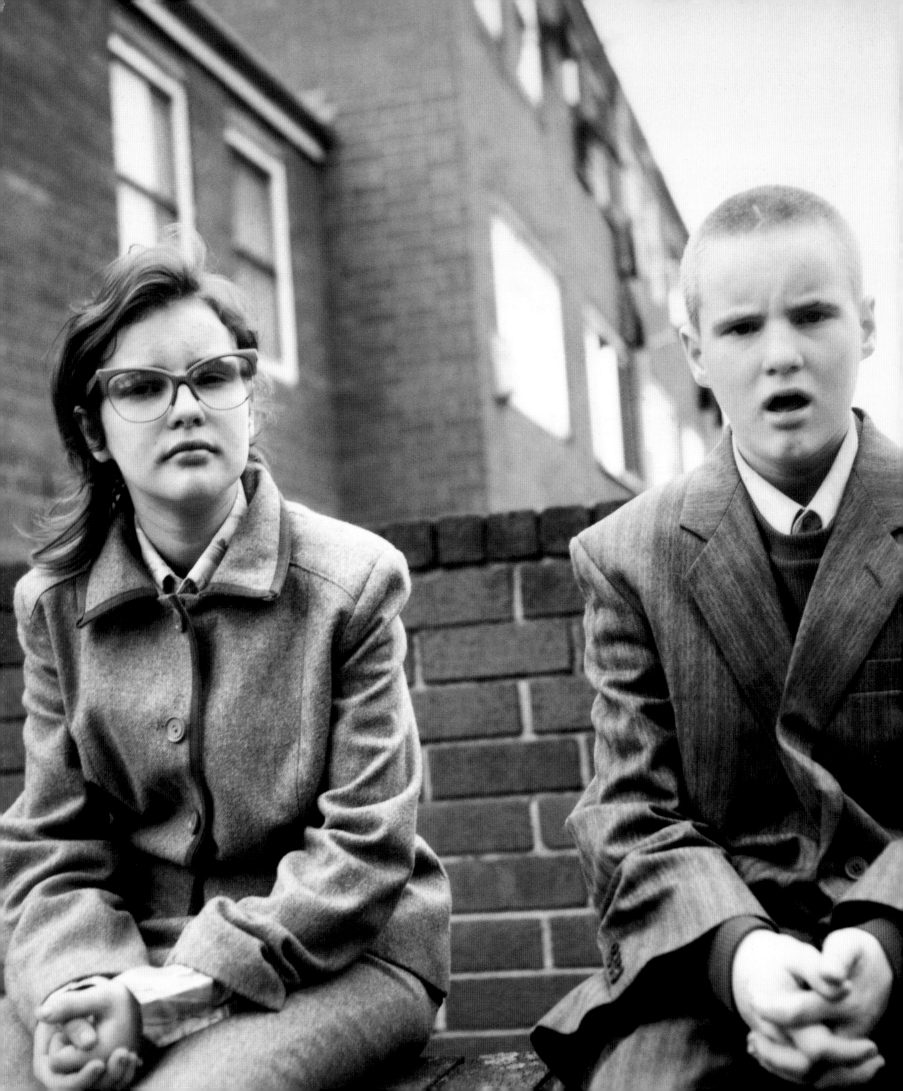

Contents

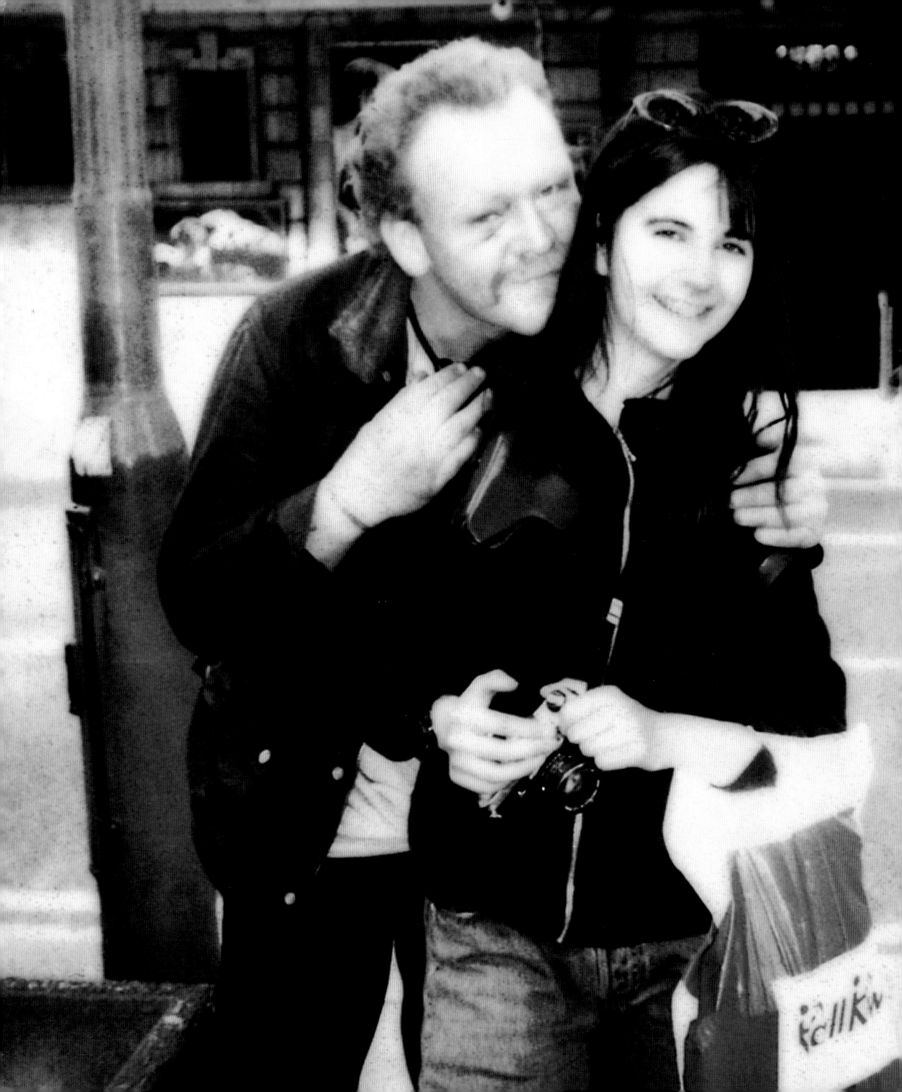

Contents

Donna De Salvo I've read that you see your work as interrupting the logic of photo-documentary through your subjects' apparent collusion in their own representation. What do you see as the relationship of your work to documentary?

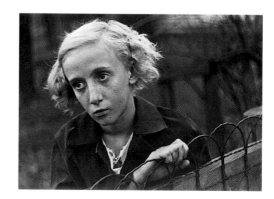

Walker Evans
Young Girl
c. 1936
Gelatin silver print
13.5 × 21 cm

Gillian Wearing **In terms of the models that existed at the time when I began working, the only thing I saw around me was documentary photography. I'd become very interested in working with people, but I didn't want to follow what had already been done. For me, one of the biggest problems with pure documentary photography is how the photographer, like the artist, engineers something to look like a certain kind of social statement – for instance, you can make someone look miserable, when this is just one side, a nuance of their personality. They might just be looking away at something, but their expression could be read as showing a kind of depression in their overall behaviour. I couldn't bear the idea of taking photographs of people without their knowing.**

De Salvo Without the individuals knowing they were being photographed?

Wearing **I didn't want that. I definitely wanted something that involved collusion. Firstly they would have to agree, and on top of that they would have to think and say something that they felt. For me this worked so much better because, when they returned with something they had written, it challenged my own perception of them. We all start making up our minds when we see someone; we all get ideas based on how people look, even though we know these ideas can be knocked out of us as soon as we get close to them or start talking to them.**

De Salvo It's true, you can see a photograph of someone's face and read what might appear as disgust, or fear, or anger, yet it could just be the result of the camera framing the face in a certain way. It's a pictorial fiction. I think of photographers such as Garry Winogrand or Lee Friedlander, or even August Sander, and the way that a visual typology emerges as expressions become codified. How do you approach the people you want to participate in your projects, such as *Signs that say what you want them to say and not Signs that say what someone else wants you to say* (1992–93)?

Wearing **I was quite shy when I first started that project and I couldn't approach anyone – or I thought I couldn't anyway. I originally started off by writing things myself, handing them to people I knew and asking them to hold them up. I set it up indoors and there was no real aesthetic or structure to it. It wasn't working. Then one day I happened to go into Regent's Park, and I realized that I just had to do it: I had to pluck up my courage and approach strangers. The first person who came along was this older woman. I asked her to write something down and she wrote, 'I really love Regent's Park'. From that moment I just knew it would work. It's hard to stop people in a busy street, but once I actually got the sentence out and explained that I was an artist, and this was what I was doing, I'd say 85 per cent of the people said 'yes', because they seemed to understand what I was trying to do.**

De Salvo Do you think it made them feel empowered?

Wearing I think so, actually. This was in 1992. At the moment we're totally saturated with TV chat shows, or fly-on-the-wall style programmes, and this has made people think that we can all be famous for fifteen minutes, but in 1992 it was somewhat different. I think people just felt, 'I *can* say something', and that it was a nice idea that they'd been approached. Some people even thought that they had to pay me, that maybe I was going to produce a portrait of them.

De Salvo How did you decide whom to approach?

Wearing One thing I didn't do was choose people from the way they looked, although I think that was connected with my shyness at that time. I'd stand on a street corner, anywhere. I'd probably be there for about ten or fifteen minutes. I didn't want to stay there for too long, as people would begin to see me as part of the scenery or as that odd girl, and I didn't want them to come back. I stopped people and just said, 'I'm an artist, and I'm doing a project where I ask people to write something on a piece of paper'. Some of them got

From **Signs that say what you want them to say and not Signs that say what someone else wants you to say**
1992–93
C-type colour photograph
mounted on aluminium
40.5 × 30.5 cm
Series of approx. 600 photographs

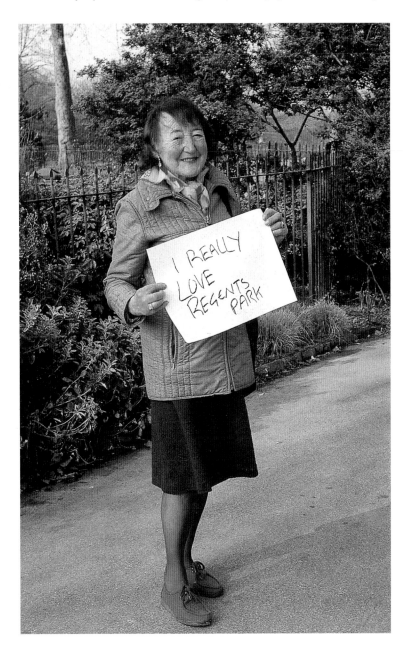

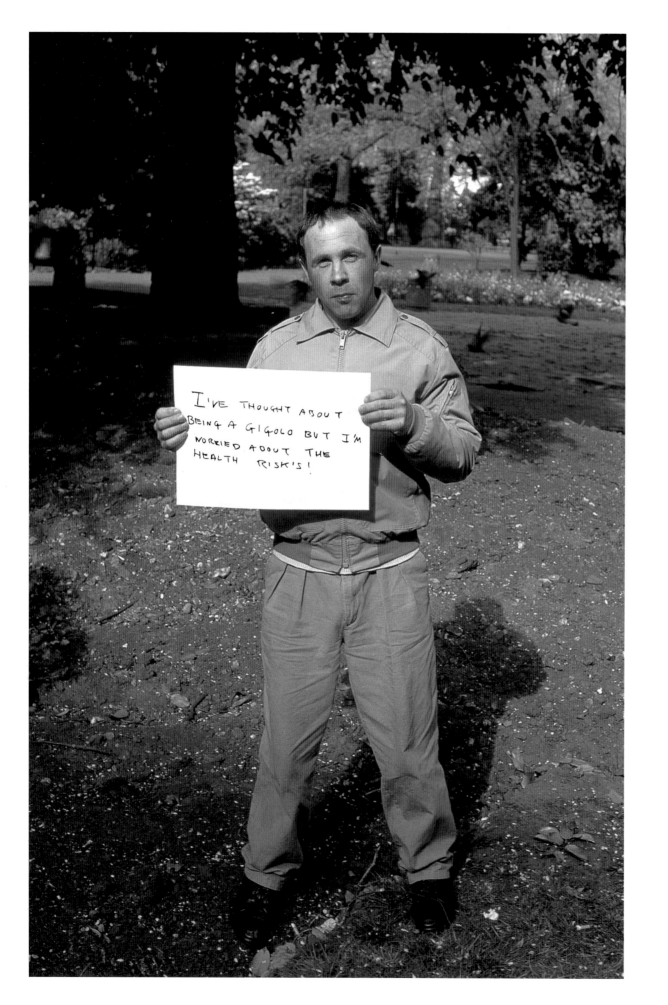

From **Signs that say what you want them to say and not Signs that say what someone else wants you to say**
1992–93
C-type colour photograph
mounted on aluminium
40.5 × 30.5 cm
Series of approx. 600 photographs

really bashful when I asked them to do something like that; for others it was just fine. Some wanted to get into a long conversation – there was one person I talked to for about two hours, and he actually went through the whole history of his sex life.

De Salvo What did his sign say?

Wearing **It was the sign that said, 'I've thought about being a gigolo but I'm worried about the health risks'. When I looked at these photographs of what people had said, I kept thinking, 'God, you said that!' For weeks and weeks there were these people saying the most amazing things.**

De Salvo So life and reality continually surprise you. I mean, you couldn't write those lines.

Wearing **If you were to write them yourself you couldn't help creating stereotypes.**

De Salvo So, not scripting, having those things come on their own …

Wearing **A lot goes back to my feeling of being totally illiterate. I always used to feel like a foreigner in my own country, because I didn't receive a very good education. I'm more interested in how other people put things together, how people can say something far more interesting than I can.**

De Salvo Do you think that also led you to pursue things on a visual level?

Wearing **Definitely, yes. I don't think I would have become an artist otherwise. When I was at art school, on the foundation course, I started off by making paintings, attempting to express what I couldn't verbalize. I was aware that there was something missing, something that could only be expressed visually.**

De Salvo Yet it's interesting how critical language is in your work: its effect derives from the relationship between the visual image and the spoken word, especially as you explore human stories and the inadequacies of language in relation to really telling that story. Do you see the *Signs* … series as portraits?

Wearing **I do now. At the time I just saw them as documents. When I first started doing the *Signs* …, the most important aspect was approaching strangers on the street and the interaction between us: that a sign and an image came out of it. I didn't think it was something in itself at the time. I didn't print them for an entire year. I didn't know if or how I could show these things. The only thing I did know was that they would work best when shown en masse, because it involved that kind of democracy. You have someone from one background next to someone from a very different background, and what they have in common is this white sheet of paper. In a certain way it breaks down all those differences, and then all of a sudden you have to start re-appraising people. In this instance, the photographic form was more democratic because, unlike in a video sequence, you could concentrate on all the images at once, if they were installed in a gallery.**

De Salvo So you could perceive the totality, you could be surrounded by the photographs, whereas with a single-channel video or multiple monitors, you could not take everything in as one image?

Wearing **Yes, exactly, and the white paper of the signs became like a uniform.**

De Salvo The photographs have, as it were, a built-in caption. Do you think you're also capturing whatever the participants' true thoughts are at that moment? An hour later, as you say, or even ten minutes later, they could write something completely different, so it's almost like getting people to externalize the actual process of thought. But what about that which remains unsaid?

Wearing **It's like, who needs a three-course meal when it's enough just to have the entrée? Also I don't believe in patronizing viewers. If you give people everything, you're doubting their ability to make up their own minds.**

De Salvo What about the project that followed *Signs* ... ?

Wearing **I made *Take Your Top Off* (1993), a series of three photographs of me lying in bed with transsexuals. I wanted to do something with transsexuals because of the way in which they represent the most overt form of sexuality. They experience both genders; in their minds they're starting afresh. They have to be more open all of a sudden.**

De Salvo You went from a very public space, out there on the street, to a deeply private one: the bedroom, with its connotations of privacy. Why?

Wearing **What was missing in the *Signs* ... was my physical presence. When I first decided to do something with transsexuals, I wasn't thinking about my own presence.**

De Salvo It's as if you came onto the stage in that series. Was it a way of exposing your own collusion in the whole process? Once you cross that line, you're there in a very different way.

Wearing **I wanted to do something that made me feel vulnerable. For *Take Your Top Off*, I phoned people without meeting them first, and then went to their place and got into bed. I wouldn't go through a rehearsal beforehand. I just wanted to know what would happen, so it was all done on the same day.**

De Salvo Did it feel as if it was a test for you as much as for the other person?

Wearing **I didn't think about it as a test, but it probably was. I was trying to find a structure that felt pure, or something like that. I'm not an exhibitionist. I think it was slightly easier for the other three people, because they'd just had, or were going through, a sex change. They were being reborn, so they actually quite liked showing off their bodies. I didn't. I felt like a bit of an impostor in that piece, and still do to an extent. I didn't even know, when I put it on the walls, whether it felt completely right. I didn't really like seeing myself in such a vulnerable position, but I did it. I thought, I have to do it.**

Sixty Minute Silence
1996
Video projection
60 mins., colour, sound
Dimensions variable
Collection Arts Council, London
Production photographs

De Salvo It would have been hard enough for you as an artist to have critical distance from your work, but the stakes would have been even higher when you became a visible part of it. Also, if the timespan between making the work and exhibiting it was very fast, it wouldn't have given you much time to absorb it.

Wearing **I think that's good. I showed the piece within a month of making it. I couldn't talk to anyone about it. When I first showed it I didn't tell anyone that the people in the work were transsexuals, even though in one of the photos there are all these pills and prescriptions next to me. People started working it out from that. I didn't want to make that point. I don't want to get into breaking down barriers all the time, but I wanted them just to be seen as people who looked like women.**

De Salvo But what about your choice of people? There exists a perception that you deliberately choose people regarded by much of society as freaks or outsiders. Are you attempting to normalize these people, or to project your own identity through them?

Wearing **That's a hard one to answer, because obviously on one level it's true. I try to incorporate as wide a variety of people as possible and hopefully, through my choices, I can cast my net much wider. I do see a continuity in the way things start to come across as representing my interests. Sometimes it feels like painting: I build up a picture, a portrait, through time, and then I can move things around. Through building up these narratives, I probably do reflect how I see the world or what I've experienced.**

De Salvo But in painting, even though chance plays a role, control manifests itself in a different way. How do you feel about the idea of giving up control?

Wearing **When you have a work that's just one take, like *Sixty Minute Silence* (1996) then obviously I couldn't edit it. *Sixty Minute Silence* felt like I was taking a chance, because I didn't know if people could actually stand or sit for that long. It actually came out perfectly the first time.**

De Salvo What made it perfect?

Wearing **The person who just screamed really loudly at the end, because of the whole frustration of the thing. That was not planned, but it put a nice full-stop to it.**

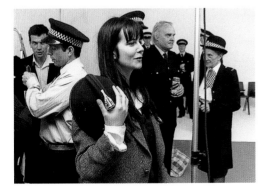

De Salvo The participants were conscious of playing a role, so it becomes a portrait of people pretending they're police officers. Suppose it had been actual police officers?

Wearing **Initially I did try to use real police officers, but due to their different shifts it was impossible to co-ordinate one time for all of them. More important for me was the metaphor of control that the uniforms represented.**

De Salvo You've also mentioned daguerreotypes in connection with this piece.

Wearing **I was interested in doing something with duration. This reminded**

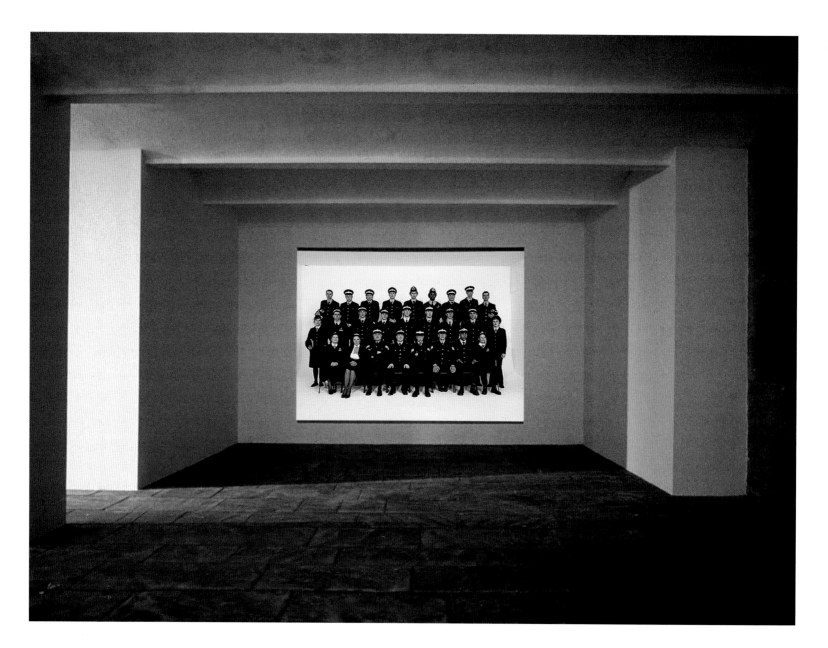

me of daguerreotypes, for which subjects often had their heads held in place by clamps; this gave them a kind of presence and seriousness. I wanted that controlled look, and of course you think of the control of the police in this country. I wanted to combine the sensibility of painting and sculpture with the sensibility of photography, but nothing tricksy, just something very simple.

De Salvo Do you think it's the most painterly of your works?

Wearing **Sculptural. I see it as slightly three-dimensional. You have these three rows …**

De Salvo But the viewing format, when enlarged to wall size, is that of painting. Did you see yourself as quoting the history of painting?

Wearing **The majority of people who saw it when it was shown at the Tate Gallery compared it to painting, but because to me these people were standing like statues, I saw it as sculpture. I first showed it, at the Henry**

Moore Studio (Dean Clough, Yorkshire, 1996), as a back-projection. It looked like a slide coming back at you, so it reminded you of a photograph. When people first saw it they probably thought, what's the point of showing a back-projected slide of a bunch of policemen? Most of them walked straight past it; then they'd pass it again and notice this very subtle movement, and get slightly freaked that there might even be someone behind the screen.

De Salvo You forced them really to look?

Wearing **If there's a thread that runs through all my work, it's that slight double-take.**

De Salvo Your work meshes together different histories ... Which artists were most influential for you?

Wearing **References for me only came in later, when people started saying I should look at this or that artist's work, but when I started the *Signs* ... series there was no-one I was aware of as an influence. That's why I didn't frame work up for a long time, because I didn't realize it was something I could actually show.**

De Salvo I see your work within the context of certain traditions of realism, documentary and also 1970s Conceptualism, particularly its legacy of video and photography and the focus on subjectivity. Do you see yourself as a video artist?

Wearing **No, I hate that term. I don't see myself in that tradition at all. I got into video because a friend had a camcorder, so it was more about things that had become accessible to everyone. I'm interested in process, I'm interested in people, but I can't bear the idea of the technology being something that represents me. The thing that goes through my head is not the technology but what I want to do, with whom, and when, and what inspires me. People talk in general terms about artists using video but I consider these things on their individual merits, not because they share the same technology. Its format does not give it any more credence. I think there is also a weakness in shows that group artists together because they all use video, when in fact they are actually totally different in their approaches.**

De Salvo How much has the culture of television influenced you?

Wearing **It was only when I started to try video as well as photography, early on, that it pricked my consciousness and jogged a memory of things I had really enjoyed in the past that I'd seen on television. It was definitely a 1970s thing that I picked up on – those earnest, serious documentaries about everyday people, like *Seven Up* (Michael Apted, 1964) and *The Family* (Franc Roddam, Paul Watson, 1974), which was the British equivalent of the US documentary *An American Family*. I was interested in remembering how I was affected by them at the time – the realization that people who were not that dissimilar from you or your friends were being represented. This was at a time when, if you were on television, it was for a very special reason.**

De Salvo With documentaries such as *An American Family* we became conscious

of the camera as a causative element in the action. The members of that family couldn't just live their lives any more, they were performing their lives. So your early influences came from popular culture rather than art?

Confess all on video. Don't worry, you will be in disguise. Intrigued? Call Gillian
1994
Video
30 mins., colour, sound
Video still
Collections, Arts Council, London; Tate Gallery, London; Kunsthaus, Zurich

Wearing **That's what jump-started me, say, in 1990–91. Those were the things that I had to fall back on, because I didn't really know what I was going into. I had no role-models, so I was going into a very unsafe area. Although I had nothing to lose, because I'd just come out of college, it was worrying that I had nothing, no money. I just had to experiment. It was exciting because I had no-one on my shoulder, but at the same time there was no-one to guide me. Since then, people have referred to Diane Arbus in relation to my work. One person used that as an insult, saying my work was dehumanizing. I hadn't really followed Arbus' work, but I do remember seeing her famous twins portrait and thinking, God, that's an amazing image, so Arbus had been in the back of my mind somewhere. However, it was only when that comparison was made that I really looked at her work, and then I decided not to take the comment as an insult, because I recognized something there, in the way she worked with people, that was to do with her own presence.**

De Salvo This historic moment is very different from the time when Arbus was making that work. Aren't you working with a greater awareness of the ways in which the maker influences the image and assumes a position of power?

Wearing **I learned that early on. I'd already seen controversies going on with documentary photography and news reporting, so I was aware that photography was a weapon and that you could say anything with that one very static image. But I have to work with what is here. Although it seems as if everything has been done already, I don't necessarily believe that. Even if an image just ends up affecting someone on a personal level, something will come out of that. We are still individuals.**

De Salvo You once said, 'It's more intimidating being watched by someone in person than by someone behind a security camera, whom you can't see'. For me, it's quite the opposite.

Wearing **It doesn't bother me at all, because I think most of these people aren't looking anyway. I'm more conscious of walking past a policeman or someone of authority in the street, because I think I have to put my head up. Normally, I have my head cast down.**

De Salvo What gave you the idea to use the voices of children, in *10–16* (1997)?

Wearing **I wanted to do something that had children coming up with things, talking about all sorts of things. I didn't know exactly what I was going to get when I set out. For *Confess all* … I had used masks, and I was thinking of using them again, because children can't know if in the future they're going to want themselves portrayed at ten or eleven years old. They have no say in that. They also tend to say more interesting things when there's just a microphone, rather than a camera pointing at them. If I just made a documentary of children talking, that would be throwing you back into the camp of television, or traditional documentary, and that's not what I wanted to do.**

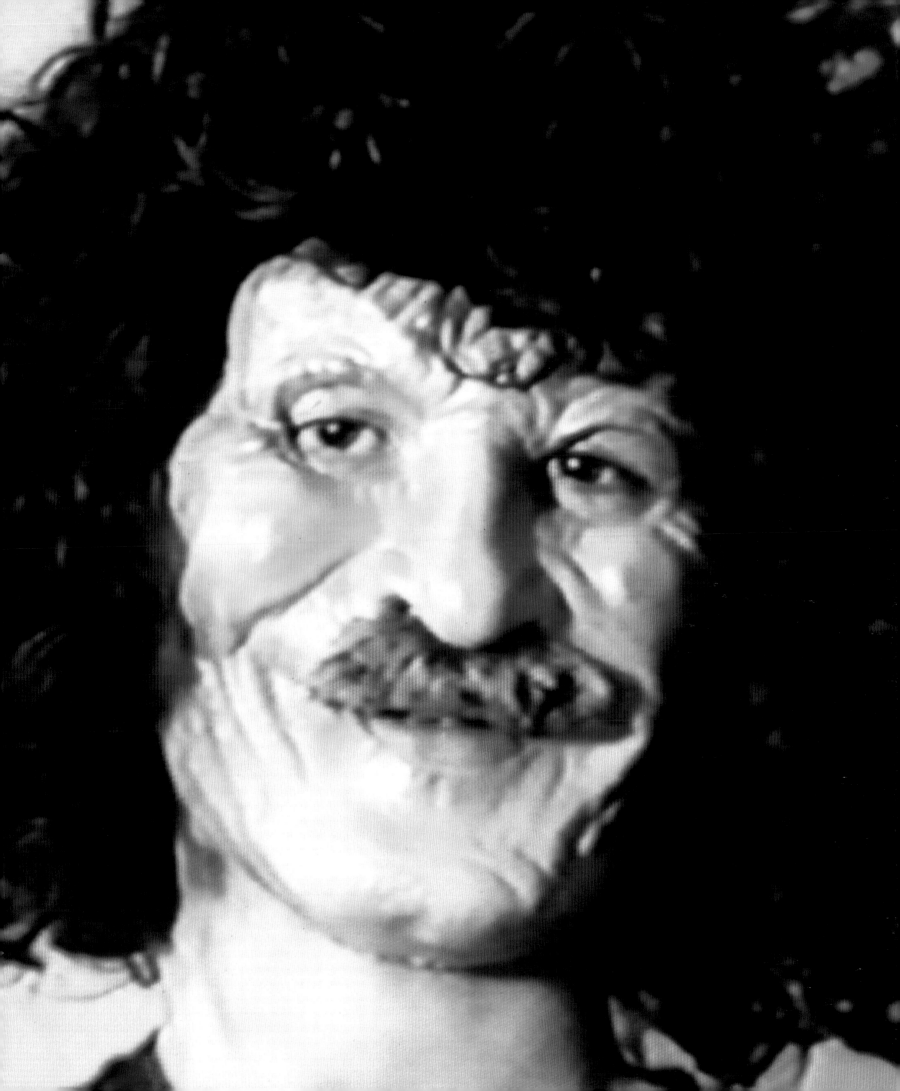

It wouldn't be about transforming what's out there into a new language, another language.

De Salvo Can you go on a little more about that idea of transformation?

Wearing **I just think art allows you to fit something into a structure that's your own, and not someone else's. You have no one telling you what you can and can't do, so you can be open. For me, transformation means, for example, how Turner's paintings made people look at the sky in a different way. We know children have interesting things to say and use language in a rich way, but when you channel this through an older body, then all of a sudden there's a pathos and you're transforming how people look at that. Especially as you get older, you realize there's something else there, screaming to come out. It offers something fresh and it's better than something straightforward, which can't make you come out of the complacency of what you already know. If we look at our existence in this way, it is pretty disturbing.**

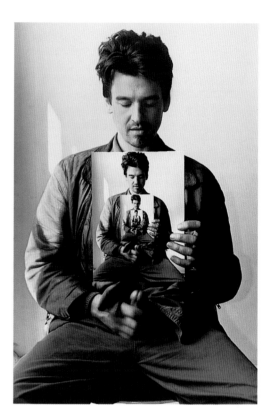

Masturbation
1991–92
2 C-type colour photographs
Approx. 244 × 183 cm each

De Salvo Some aspects of that piece are almost terrifying. There's a kind of terror that comes across in the people's voices, and it isn't always about the extreme things; there's also a terror in normality.

Wearing **There's more, because people have kept themselves in this very tight strait-jacket for so long. How long can you last before you crumple up inside, before your body crumples.**

De Salvo It's curious how that plays out culturally. In America it would follow different routes; in Britain it seems one is expected to repress things more.

Wearing **Yes, and this has totally fed my work from the beginning. I understand that reserve. I see myself as being unable to get beyond my own reservations, and a lot of my work obviously deals with me trying to go out there myself. I found that there's something quite intense about a person's reserve. In every culture, once you're dealing with that one aspect, you become more aware of what's been negated. For the *Signs*... series, people were quite eager to be involved, even though they often didn't really know why they were doing it.**

De Salvo When I watched *Confess all*..., that desire to confess, the need to unburden, to feel understood, reminded me of the darkened rooms of Catholic confessionals. One could say that asking people to confess on video is sick or weird, and yet when you think about the way confession exists within that religious context, it seems even stranger.

Wearing ***Confess all*... was different from the religious context because people felt they just had to confess anything, so they could have made it up. They all wanted to wear a mask, none of them wanted to be revealed. People wanted to exhibit some emotion, but not to be identified, and that's where the odd thing comes in. The last person, who talked about his problems with his sexuality when he was sixteen, was a middle-management type. He had money, he didn't need to be an exhibitionist. He was seeing a psychiatrist at the time, but he came to me, as he says himself in the video, as part of the**

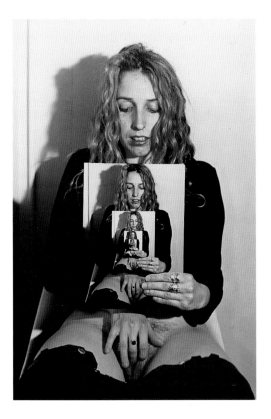

therapeutic process. He particularly wanted it to be seen in an art gallery and not on television, because he thought that no one he knew would ever see it in an art gallery. He wouldn't see it, but he would know it was somewhere out there, somewhere where it would just disappear. It was definitely a form of exorcism. Therapists know your identity because they see your face, whereas he and I were never going to set eyes on each other again, so that was better for him.

De Salvo There's such a performative quality to it all. How did you get the idea for *Confess all* …?

Wearing **Originally I was almost going to use an idea which I then discovered the artist Tony Oursler was already working with. It would have involved members of my family confessing, with small projections of their faces onto something like rag dolls. Then I happened to read a preview feature in a newspaper on Tony Oursler's next show, and realized that my piece would be too similar. So I had to change things. It would have something to do with a kind of mask, but how wasn't quite clear. It doesn't make much sense where it all comes from; I don't start with some kind of great insight, I can tell you that. I decided to use the masks and have all these confessions, and make it much more straightforward. I'd just place an advert in the paper asking people to come and confess. I'd used adverts before, so I went back to using them. I was fascinated by the added element of which mask they would choose, and how this might end up influencing how the whole story was perceived. They could hide behind it and that would enable them to say things they wouldn't normally say.**

De Salvo There's a degree of acting-out in your work, even a pathology at times.

Wearing **Because we're aware of the camera, some parts of the work are very narcissistic, so, again, there's good and bad aspects of the video camera. However, even though it involves acting-out, it is cathartic. The people are trying to be as honest as possible, within the context of an alien environment, which is obviously very difficult for them. That was the good thing about having the mask, because they already felt protected. They didn't have to wait for me to go and use a computer to pixelate the image of their face and promise I would protect them. Also, since they'd read the advert I placed, some came knowing what they were going to say. They had already taken control.**

De Salvo Are there any works that you feel are like self-portraits, or that you strongly identify with?

Wearing **I think *2 into 1* (1997) – the mother with her two sons. That strikes home a bit uneasily – the criticism of the children, and also the male-female thing, where the boys are being critical about her looks. It's very hard-hitting and quite painful, I think, in the way the children view adults and the family. It's not just about children and parenting. The piece is about familiarity, closeness, breeding and contempt.**

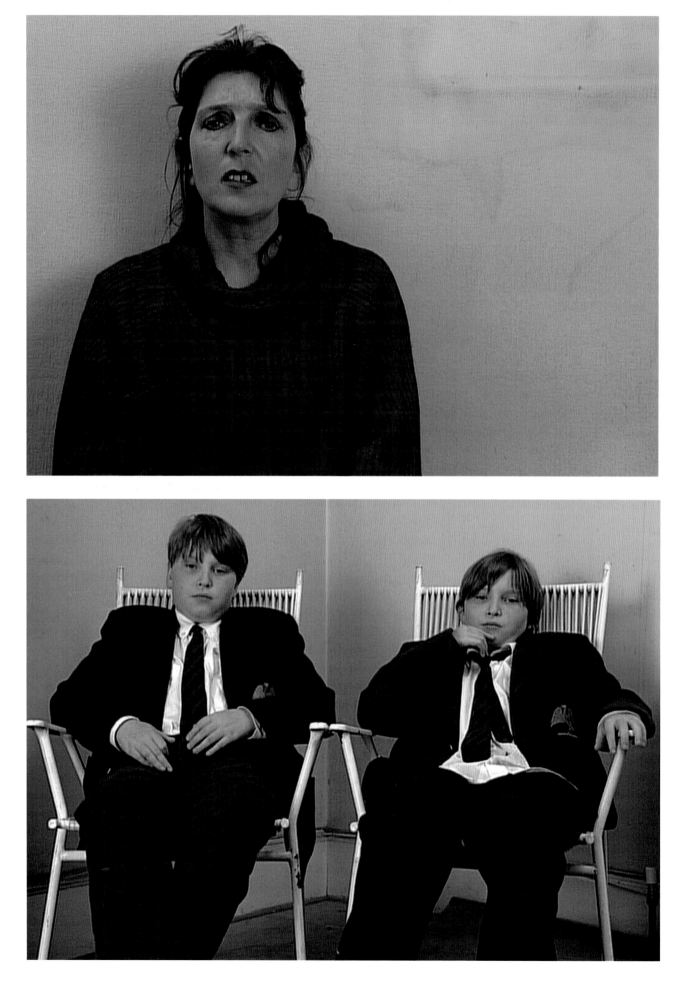

2 into 1
1997
Video
Approx. 4 mins. 30 secs., colour,
sound
Video stills
Broadcast on television by BBC 2,
as part of 'Expanding Pictures'
series, 1997

De Salvo It seemed especially about the male-female relationship. It seemed to embody so many aspects of the way women are regarded in the culture, and how roles are formed so early on.

Wearing **Even an eleven year-old can totally undermine someone, very acutely, in a very sophisticated way. The boys use humour, and they have a wonderful way with language – I always think humour and vitriol work so wonderfully together. When you have that in two eleven year-olds you have a winning formula for attack.**

De Salvo How did that piece evolve?

Wearing **I didn't meet the people before making the work, I met them and taped them at the same time. I'd already had the idea that I wanted to exchange parents and children and it didn't matter to me whether it was girls, boys, mothers, fathers – it wasn't intended to be about gender difference. It was hard to find an interesting relationship, so discovering those two boys and their mother was a godsend because they were honest and bright enough to give you everything in one full blow.**

De Salvo Throughout your work, there is a focus on power relationships: your power in the situation, and the participants' power. In this piece, the mother was presumably in the position of authority, and yet these boys were amazingly disrespectful. How you do think being female plays out in the work you make?

Wearing **It's quite funny, because when my work was on the cover of *Artforum* in 1994, a lot of American readers thought I was a man because the name Gillian isn't familiar there. They read it as slightly genderless, but also immediately presumed it to be a male name. But I see myself as an individual with my individual approach. I have been quietly saying things such as, 'I think it's easier to do some of the work that I do as a woman talking to men', because I think women are used to talking to women and to men, whereas male to male relationships still always seem uneasy to me. I think that in the culture of male bonding there's something missing, as if there's an openness on the surface but the more emotional side never really surfaces. If you look at the difference between Diane Arbus and August Sander: Sander captured people in a very formal way, whereas for Arbus it seems more about an emotional agenda. I think about Cindy Sherman – any woman can relate to her because of the many different masks women wear. It's incredibly perceptive work. When I was younger, I used to dress up with my friends, wear different clothes all the time and pretend to put on different stances. You realize she's tapped into something that's been going on for years.**

De Salvo There's a degree of what could be termed social experiment in your work, like the idea of bringing together people who don't know one another, and seeing what will happen. It reminds me of Andy Warhol's early films, except that Warhol had these loosely-based narratives. How do you approach that idea of narrative? His early films also used low production values. If you were to get involved with special lighting and sets, how would that change the work?

Wearing **If something ends up looking visually good, that certainly wasn't the**

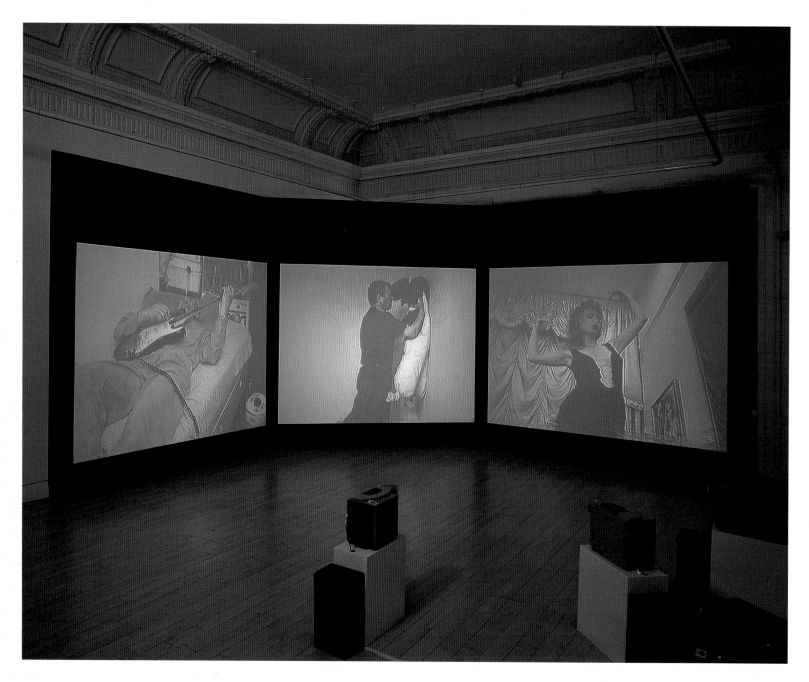

The Unholy Three
1995–96
Video projection
3 screens, 10 mins., colour, sound
Dimensions variable
above, Installation,
'Pandæmonium' exhibition,
Institute of Contemporary Arts,
London, in collaboration with
London Electronic Arts, 1996
opposite, Video still

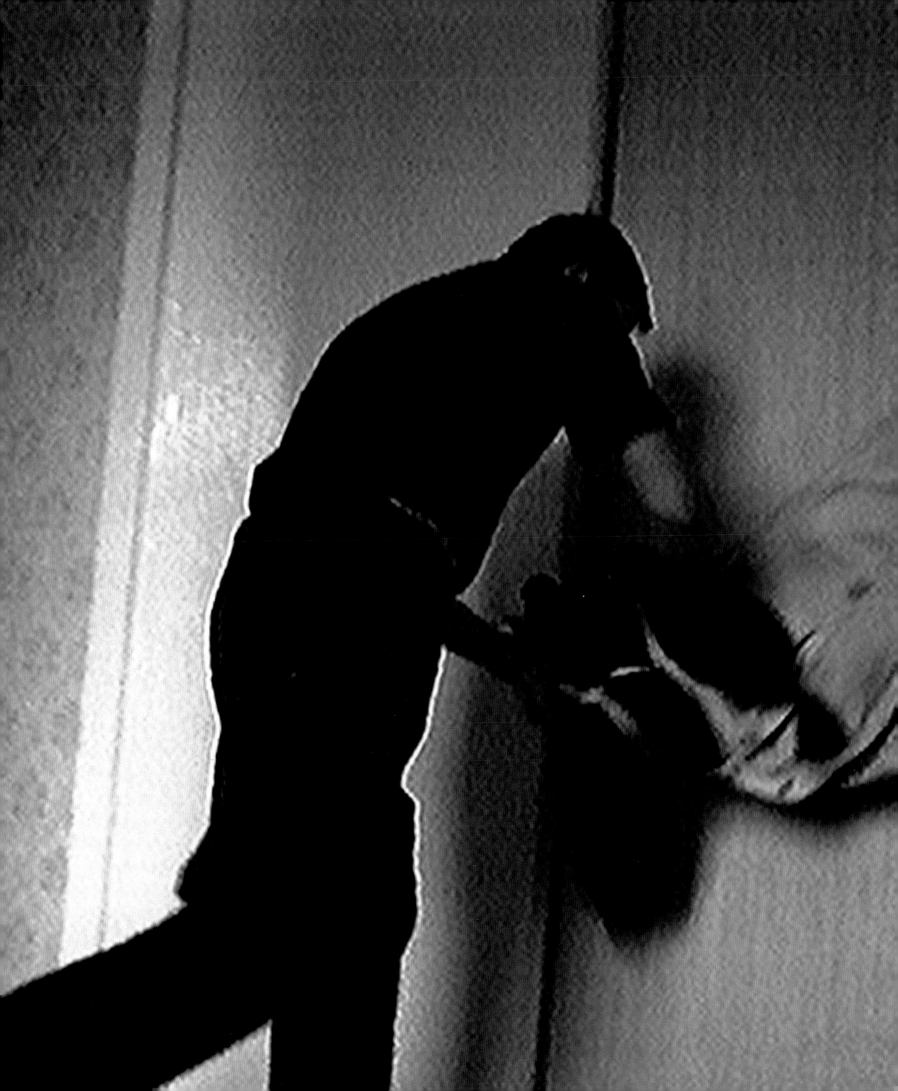

important thing I worried about, because I can't always control what happens. I have to be quite simple about situations. I think there is a kind of narrative that flows through the work in many cases. With *The Unholy Three* (1995–96), I brought three unconnected people together, which was definitely my doing, and I threw them into meeting each other. Because they also had very extreme views of life, they were willing to work off each other, and create some debate. I was creating something that had a plot-line, I suppose, but some people bring their own story and plot along. It's just by chance that it becomes a kind of fully formed story. Other things I do, through the editing process, also build up a narrative.

De Salvo What about the editing process?

Wearing I really like the editing process. It's the closest thing that you get to the old-fashioned way of making art. I can get quite obsessive about it. It's one of the things I got out of painting: all of a sudden I get totally into it and no one can tear me away.

De Salvo You become a kind of story-teller, except that in telling the story you

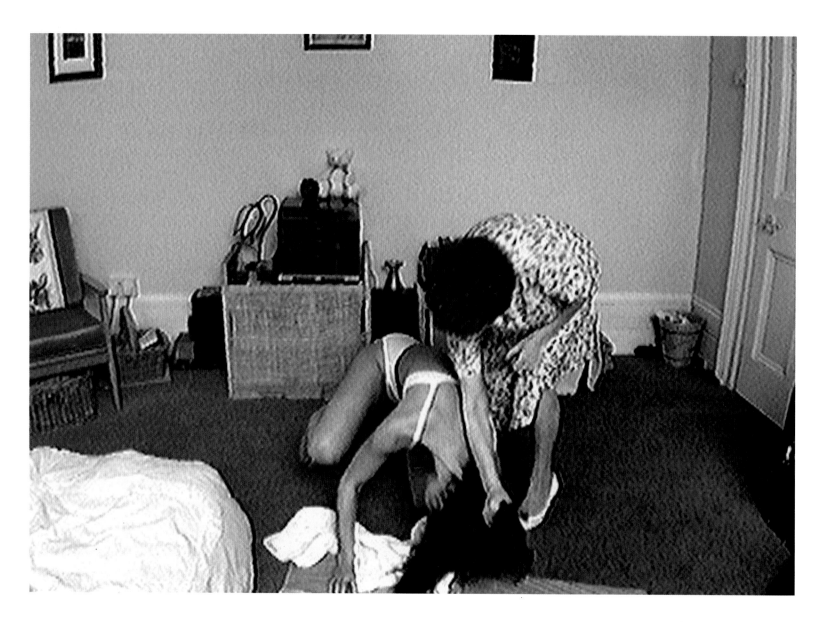

end up adding your bias, so you also become a part of that story. We don't know where you begin and they end.

Wearing **I was thinking about the problems with that. People could ask, where does Gillian Wearing come into this? We want to know the full facts. And then I was thinking, you don't, because you're never going to get the full facts anyway, whether you want them or not. It's like that whole idea of photography and truth: however simple you make your process, there's still a lot missing anyway. In *Sacha and Mum* (1996), there were actors, who were used to someone changing and controlling the camera angles. You can't do that with 'real' people, because it would seem completely illogical to them to make something aesthetic out of it. Sometimes you see documentaries that go for crazy camera angles and it doesn't really work, because real people can't perform that way.**

De Salvo *Sacha and Mum* seems to be the one piece where you most reveal the manipulative aspects of the medium by running it in reverse, and this becomes part of its subject matter. Would you agree with that?

Sacha and Mum
1996
Video projection
4 mins. 30 secs., black and white, sound
Dimensions variable
Video still
Collections, The Irish Museum of Modern Art, Dublin; Guggenheim Museum, SoHo, New York; Tate Gallery, London

Wearing **Yes, it's totally contrived from beginning to end, it was heavily story-boarded. The volume is turned up far more to start off with. That aggression is something that people would never normally reveal to me. The woman pulls the girl's hair five or six times on many shots, so all in all she must have pulled her hair about thirty-odd times. It had to be far more aesthetically aggressive because the camera had to record it all in one go.**

De Salvo At times you use real people and at others actors, but the audience doesn't always know the difference. Do you want people to know?

Wearing **I didn't try to pass that piece off as involving real people. I've always said they were actors and actresses, but when it was exhibited for the Turner Prize (Tate Gallery, London, 1997), people were saying how terrible it was that I was encouraging violence in children. It's so ridiculous. I can't even take those arguments seriously. I just can't be bothered discussing them.**

De Salvo When we know it's a real person, I think it becomes more disturbing. There seems to be a progression in your work towards taking these complex ambiguities even further and weaving them together in different ways.

Wearing **I didn't choose to be much more complex. When I chanced on the idea of the mask for *Confess all* ..., I began to see the power of working with internal states through external channels. Obviously a lot of my work is about that, but I wanted to stretch that point.**

De Salvo There's an anthropological aspect to your pursuit; clearly people are your subject matter – is that what really interests you?

Wearing **Yes, and I'm moving towards more narrowed-down formats – which are in fact more open. I'm now focusing more on things that are slightly more problematic and uncomfortable for some people. When I narrow down the possibilities, I also try to open things up every time I do a new piece.**

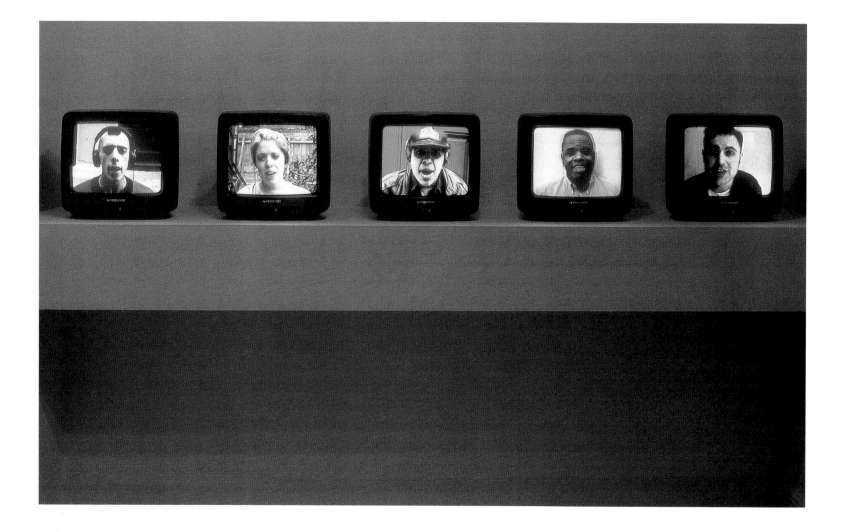

De Salvo When you mentioned the internal and the external, it suggested
to me how much you are working with certain conceptual notions about the
construction of space – political and social space in particular – especially
the ways in which being looked at is so important in contemporary cultures.

Wearing **I sometimes think of this in relation to the quiet way I live in my
own flat. In England our flats are small, so you're quite aware of what's
around you. I often think that people are not very relaxed; it's as if the only
time they're really relaxed is when they're asleep. For the rest of the time
they're very aware of the four corners of their room or the street. It often
seems that there's hardly any disparity between the interior of their homes
and the street.**

De Salvo In *Dancing in Peckham* (1994) you're very much in your own world.
Some people really stare at you, yet then they casually look away.

Wearing **I had to make a conscious decision to do that piece. It didn't come
easily. It was actually because I had seen someone else dance crazily – she
was someone whom I instantly liked, or was interested in, someone who
could do that without feeling totally self-conscious. It was about taking that
kind of fantasy and being able to do something in a public space, where you
do end up looking like a nutter, ultimately, because it's not acceptable**

My Favourite Track
1994
Video installation
5 monitors, approx. 90 mins.,
colour, sound
Dimensions variable
Installation, Interim Art, London,
1994
Collection Tate Gallery, London

behaviour. But when someone saw it at the Royal Festival Hall, there was a bunch of South London girls standing around it, going 'Wow! It's South London, it's Peckham!' So people could enjoy that piece on different levels.

De Salvo There's a strong focus on isolation in your work, which is greatly emphasized in *My Favourite Track* (1994).

Wearing **My Favourite Track uses five monitors showing five or six people singing the tunes playing on their Walkmans, but their Walkmans are turned up so that they can't hear themselves. Listening to it is like being in a kind of tower of Babel, where everyone is talking at once but no one is listening to anyone else. The piece is about isolation, and the Walkman is a kind of isolating factor to escape the reality of street life, to have both things going on at once, bringing you some other element to enable you not to bother about the others around you. Maybe that goes back to subjectivity and objectivity. People want escapism somehow, and if you've got something that can make you feel good, like music, you can escape from the banality of any situation, be it shopping or having to post a letter. We want access to things that can make us temporarily escape into the spaces in our heads.**

De Salvo How important to your work is the viewing context?

Wearing **The one thing I have no problem with is the art gallery. I've always preferred a simple smart space to any kind of rough space. I actually like a neutral space that doesn't interfere with the work. And there's something quite sympathetic about the gallery space. People might not feel that when they walk into a gallery, because it can feel slightly intimidating. It's this clean white space, where people are very quiet. It can be like going into a chic dress shop, where you might expect the staff to be more intimidating than what's on show. But I think there isn't a better space to show, because you can control the whole environment, and even some cinemas can be very unsympathetic spaces for certain films.**

De Salvo In what way?

Wearing **Well, the seating, and also you're sitting with people who might be ten times taller than you, or people are eating, which I hate. I hate food in the cinema. I think it's a disgusting idea, because you can always hear crunching. People have weird habits. The only thing that puts me off going to the cinema is the habits of some of the other people watching. People don't eat in a gallery, that's one good thing.**

De Salvo What strikes me about a lot of video installations in galleries is that seating is often not provided, even when the work has a long duration.

Wearing **It helps sometimes if there are seats, but not if they're tiered in any way. It's nice to experience work when there's just three people in the room. Galleries and museums don't want this, but in this way you can have a very personal experience with the work, which is different from seeing a film.
We haven't yet talked about *Homage to the woman with the bandaged face* ... (1995).**

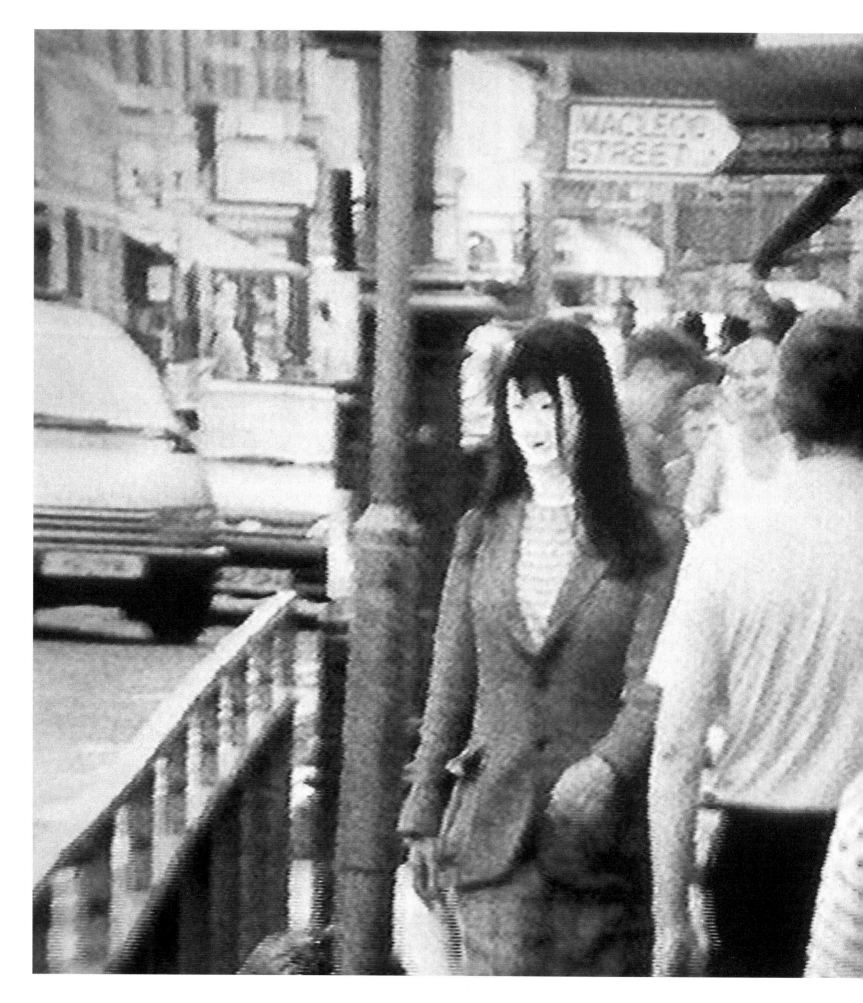

**Homage to the woman with the
bandaged face who I saw
yesterday down Walworth Road**
1995
Video projection
7 mins., black and white/colour,
subtitles
Dimensions variable
Video still

De Salvo When I asked you earlier which piece you thought was most like a self-portrait, I was thinking about that one.

Wearing **In *Homage to the woman with the bandaged face* ... I was answering a lot of my own questions about how I perceive people, and the perception of someone looking at me. Even though I was still holding the camera and I was a total voyeur, I really stood out somewhat maniacally from everyone else. They still looked at me, en masse, as the one, the freak, the odd person out. It was a real choice. I had seen someone with a bandaged face like that, and I just knew that this wasn't one of the times that I could approach the person. So she remained a mystery; I couldn't work out who she was or why her face was bandaged. That was fascinating, and quite exotic, in a way.**

De Salvo So you just saw her on the street?

Wearing **Yes, I was in a friend's car, and I told my friend to circle round a couple of times, it was just so fascinating.**

De Salvo So first you saw the woman, and then that inspired ...

Wearing **Inspired me to pay homage, so I became that person, in black and white.**

De Salvo It's as if you assumed her identity, like a role you took on, except that for her it's not a role, it's whatever happened to her. It could even have been a face-lift, we just don't know.

Wearing **Yes, it could have been absolutely anything. And so that mystery was never resolved.**

De Salvo You are certainly very mysterious in it. That line between fact and fiction is very blurred. If viewers were to see it without the subtitles, they wouldn't really know. What was it like having someone else film you?

Wearing **Two parts of it are me filming from my perspective and there's one part of me being filmed, but I didn't really enjoy that. I find it highly embarrassing. But when I was filming, it was far more horrific, because I went out by myself. I had the camera, but I had to keep it quite low. When I first walked out on the street I was laughing because I felt such a mess – not laughing because it was funny but because it was embarrassing, like I hope no one sees me. I had to have a few drinks before I went out. Also, I didn't want anyone I knew to see me. In a way I was much more vulnerable than in *Take Your Top Off*, because I could easily have been attacked. People do find it quite offensive sometimes when you look so odd. I haven't got it on video, but one person did tell me to fuck off very blatantly and straight to my face. Also, because your vision is slightly cut off because of the mask, you don't feel so aware.**

De Salvo Throughout your work, there's a way in which you present things in seemingly normal contexts, either domestic settings or very simple settings, that heightens the normal.

René Magritte
La reproduction interdite (Not to be reproduced)
1937
Oil on canvas
81.5 × 65 cm

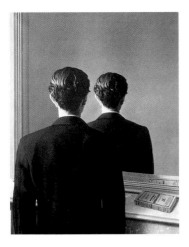

Wearing I remember from my years at college, when I was still making sculpture, seeing Robert Gober's and Jeff Koons' work for the first time. It left me feeling that I, as the viewer, could think creatively of all the possibilities inherent in the idea.

De Salvo There's an ambiguity in that work, especially Gober's. It's familiar in some ways, and then again it isn't. It's like Magritte's work on that level.

Wearing Magritte was fantastic in the way that he could express something abstract, but through images of familiar-looking objects and people. I remember, years ago when I didn't know much about art, coming across his work and thinking how it reminded me of something, but I didn't know what it was. It's that kind of unknowability of everyday things you encounter, like the back of someone's head, that's frightening.

De Salvo Was he one of the first artists that you remember being attracted to, even before you started making art?

Wearing Yes, I also liked the aspect of Pop Art where a banal object would be blown up and exaggerated. That makes you more aware of it: all of a sudden it feels like something you do know, but which hasn't been pointed out to you. Sometimes it can only be pointed out to you by going around it. Someone has to draw it out in a way that's different, pull it apart, because from an early age we've learned to blank so many things we've seen.

De Salvo This seems to be precisely what you do: you take things apart, put them back together with a different structure, and make us go round them in a way that makes us look again.

Kelly and Melanie (detail)
1997
Black and white photograph, Iris
print text panel
90 × 124 cm each

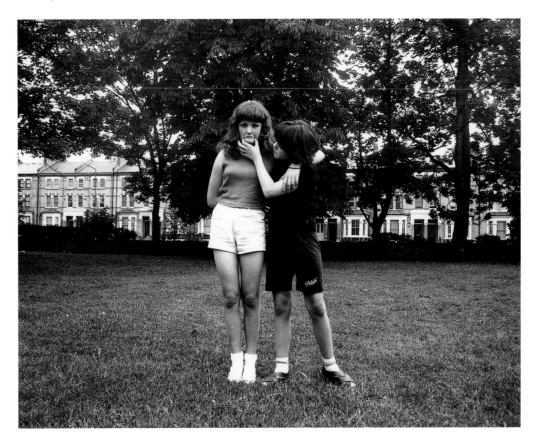

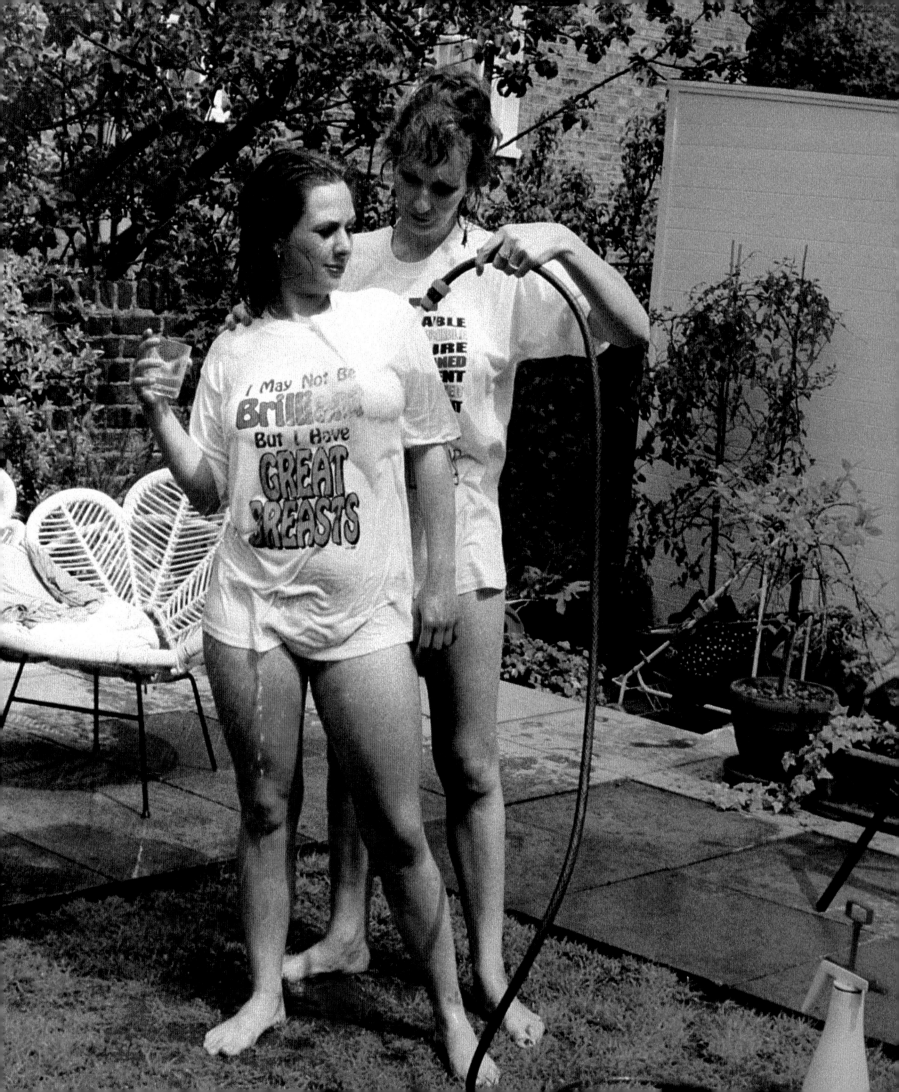

Contents

Sherrie Levine
After Walker Evans (After Walker
Evans' Portrait of Allie May
Burroughs)
1981
Gelatin silver print
25.5 × 20.5 cm

Richard Prince
Untitled (Girlfriend)
1993
Ektacolor print
162.5 × 112 cm

A woman is dancing alone in a shopping mall to the music in her head, apparently oblivious to her surroundings. As the awkward gyrating continues, one can see passers-by averting their eyes from the sight of someone so obviously out of it. And as viewers of Gillian Wearing's *Dancing in Peckham* (1994), we share something of this embarrassment, the desire to turn away lest we be implicated in a kind of public humiliation. The dancer, of course, who is in fact Wearing herself, shows no sign of recognizing any such discomfiture; she continues regardless. And after a while, perhaps, we begin to feel a grudging admiration. Isn't she really just doing what she feels? And isn't that what we should be doing, if we weren't always too worried about what other people might think?

The freedom from convention demonstrated by Wearing's dancing in this simple piece sets up some of the key issues in her work. In a casual, apparently spontaneous way, she touches on some of the most difficult and intractable issues of identity and self-presentation. How do we show ourselves to others, and how can that face be reconciled with what we believe to be our true feelings and desires. As early as the seventeenth century Pascal had recognized and condemned the theatrical element of everyday life: 'We are not satisfied with the life that is in us and in our own being: we want to live an imaginary life in the minds of other people. For this reason we are anxious to shine. We work continually to embellish and preserve this imaginary being, and neglect the true one'.[1] Since the late eighteenth century, artists have tended to position themselves in opposition to this 'false' way of living. The belief grew that one of the central

activities of the artist was to reveal, as directly as possible, the inner emotions that drove human life. This basically Romantic quest for authenticity of feeling, direct expression and unalienated creativity reached its peak, or perhaps its crisis, after the Second World War, in the era of Existentialism, the Beat Generation, and Abstract Expressionism, although it has certainly not disappeared since. How can we live a life that is truly ours? And how do we know that anything, including our own personality, is really authentic?

Such questions, it is true, have been somewhat out of fashion for a long time now, superseded by the acknowledgment that personality and identity are inherently multiple, defined as much by others as by ourselves, and by the various contexts in which we live. Artists are still conventionally thought of as the exceptions to that mutability, and are often granted a certain license accordingly, on behalf of the rest of us. But even some artists have welcomed the death of the author proclaimed by the early Roland Barthes: ' ... life never does more than imitate the book, and the book itself is only a tissue of signs, an imitation that is lost'.[2] The work (quite different from Wearing's) of Sherrie Levine, Richard Prince and Cindy Sherman might be taken as paradigms of the embrace of multiple identities, and the move beyond over-simplified ideas of essential identity. It is not necessary to reject such an analysis, however, to recognize the continuing appeal of the older idea of an integral core of authentic identity, with which we are constantly in danger of losing touch. This in turn gives an enduring appeal to the search for undiluted forms of self-expression with

Dancing in Peckham
1994
Video
25 mins., colour, silent
Video still
Collections, Government Art
Collection, London; Southampton
City Art Gallery

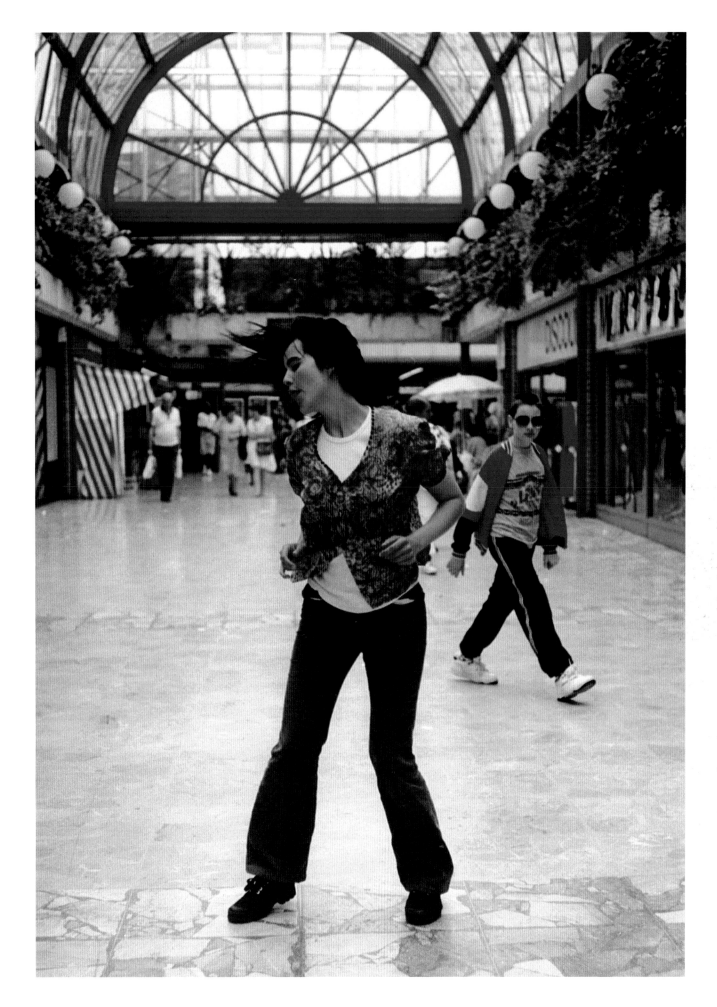

which to resist co-option. This concept has been particularly fraught in England, with its long tradition of repressed emotions. The most favoured rhetorical trope in England remains a sardonic irony, and irony has a horror of attempts at unmediated emotional expression. The preferred statement is understatement, and when that is on occasion abandoned the results can be frightening, like paintings by Francis Bacon.

Wearing's dancing combines an only too familiar 'out of it' cliché with one of the great clichés of 'self-expression' – the 'modern' dancer getting in touch with elemental truths through the body itself; an idea already collapsing by the early 1960s, when the figure of the 'expressive' modern dancer began to become a recognizable figure of fun in, for example, Jules Feiffer's *Village Voice* cartoons. Wearing's dancer can perhaps be seen as an inheritor of that tradition, playing out a debased version of self-expression in true disregard of what other people might think. And yet even this most elemental expression we know on another level to be thoroughly inauthentic. In most cases when Wearing appears in her own work, it is only after having appropriated another personality, often one only glimpsed in passing, thus precluding any real intimacy. In the case of *Dancing in Peckham*, the inspiration for the piece came in just this form: a young woman seen for only a few minutes. Wearing thus undercuts, through her own version of appropriation, the very appearance of authenticity suggested by the oblivious dancer in the first place.

Wearing operates in the space *between* the parameters that define our social normality and the notional point of unmediated expression. Into that space she inserts disjunctive elements that both separate and unify. These elements (masks, lip-synching, signs) are her tools. They are the levers she uses to get beyond the doubtful distinction between authenticity and inauthenticity, to make art instead. The idea of unmediated expression invokes the real, the immediately present. But all art is a form of representation, a step away from true immediacy. There is an inescapable distance between the spasm of feeling and the work of art. It is in that gap that the art is made.

Wearing recognizes both the arbitrary and socially constructed nature of identity, while at the same time acknowledging the continuing desire to escape from the apparently limited and inherently false personae in which we find ourselves clothed. Her intent, however, is not to valorize one over the other. Rather it is to put her work into the contested space between the two crude poles. It works as a kind of hinge that can swing in either direction. Her work engages directly with all the confessional and inward-looking attributes of the authentic, but does so through an elaborate apparatus of masks and disguises, the visible signifiers of patently false identities.

The most striking use of masks is in *Confess all on video. Don't worry you will be in disguise. Intrigued? Call Gillian* (1994), in which an array of people recruited through classified ads confess to a variety of real or perceived misdeeds while disguised by one or other of Wearing's collection of wigs and Halloween masks. *Confess all ...* combines in one visual structure both an extreme level of

authenticity – the straight-into-the-camera confessions of those who are haunted enough by their guilt to come forward and confess – and an extraordinary level of artificiality, in the form of the bizarre 'disguises' that each speaker wears. Yet while we can clearly see the artificiality and concealment represented by the masks, the authenticity of the confessions themselves remains more problematic. The classified ad approach – 'confess all on video' – suggests that the volunteers may be exhibitionists of a sort, suspiciously eager to unburden themselves of baroquely fascinating crimes and transgressions. But the crimes tend to be trivial or banal. And in fact the supreme inauthenticity of the masks helps to undercut that initial suspicion. Wouldn't the masks themselves preclude an exhibitionist interpretation? But then perhaps one can be an

exhibitionist in disguise. Continued viewing produces continued vacillation. Perhaps the speakers are simply fantasists for whom the disguise acts as a license to indulge in freewheeling lying, with a more or less captive audience. But the confessions themselves seem too painfully raw, and we are returned to a hedged-around acceptance of their truth.

And then the masks themselves – those tokens of anonymity that promise both truth and lies – begin to creep up on us in a disturbing way. We know, of course, that this is not George Bush speaking (or Neil Kinnock), but despite ourselves these false identities begin to assert claims of their own. Even when the mask-identities are unfamiliar, it is hard not to ascribe to them personality traits that cut across the words of the speaker behind them. This confusion of the oral, the textual, and

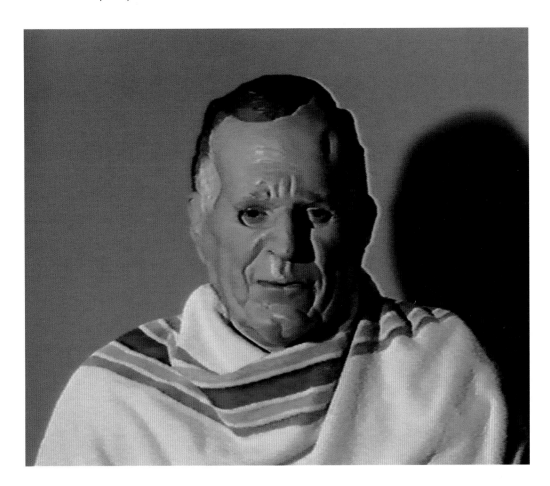

Confess all on video. Don't worry, you will be in disguise. Intrigued? Call Gillian
1994
Video
30 mins., colour, sound
Video still
Collections, Arts Council, London; Tate Gallery, London; Kunsthaus, Zurich

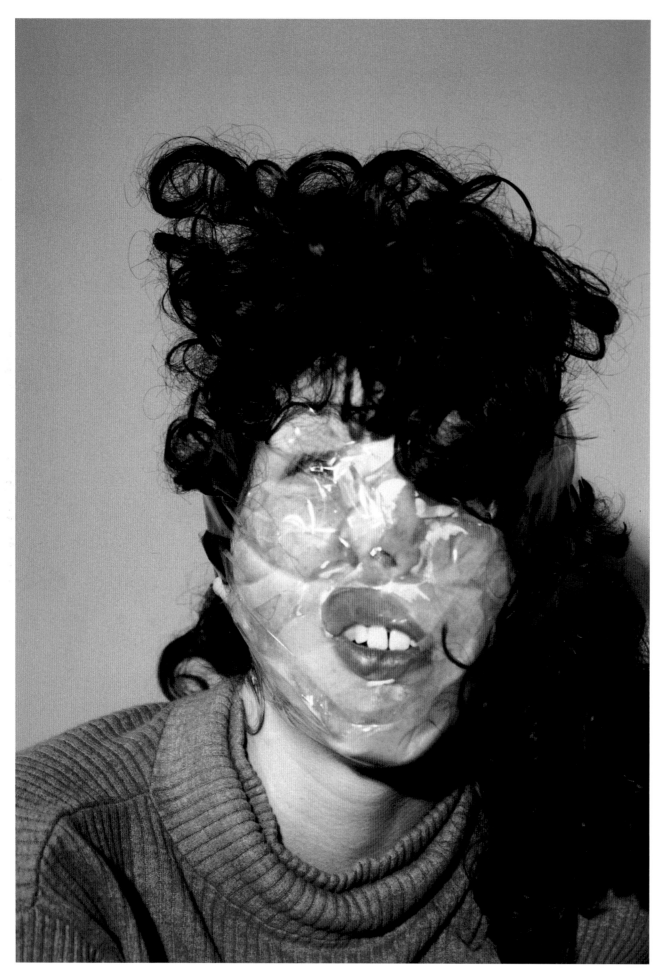

Confess all on video. Don't
worry, you will be in disguise.
Intrigued? Call Gillian
1994
Video
30 mins., colour, sound
Video still
Collections, Arts Council, London;
Tate Gallery, London; Kunsthaus,
Zurich

left, **Cindy Sherman**
Untitled No. 96
1981
Colour photograph
70 × 122 cm

the visual conjures up a sense of 'the truth' that is powerfully threatened from each aspect that is not at the centre of our attention at any given time. As viewers (and listeners), we are left with the uncomfortable sense that we have been witnesses to the most naked of soul-barings, and yet that we have heard nothing that we can be sure of. And what have we even seen, except some cartoon characters? Perhaps the most haunting aspect of this piece remains the beseeching human eyes that stare out from behind the masks, authentically unreadable. The masks themselves, no matter how ostentatious, are hiding places, like confessionals, where secrets can be told.

Does it matter in the end whether the people confessing are telling the truth or not? Michelangelo famously dismissed criticism that his portraits of two Medici dukes were not good likenesses. In a thousand years, he said, no one would know or care what the two men had actually looked like; his work would endure on its own terms. In *Confess all … ,* the element of likeness is deliberately destroyed. So are most clues to the legitimacy of the 'confessions'. Out of a process that begins by opening up to other people's stories (their 'content') and continues to welcome specificity while all the time erasing visible identity, Wearing makes a work of art with its own claim to autonomy, its own kind of authenticity.

It was suggested earlier that the work of Cindy Sherman could be taken as paradigmatic of what might loosely be called a 'postmodern' acceptance of identity as multiple and mutable. Sherman, like Wearing, makes extensive use of disguise, and of masks; but Sherman submerges herself in an

endless sequence of variations, each apparently as valid as the last. She plays off the vast repertoire of cultural stereotypes that everyone in our society can read at a glance, demonstrating how easy it can be to slip in and out of them, begging the question of what, if anything, might lie concealed behind them. Wearing, in her use of masks, appears to be drawing on a much older tradition, one in which the mask functions not so much to substitute one identity for another as to obliterate the superficial aspects of physical appearance in order to reveal more fundamental truths. This is a tradition which runs back at least as far as classical Greek tragedy, and can also be found in the Noh Theatre and in the archetypal characters of the Commedia dell' Arte. Police uniforms, cowboy outfits, whatever disguise is available: Wearing makes us pass through the archetype (not the stereotype) before reaching the individual.

In painting, a powerful predecessor can be found in James Ensor, for whom the mask offered a route beyond realistic or anecdotal detail, simultaneously opening up narratives stripped of local specificity and offering Ensor as an artist the possibility of giving free rein to fantasies and desires previously hidden even from himself. 'I have joyously shut myself up in the solitary domain where the mask holds sway, wholly made up of violence, light, and brilliance', he wrote. 'To me the mask means freshness of tone, acute expression, sumptuous decor, great unexpected gestures, unplanned movements, exquisite turbulence'.[3] For Ensor, it is clear that the mask represented access to a world of spontaneous authenticity. He accepted the conventional artificiality of the

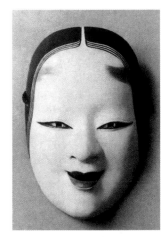

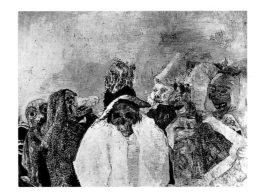

Noh Mask
c. 1650
Carved wood, paint
Approx. 21 × 17 cm

James Ensor
Masks Confronting Death
1888
Oil on canvas
80 × 100 cm

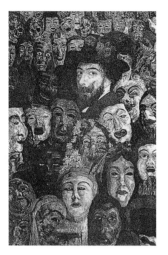

James Ensor
Portrait of the Artist Surrounded
by Masks
1899
Oil on canvas
120 × 80 cm

mask only as a point of departure into deeper truths. In works such as *Masks Confronting Death* (1888), the masks are juxtaposed with the most elemental of all hidden faces, the skull. As Jean-Pierre Vernant has written of the mask in ancient Greece, it is 'a means of expressing absence in a presence', by which he means 'the absence of a god who is somewhere else but who tears one out of oneself, makes one lose one's bearings in one's everyday, familiar life, and who takes possession of one, just as if this empty mask were now pressed to one's own face, covering and transforming it'.[4]

Ensor's self-portrait of 1899 shows the artist in a stagey disguise, with a Rubens-like beard and moustache, and an elaborate flowered and plumed hat on his head. This central figure is surrounded by dozens of masked faces, some grotesque, some merely blank. Looking at this painting today, it is hard not to be reminded of Wearing's masked subjects in *Confess all* ... Ensor's steady, placid, look out at the viewer from the centre of the cacophony he has created echoes the way in which

Wearing stays one step back from the psychologically loaded scenarios she puts underway. In both cases, however, it remains the artist who orchestrates the overall situation. It also seems true, in both cases, that the masks conceal only to promise greater revelation. Masks remain static, yet at the same time they seem to speak to us, to carry some message from an inaccessible realm.

A more direct precursor of Wearing's interests can be found in the work of Diane Arbus, especially in some of her photographs of institutionalized mental patients. The awkward children with their homemade masks in *Untitled (4)* (1970–71), or the 'witch' in her wheelchair of 1970 seem to come directly from the same blandly generic but psychologically scarred landscape in which Wearing works. For Arbus too, as for Wearing, the process of masking and disguise comes from a desire to obscure the specificity of individual appearance the better to open up more direct roads to the interior essences of personality. As children we used to call those Halloween masks 'false faces',

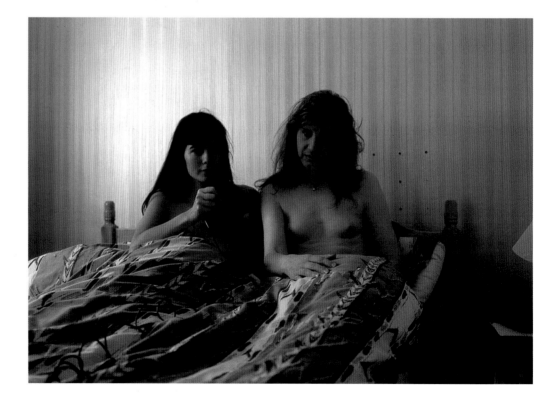

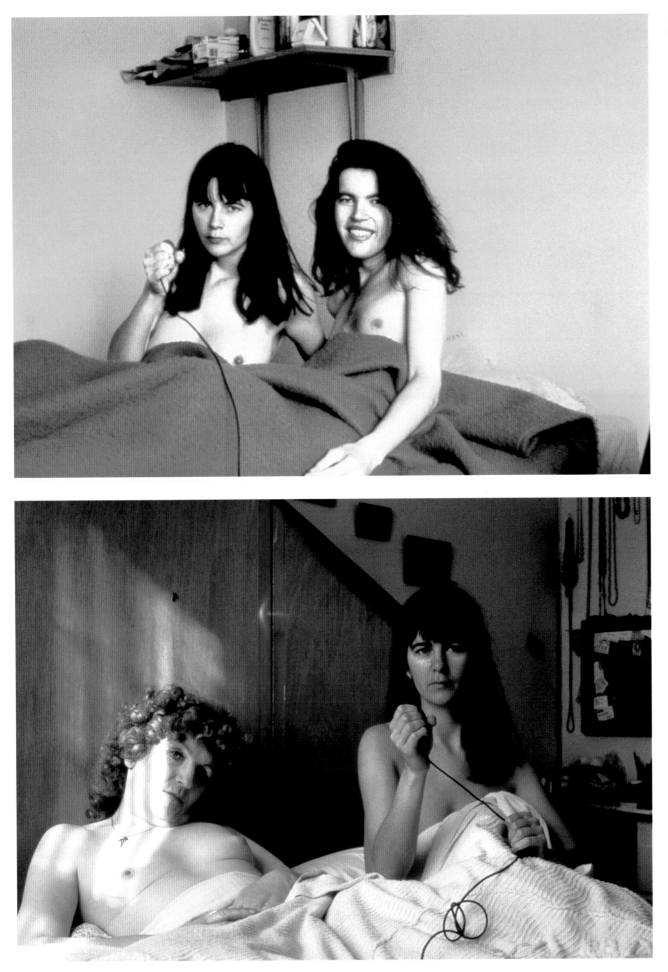

left and opposite, **Take Your Top Off**
1993
3 C-type colour photographs
mounted on aluminium
73.5 × 99.5 cm each

Survey

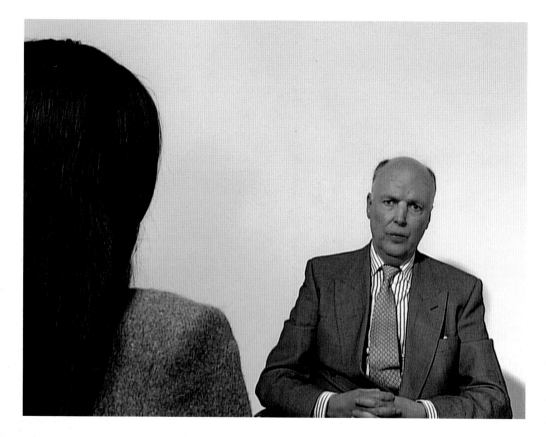

10–16
1997
Video projection
Approx. 15 mins., colour, sound
Dimensions variable
Video still

and the term is appropriate not only for the cheap plastic masks that the people in the photographs wear, but also, of course, for the various accommodations that everyone is expected to make in order to live in society – false faces that some seem better equipped with than others.

In the photo series *Take Your Top Off* (1993) Wearing presents three transsexuals in various stages of transformation, these also recruited through classified ads. The mid-gender status of her subjects introduces in the viewer some of the same ambivalences produced by the masks in *Confess all on video* ... While the transsexuals are unmasked, their bodies reject any final positioning. This fundamental ambiguity hovers around the work. In a gesture variously interpretable as confidence-winning, exhibitionist, or intimate, Wearing sits in bed alongside her subjects, her own top off, a friendly participant but at the same time strangely over-involved.

The literal stripping bare of everyone in this work suggests a metaphor of revelation: that we will see more than just bodies – that in fact we will be offered access to deeper levels of the psyche. The presence of the artist herself acts as a token of this promise. Her vulnerability suggests an almost mythical willingness to expose her body to risk in order to find out the secrets of another world. Like Theseus, who ventured into the labyrinth in search of the half-man, the Minotaur, Wearing ventures here beyond conventional norms of the body. The shutter-release clutched in her hand is the thread connecting her to the straight world, and is in fact the means by which she will deliver her discoveries, the evidence of her exploration in the labyrinth of sexual identity. The evidence, of course, is inconclusive.

Wearing often both acts out and parodies the idea of the artist as anthropologist, a pervasive trope of art in the nineties. Her deadpan recording of her subjects' appearances, fantasies, and opinions demonstrates a kind of 'scientific' indifference to content, absorbing with equanimity both the utterly banal and the utterly bizarre. In the final sequence of *10–16* (1997) for example, the speaker is shot with Wearing's shoulder just visible in the classic 'concerned and sympathetic' interviewer pose, although of course she remains silent. This brief shot of Wearing listening impassively also carries with it the suggestion of the psychoanalyst, and in a way some of her video works could be considered versions of the 'talking cure'. Or at least they could if it were not so evident that no cure is in sight. The endless cycles of repetition seem all but unbreakable.

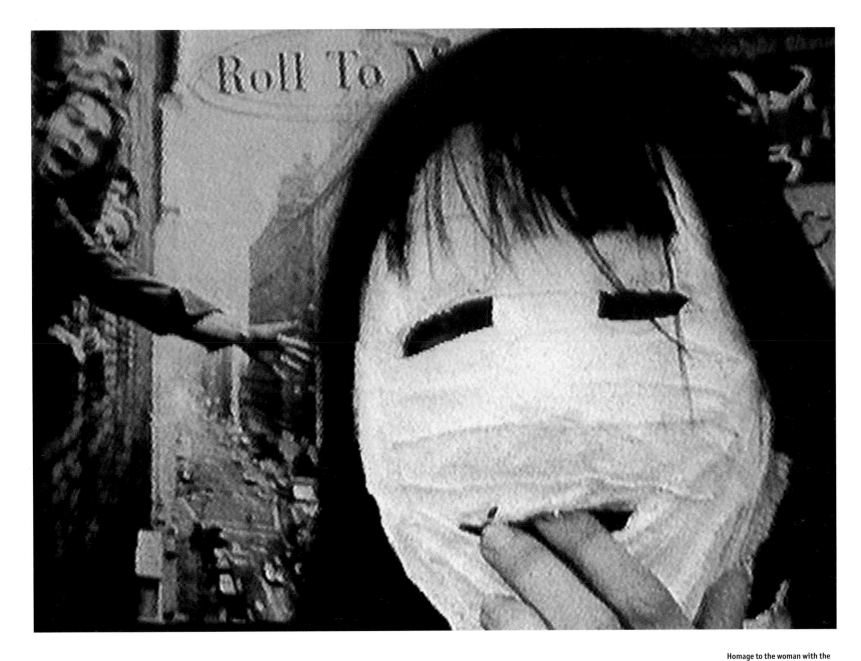

Homage to the woman with the
bandaged face who I saw
yesterday down Walworth Road
1995
Video projection
7 mins., black and white/colour,
subtitles
Dimensions variable
Video still

Jacques-André Boiffard
Untitled
1930
Black and white photograph
Approx. 24 × 18 cm

Hans Bellmer
La Poupée (Doll)
1934
Black and white photograph
Approx. 30.5 × 45.5 cm

Wearing's nakedness in *Take Your Top Off* has its counterpart in *Homage to the woman with the bandaged face who I saw yesterday down Walworth Road* (1995), in which the artist appears walking down the street with her face almost completely covered by bandages. Here the idea of (literal) self-exposure is turned around into a kind of concealment close to self-obliteration. The swathes of bandages in fact call to mind nothing less than the invisible man or, in this case, the invisible woman. In fact, however, this woman is anything but invisible. People turn to stare, their attention caught by the hint of some disfiguring injury too horrible to be exposed, then quickly look away, trying unsuccessfully to return her to the realm of the invisible, the never-seen.

Wearing's starting point for *Homage to the woman with the bandaged face* … was, again, a woman she glimpsed only for a few moments, a woman she does not know and whose uncovered face she never saw. And while that woman was accompanied by 'raucous friends', Wearing herself, alone, finds that the bandages make her only an object to be furtively stared at. No one will communicate with her, except for the Quik-Fit fitter's tentative, half-mocking 'hello'. She thus positions herself at a kind of degree zero of identity, simultaneously Gillian Wearing and a blank screen (she describes the bandages as 'a sheer, brilliant white') on which we, her viewers, can project whatever fantasy we wish. While the ten year-old in *10–16* escapes to a tree house where he can 'think about my future', *Homage to the woman with the bandaged face* … implies a horrific, damaging past leading to a future that remains completely blank,

the potential for re-invention juxtaposed with the possibility of obliteration.

Wearing's ghostly passage through the city recalls that of André Breton's Nadja, another damaged and unconventional protagonist discovered by chance in the street. One evening, Nadja gives Breton a drawing that includes an expressionless mask 'about which she can say nothing'. Later, Breton notices that 'everyone – even people in a great hurry – is turning around to look at us', and at the end of the evening, 'Nadja says she wants to be Madame de Chevreuse; how gracefully she conceals her face'.[5] But even more relevant than Nadja's masking, or her desire to change identities, is the general feeling of disengagement from society that she embodies, her presence a kind of drifting rejection of convention. Nadja makes everyday life strange and marvelous. It is this quality that attracts Breton, who uses her as a vehicle for his work, as Wearing has done with the woman she saw down Walworth Road. Indeed, the artist's bandaged face resembles some of the dolls made by Hans Bellmer in the 1930s, reinforcing the recurring suggestion of a violent disruption of the human body that goes hand in hand, in Wearing's work, with a total acceptance of every subjectivity. This tendency has an unmistakable relationship to the making-strange of everyday life that was so important for Surrealism. Surrealism pursued direct access to the unconscious, the source of desire, and sought to make more porous the barrier between conscious and unconscious in every aspect of living. This area of contact between the strictures of daily life and the unrestrained license of fantasies and dreams

exercises an equal fascination for Wearing. To be abruptly stopped on the street and asked to write down a statement for display to the world seems to appeal for a disruption of the conventional distinction between public face and private thoughts.

The masked figures of *Confess all ...* bear a striking resemblance to 1930s photographs by the sometime Surrealist Jacques-André Boiffard that show a man in a very bourgeois suit and tie wearing a clownish mask and sitting at a child's desk. In Boiffard's photographs we seem to be beyond the question of whether there is another, concealed identity beneath the mask. Wearing's attitude, too, is not that of the troubled sixteen year-old voice we hear in *10–16*, who describes his overweight body as 'like I'd been given this horrible mask to wear'. Clearly, this boy believes that it should be possible to tear off that mask, and that his real personality lies underneath somewhere. Wearing's own attitude, quite different, is expressed in her first response to the bandaged face of the woman in the Walworth Road, whose bandages seemed 'more aesthetic than practical – like a mask'. Here we have the mask as a creative choice, a way of getting beyond the limiting specificity of individual appearance and into a new territory of re-invention.

The cumulative effect is one of consuming strangeness. When Wearing shows us a specific environment, it is always shabbily familiar: a slightly run-down flat, or a dingy outer-London street. This sense of familiarity gradually dissipates as we are witness to one more or less odd subjectivity after another. There is a growing sense that the idea of normal is becoming meaningless.

Each bland setting serves only to introduce a new wave of mild but increasing dislocation. Wearing's anthropological activities seem in the end less directed at making sense of a foreign culture than at breaking down our sense of the one we thought we already knew. The parade of citizens depicted in *Signs that say what you want them to say and not Signs that say what someone else wants you to say* (1992–93) bears some formal resemblances to August Sander's documentary survey photographs of the 1930s, yet while there is no shortage of specific class and subcultural information, the 'anthropological' element of the information we might draw from these portraits is constantly disrupted and upstaged by the intrusion of the subjects' own version of direct address. As Wearing has put it, 'When you are working with strangers there's that chance element which is a way of finding things that you don't think are there. It dislodges the perception of what is in front of your eyes'.[6] We are denied the luxury of imposing our own interpretations and fantasies onto these people. Or perhaps it would be more accurate to say that, while we will no doubt continue to impose our own fantasies, these are at least contested or partially directed by the subjects themselves.

The later Barthes could find the *punctum* in any detail of a given photograph, if it spoke to him. So can we in these photographs, but only after dealing with their subjects' attempts to impose a *punctum* of their own. Even those who choose not to make any personal revelation, those who make jokes, or who remain completely banal, have their say. The entire process becomes more dialogic than the conventional models of anthropological or

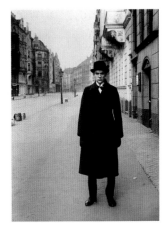

August Sander
Anton Räderscheidt, Cologne
c. 1927
Gelatin silver print
22 × 17 cm

following pages, From **Signs that say what you want them to say and not Signs that say what someone else wants you to say**
1992–93
C-type colour photographs mounted on aluminium
40.5 × 30.5 cm each
Series of approx. 600 photographs

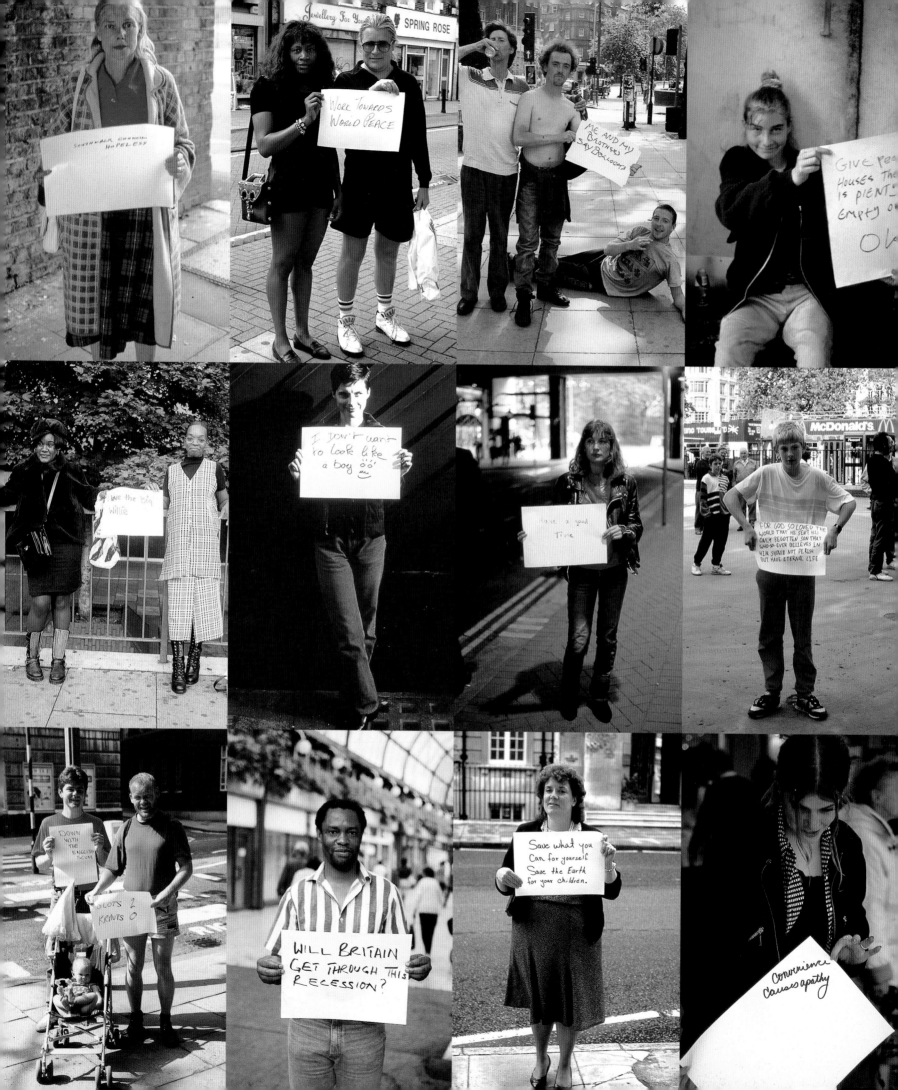

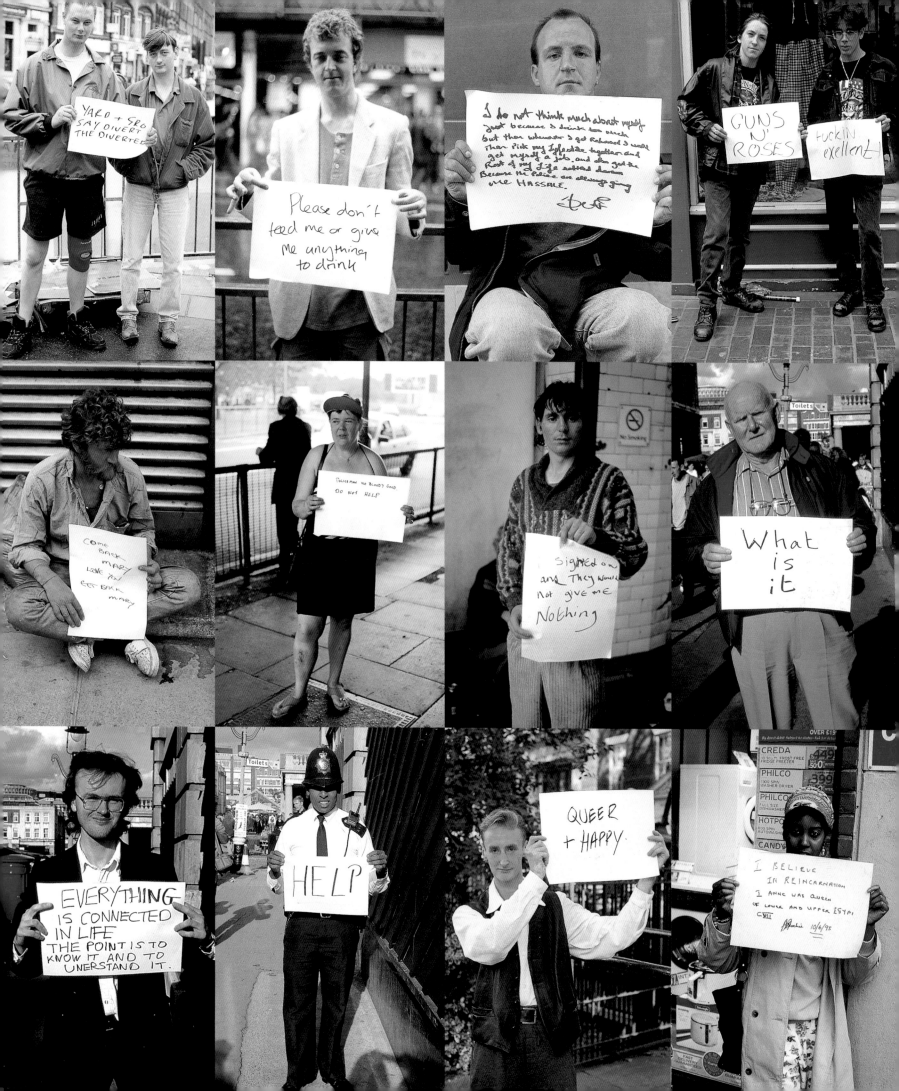

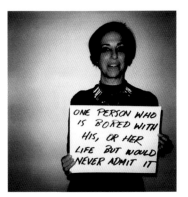

Douglas Huebler
Variable Piece No. 70 (In
Process)
Global
1971
Colour Polaroid photograph
10.5 × 9.5 cm

'Throughout the remainder
of the artist's lifetime he will
photographically document,
to the extent of his capacity,
the existence of everyone alive
in order to produce the most
authentic and inclusive
representation of the human
species that may be assembled
in that manner. Editions of this
work will be periodically issued
in a variety of topical modes:
"100,000 people", "1,000,000
people", "10,000,000 people",
"people personally known by
the artist", "look-alikes",
"overlaps", etc.'
Douglas Huebler, November 1971

portrait photography.

The attempted confusion of roles between artist, subject and audience in *Signs ...* can be found in a different form in the most obvious precursor to this work: D.A. Pennebaker's 1967 film of Bob Dylan's *Subterranean Homesick Blues*, in which Dylan holds up sheets of paper with the song lyrics scrawled on them. In this work, too, the conventional relationship between artist and audience is deliberately challenged. Dylan takes up a position that suggests that it is in fact the audience who are in front of the camera, reading the cue cards he holds up. Nevertheless, despite the sophistication of this play with point of view, it always remains clear that it is in fact Dylan himself who remains the author. Wearing's approach goes much further in actually surrendering control of the 'message' to those who agree to collaborate with her. It is all the more painfully ironic, therefore, that the visual style of this work has repeatedly been co-opted for commercial advertising – the epitome of signs that say what someone else wants you to say, of self-expression defined as your choice of commodities.

A more art-related precursor of Wearing's *Signs ...* can be found in a series of works by Douglas Huebler made in the early 1970s. Beginning in 1971, Huebler photographed a number of people holding cards bearing texts such as 'One person who is as pretty as a picture', 'One person who is not afraid of life', or 'One person who always has the last word'. While this work has a striking formal similarity to Wearing's *Signs ...*, Huebler's procedure was quite different. His subjects chose cards at random from a set of eighty written by

Huebler himself. Rather than presenting the thoughts of the portrait subjects, this work sets up a contradiction between the apparent relevance of the label held to the person holding it and the information provided by Huebler that the connection is purely arbitrary. While Huebler's and Wearing's pieces seem to be at opposite ends of a notional scale of authenticity, their combined effect is in fact to call into question the concept itself. Huebler's labels might, after all, be accurate. Wearing's subjects might, after all, be lying, no matter how much we are convinced of their authenticity.

While the subjects in *Signs ...* have passed on into the urban flux, in other works Wearing has made the interactive relationship even more explicit. This is evident in the series of photographs in which she returns to earlier subjects, solicits a text from them, then photographs that and displays it equal in size to the original image, as if inviting us to re-evaluate our original reactions in the light of the subjects' own reflections. This return risks weakening the iconic status often achieved in the earlier work, but on the other hand its generosity indicates the degree of commitment Wearing is willing to make to those with whom she collaborates.

Wearing productively combines the solicitation of direct self-expression with a set of formal structures that tend to emphasize repetition and seriality. It is almost as if she wants to test the authenticity of the emotion she has sought against the flattening power of the framing structure. First there must be a draining out of the more conventional signs of individuality, whether

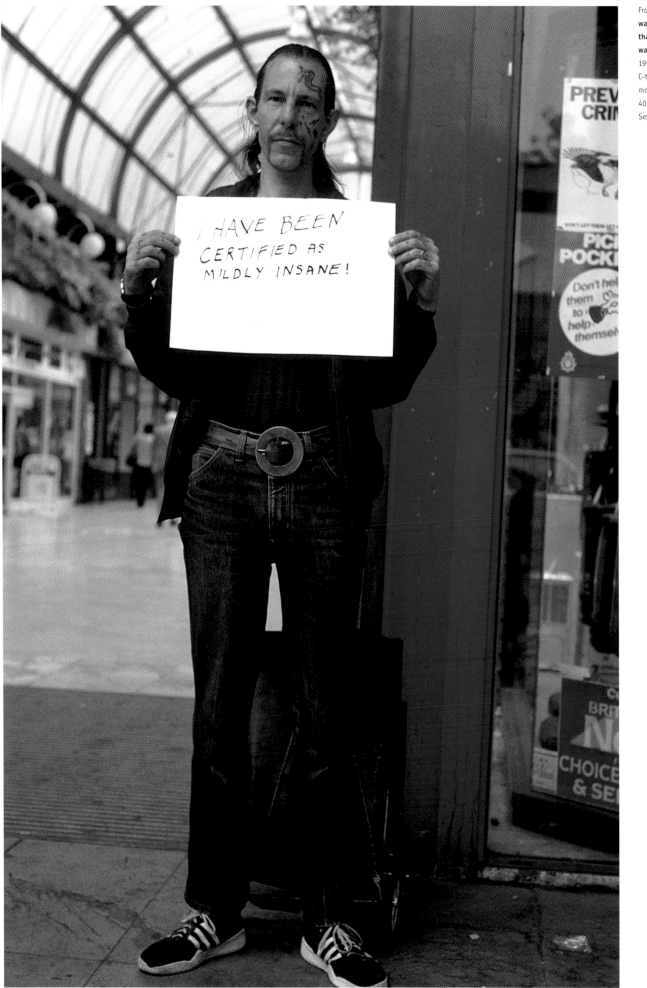

From **Signs that say what you want them to say and not Signs that say what someone else wants you to say**
1992–93
C-type colour photograph, mounted on aluminium
40.5 × 30.5 cm
Series of approx. 600 photographs

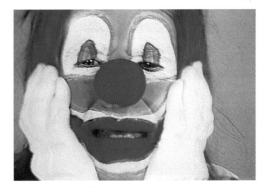

Bruce Nauman
Clown Torture
1987
Video installation
2 video projectors, 4 video
monitors, 4 loudspeakers, 4
videodiscs, colour, sound
Dimensions variable

through masks, lip-synching or other means. Much of her work consists of series of subjects responding to a given set of variables defined by the artist. *Signs* ... demands authentic and unmediated expression from its diverse subjects, but the simple economy of Wearing's serial approach gives the work a kind of steady rhythm that structures it as a whole rather than as a truly random sequence. Desperate or not, we still always know that up next will be another piece of white paper the same size, with another personal message from someone we don't know. Only after the artist has imposed her own structure can we have the re-emergence through it of a distilled self-expression, the stronger for its trials. As she herself has put it, 'When you find a structure to explore, you go there with certain notions but enter a state where you forget that knowledge, and see beyond it to something further, unexpected'.[7]

In Wearing's work the formal armature around which she organizes her work tends to be an apparently open structure that invites the unstructured participation of her collaborators. The artist, however, organizes her material into a repeating structure both in terms of its internal serial structure and in the looping that repeats the entire work indefinitely. In terms of actual content, this anti-teleological structure of repetition serves to reinforce the irreducible elements of interior life, suggesting that the baggage we take on board in childhood, whether trauma or fantasy, will be with us forever.

The protagonists of Wearing's work struggle to speak, to articulate their emotions and what they see as their most essential qualities. The visual

arts, of course, have been defined as the silent arts since ancient times, but that limit has been increasingly challenged since the 1960s. Michael Fried's landmark essay 'Art and Objecthood' (1967) is a passionate plea for resistance to what he called the theatrical. For Fried the theatrical is that element in art that presupposes a durational quality integral to the work itself. Fried's essay – directed primarily against what is now known as Minimalism – actually predates the leap into the genuinely – inescapably – durational and interactive mode made in Bruce Nauman's early video work of the later 1960s. Nevertheless, the very fact that Fried felt it necessary to make the anti-theatrical argument suggests the pressures that were already building towards direct speech in art, whether truly theatrical or not.

Thirty years later, art is awash in speech. Direct address is everywhere, text proliferates, and the battle against theatricality has long been lost. Gillian Wearing's work, therefore, despite its particular attention to speech, is breaking no new ground simply by virtue of that focus. It is, rather, in her exploration of the various failures and aphasias of speech, and indeed in the return to an often painful silence, that her work finds its true force. The intense desire to speak, to explain, is often coupled with acute difficulty in communication. There is sometimes an almost unbearable tension between the palpable desire to speak and the limits that surround the desire. In this it is in fact possible to see a parallel with the later work of Nauman, especially pieces like *Clown Torture* (1987). Even when Wearing's subjects speak fluently, we are made to doubt their speech,

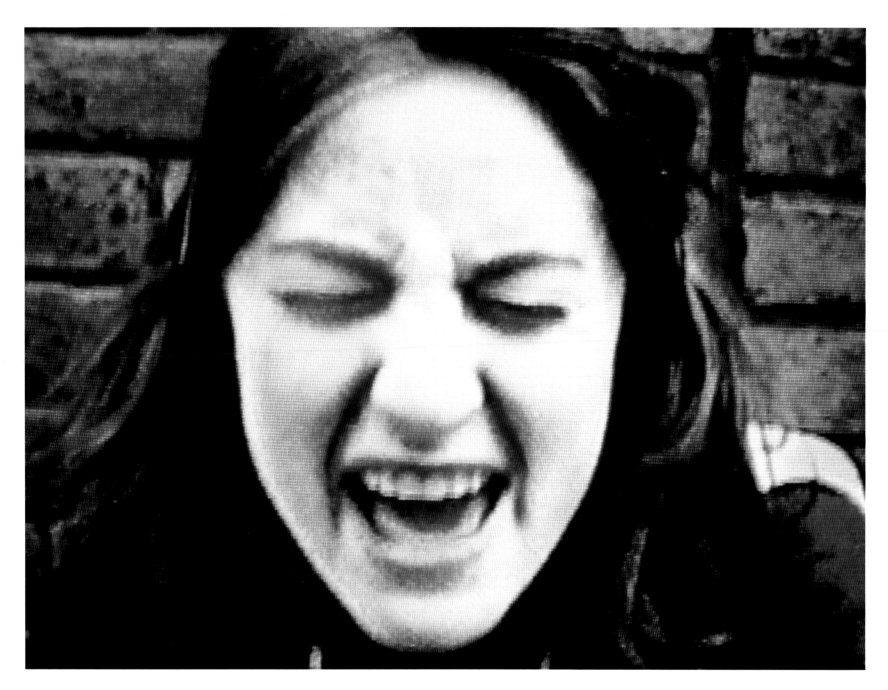

My Favourite Track
1994
Video installation
5 monitors, approx. 90 mins.,
colour, sound
Dimensions variable
Video still
Collection Tate Gallery, London

through the obvious 'disguises' (including not just masks but also, for example, not-quite-perfect lip-synching) that quickly call its legitimacy into question. Even when the mood is relatively cheerful, as in *My Favourite Track* (1994) the participants mumble and mistake their words. We are left with a stumbling inarticulacy that forces us back instead onto the visual presentation of those who attempt to speak: their hideous masks, their surrogate bodies, their lips tight shut.

Even in *Signs ...*, the work which is perhaps most engaged with opening up access to public speech, the protagonists do also in a way remain silent. Gridded up on a gallery wall, her photographs still present these figures as subjects for (our) viewing. Their signs say what they want them to say, but their silent forms are fixed by the artist.

It is clear that, for Wearing, silence too is a form of speech, of language. Think of the silent music of *Dancing in Peckham*, the sealed-up mouth in *Homage to the woman with the bandaged face ...* or the fidgety police held captive in *Sixty Minute Silence* (1996). The various silences of these works return us in one way to a kind of 'pre-theatrical' silence. To watch the stasis of *Boytime 1* (1996–98) is on one level to come close to experiencing video as painting. The virtually motionless coloured shirts of the boys in front of the white wall form an elegant and sophisticated composition. It evokes the tranquility associated with some *plein air* painting. But such misconceptions can last only for a moment – until the first twitch of a leg or adenoidal snort returns us to the reality of the four young boys doing their best to hold still and to remain silent.

The most evident precursor for Wearing's 'silent' works can be found in Andy Warhol's 'Screen tests' of the 1960s, films that also push the tolerance of both audience and viewer through an enforced stasis that often becomes acutely uncomfortable. And Warhol, like Wearing, was clearly an artist obsessed with issues of control and the lack of it. While the screen tests are the closest to Wearing's work formally, it is also worth comparing Warhol's film practice in more general terms: the unrehearsed performances, the attention to personalities far outside mainstream limits, and the strategy of simply setting up situations from which the artist can then in a sense withdraw. All of these elements form part of Wearing's practice too.

To watch *Boytime 1* is in some ways to have an experience not dissimilar to that of the boys who are shown in it. The video format itself leads us to expect some kind of action, or at least narrative, and we are denied it. After about twenty-five minutes, one of the boys (the one in the yellow shirt) starts to become a little agitated, to sigh heavily, and then to mutter under his breath. His evident discomfort makes the stoicism of the others all the more evident, while at the same time taking on the function of a minimal narrative line for the viewer. The overall stasis and lack of action, however, is in the end overwhelming. Wearing almost never offers us any kind of passage from one state to another, even though she works primarily in a medium from which we are accustomed to expect it. Like the serial repetition and looping that she also uses extensively, stasis acts as an overt rejection of development.

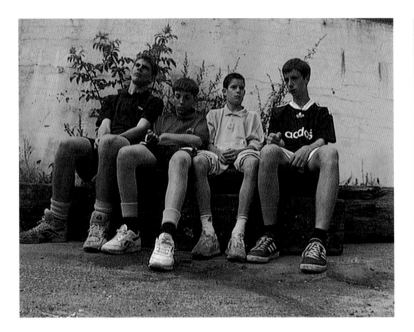

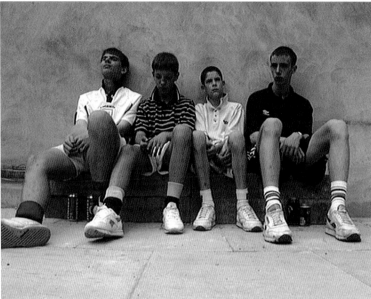

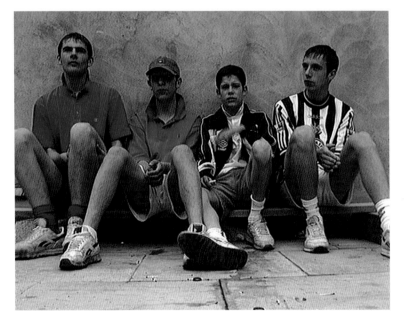

clockwise, from top left, **Boytime
1**; **Boytime 2**; **Boytime 3**
1996–98
Video projection
Approx. 60 mins. each, colour,
sound
Dimensions variable
Video stills

right, **Girltime 2**
below right, **Girltime 1**
1996–97
Video projection
Approx. 60 mins. each, colour,
sound
Dimensions variable
Video stills

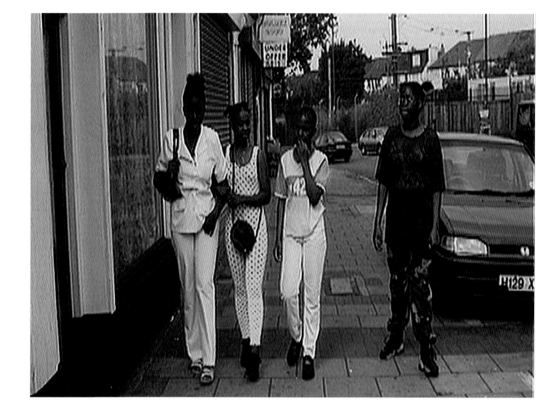

Sometimes nothing changes, even if we are waiting for it.

Beneath *Boytime 1*'s apparent formalism and austerity, however, lurks a structuring element of power relationships. Wearing uses her power as an artist to confound gender expectations. She enforces silence on a group of adolescent boys, who become increasingly agitated. Isn't it girls who are supposed to sit quietly, to be seen and not heard? (While Wearing has often denied experiencing any discrimination as a woman artist, it is worth noting nevertheless that when she wants to ... *Teach the World to Sing* in perfect harmony (1995), the tuneless but willing performers are all women.) In *Sixty Minute Silence*, the group of police officers is an equally clear reversal of expected norms. The police tell other people what to do; they are not supposed to be held there in silence for our observation, and their discomfort with the situation is evident. In both *Boytime 1* and *Sixty Minute Silence*, Wearing compels silence, but these pieces remain intimately linked with those in which she appeals for speech.

Wearing continues to experiment with a self-conscious surrender of the power of an artist to control content, even as the choices she does make continue to mark her work as unmistakably her own. She never asks leading questions. As Hélène Cixous has written, 'As soon as the question is put, as soon as a reply is sought, we are already caught up in masculine interrogation. I say "masculine interrogation" as we say so-and-so was inter-rogated by the police'.[8] The silence in Wearing's work is itself an unarticulated form of counter-speech. As she told Marcelo Spinelli, 'A lot of people have wanted a male sort of dominance. That is what an artist was'.[9] Wearing's response to this burden is not to assert an alternative kind of dominance, but rather to explore the very nature of self-silencing, suppression, and the attempt to speak. 'They cannot represent themselves', Marx wrote of the French peasantry, 'They must be represented'.[10] But Wearing, even as she represents, seems also acutely aware of what Gilles Deleuze called 'the indignity of speaking for others'.[11] There is an enormous effort to avoid it, to open another space within the work where her collaborators can speak for themselves, even if the result is sometimes close to silence.

It is difficult, however, to go too far in discussing Wearing's work in these terms, because although issues of control and power are undeniably present throughout her work, Wearing's interests actually lie as much or more with those whose psychology puts them beyond any meaning-ful classification in terms of social formations. The semi-literate rapist *Brian* (1996), with his shirt pulled tightly over his head, represents only himself. Wearing is interested in people who are often, willingly or unwillingly, completely outside the parameters of 'normal' life. In a video piece currently in progress (*Untitled*, 1997–), she has been working with alcoholics recruited from the street, again going outside conventional norms, and again risking a loss of control over her 'material'. Although Wearing rejects the term, like Diane Arbus she is drawn to 'freaks'. 'I just used to adore them', Arbus wrote, 'They made me feel a mixture of shame and awe. There's a quality of legend about freaks, like a person in a fairy tale

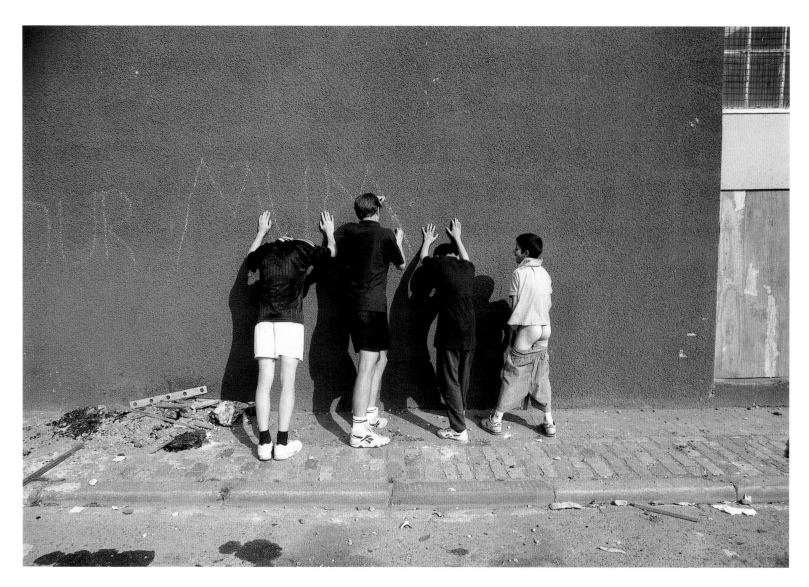

Steven, Danny, Daniel, Ryan
1996
Black and white photograph, Iris
print text panel
90 × 124 cm each
above, Photograph panel
opposite, Details from text panel

Daniel Ross

When I was 11, I started secondary school and I was a boffin. I got loads of merits and no demerits. They are an award scheme. My previous school was Riverside and my secondary is Bacon's college.

When I was 12, I was in Year 8. I wasn't a boffin anymore. I got suspended for 3 days because I had a fight. I had a teacher called Mr. Gleney who I hated so much. He told you to do work but he didn't tell you how to do it.

In year 9 nothing special happened, except I had to do my SATS. I got level 5 in science, 6 in maths, and 7 in English. I had a new mate called Minkley.

In 1998 I hope to get good GCSE's and be a computer programmer to earn lots of dosh.
P.T.O

In the future I would like to move out of my house and move in with a nice girl. I would like to be a computer programmer and earn lots of dosh if I can not do this I would like to play for Millwall football club but I do not think I am up to that standard. I will try to keep in touch whith all my freinds however rich or poor they are.

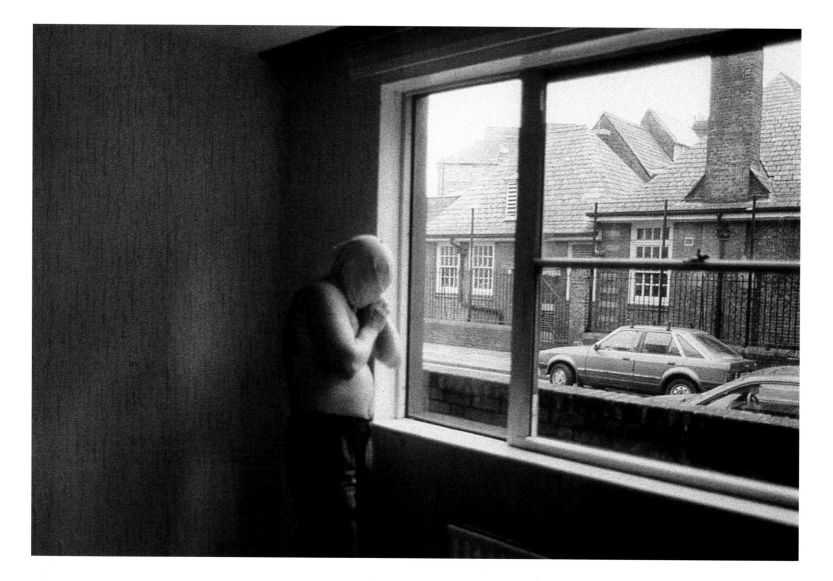

Brian (detail)
1996
Black and white photograph, Iris
print text panel
90 × 124 cm each

who stops you and demands that you answer a riddle. Most people go through life dreading they'll have a traumatic experience. Freaks were born with their trauma. They've already passed their test in life. They're aristocrats'.[12] Looking, for example, at the *Mexican Dwarf in his Hotel Room* (1970)[13] we are reminded immediately of the dwarf in Wearing's *10–16*, and not simply because both men are dwarfs. Both also radiate a cocky self-confidence that does indeed convey the sense that they have 'passed their test in life'. As Wearing has put it, *'I'm attracted to all sorts of people, average as well as extreme. But above all I really love people who go*

through life without compromise and stick to their character even when it means they remain unemployed, or they don't have any friends or relationships. In a world which is willing to be elastic, they stick resolutely to this one path, this fixed belief in themselves. We all have a certain madness about us and these people don't mind showing it'.[14]

Both Arbus and Wearing demonstrate an extraordinary empathy with the subjects of their work. For both artists there seems to be an underlying implication that the depth of their identification and the intensity of their scrutiny of the unassimilable is going to reveal to us hidden things

about the mainstream world. When Arbus photographs a perfect suburban family on their lawn, we feel at once the great waves of angst rolling just below the placid surface. When Wearing photographs a smart young executive we are not in the end surprised to discover that he is 'desperate'. Thus she can say, 'I don't see the people I film as freaks ... I am saying that everyone is different'.[15]

Many of the most poignant and telling moments in the work of both artists, in fact, come at the point of disjuncture between those they photograph and their desire to be normal. In Arbus' version of a 'sign' work, the *Patriotic Young Man with a Flag* (1967) wears a badge that says 'I'm proud', while anyone looking at him might think it should more accurately read 'I'm deranged'. Arbus' *Jewish Giant at Home with his Parents* will never fit in. She shows this literally, as he bows his head to fit into his parents living room. Yet at the same time every detail of the context, including the parents themselves, demonstrate an ur-normality that visibly strains to accommodate the giant whose very presence is throwing everything else out of kilter.

The voice of the child in Wearing's *10–16*, who is so disgusted by his mother and her lesbian lover is suffused with his fear of himself drifting outside the realm of the 'normal'. 'One of the things I do feel anxious about is my mother. I would love to kill her very much as I found out she is a lesbian'. Since we hear his voice through the mouth of a naked dwarf – like Arbus's giant, his size will always mark him as other – we are given a visual correlative for what he fears is just around the corner for him, and against which he threatens such unremitting

violence. The small but unequivocally adult body we see powerfully conflates childish rage and adult self-possession.

It is no accident that these scenarios of normality in jeopardy take place in the heart of the family. 'They fuck you up, your mum and dad', as Philip Larkin wrote so memorably:

'They may not mean to, but they do.
They fill you with the faults they had
And add some extra, just for you'.[16]

Wearing knows that the most pervasive traumas take place in the context of people's own families, and she returns again and again to that inescapable nexus of angst. It is out of the family context that each individual has to assert his or her own individuality, and it is thus an inevitable site of conflict and intense emotion.

In all her work the struggles of family life are nowhere more directly acted out than in the video *Sacha and Mum* (1996), in which the two protagonists alternately wrestle and hug. The video is shown both forward and backwards, rendering it crude and fragmented, the audio a blur of grunting and unintelligible terms of endearment. The reversal succeeds in calling into question the entire relationship between mother and child, while at the same time stressing its endless cycle of repetition. It is often hard to disentangle the apparently hostile from the apparently loving gestures: precisely how many people experience their family relationships. Sacha is repeatedly gagged by her mother, a direct evocation of Wearing's fascination with the inability to speak. There is no suggestion that the cycle will ever be broken. Just the opposite, in fact: it seems that it

top, **Brian**
1996
Black and white photograph, Iris print text panel
90 × 124 cm each
Installation, Maureen Paley/Interim Art, London, 1996

above, **Steven, Danny, Daniel, Ryan**
1996
Black and white photograph, Iris print text panel
90 × 124 cm each

Roger and Peter
1994–96
Colour photograph, Iris print text panel
90 × 124 cm each
Installation, Maureen Paley/Interim Art, London, 1996

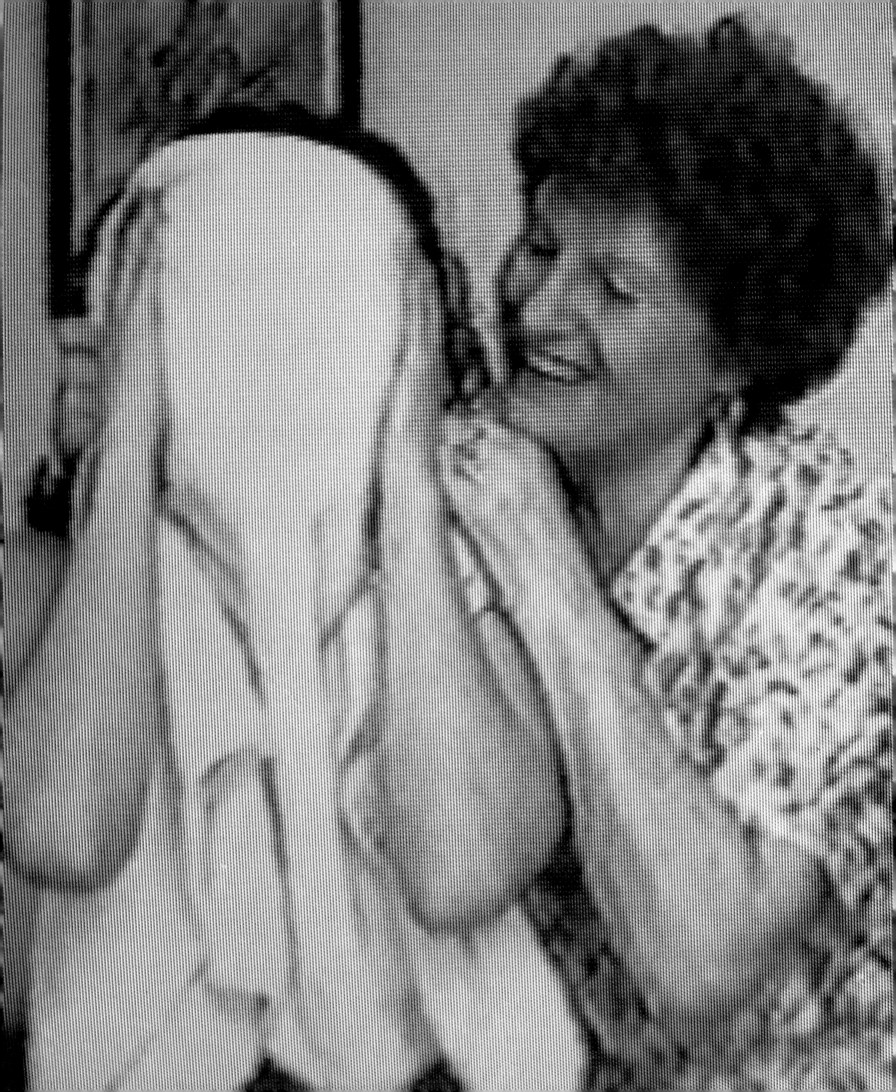

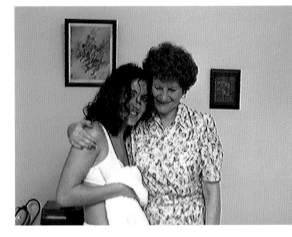

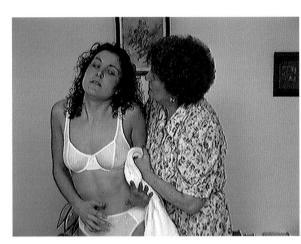

Sacha and Mum
1996
Video projection
4 mins. 30 secs., black and white,
sound
Dimensions variable
Video stills
Collections, The Irish Museum of
Modern Art, Dublin; Guggenheim
Museum, SoHo, New York; Tate
Gallery, London

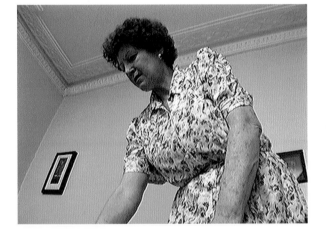

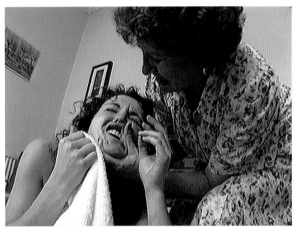

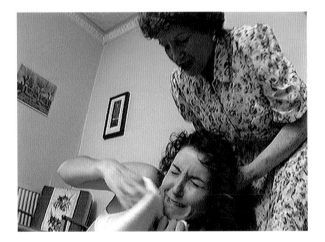

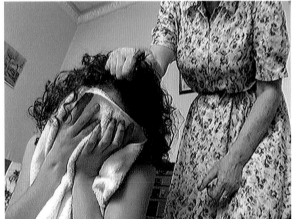

(Slight reprise)
1994–95
Video
17 mins., colour, sound
Production stills

Jimi Hendrix
c. 1968

could continue forever without ever reaching any kind of resolution. Or perhaps it is resolved, and we are looking at the results.

In *2 into 1* (1997), two boys, Alex and Lawrence, lip-sync the words of their mother talking about them, and she does the same in reverse. The relationship between mother and sons established by the lip-synching is quite shockingly intimate. The lip-synching serves in the end to emphasize not only the visceral psychological closeness of family relationships, but also the fundamental, genetic, links between members of different generations. We are reminded of the way in which the most basic sets of information are passed on from one body to another. Although we are never in any real doubt about whose words we are hearing, the lip-synching does produce a constant series of minor slippages that prevent us ever becoming completely comfortable. And indeed, we might not be that comfortable anyway, since all three participants speak with a frankness about each other that it feels inappropriate to overhear. There is an invasive quality to this piece that not only pushes inside the family depicted, but drags the viewer along, fascinated by the nakedness of the testimony but at the same time embarrassed to be hearing it. This very English, very middle-class family seem to have abandoned the repression of their feelings about each other, but without achieving any cathartic breakthrough that might bring them closer. Except that, horrifyingly, they speak with each other's voices.

Since the video loops, we are able, as it repeats, to see details that might not have been evident on a single viewing. When the two boys are

on screen, the one actually speaking at any given time seems relatively straightforward, no doubt concentrating on his lip-synching, and of course it is the speaker who at first commands our attention. On subsequent viewings, the other boy is more present, and when it is their turn to be silent, each of them smirks at the camera as they listen to their brother/mother speak. This smirk reads as a mark of complicity with the viewer, implicating us even further into the psychodrama of the family. In the end, however, the loop begins again before we can satisfy our stimulated desire to discover any more than we have already been shown. The father is referred to, for example, but never appears, remaining a powerfully missing presence. We will never see him, and his structuring absence marks the limit of the loop.

10–16 uses a somewhat similar technique, in this case the voices of seven children, progressing in age from ten to sixteen, lip-synched by a variety of adults. The piece touches on issues of puberty and childhood sexuality, documenting the passage from supposed innocence into ravaged adulthood, with increasingly evident wear and damage. Naive dreams for the future are articulated that we know will be soon abandoned. Only the ten year-old seems really positive, and he prizes his solitude. By the age of eleven we already hear the need to appear tough in relation to others. This girl has long lists of friends, but wants to kill them. By fourteen the child can already assert that he feels 'like a man in a boy's body', an irony emphasized by the fact that what we see and hear on the screen is a boy in a man's body. Wearing uses a chronological structure reminiscent of Michael Apted's great

The Regulators' Vision
1995–96
Video projection
7 mins., colour, sound
Dimensions variable
Video still

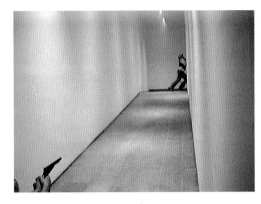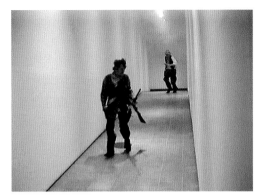

Seven Up documentary and its sequels, to demonstrate even more brutally than those films the degree to which childhood experience is dragged into adulthood. Many artists have depicted childhood and adolescence. Few have pursued its traumas into adulthood with the intensity of this work. *10–16* rejects development in favour of an endless cycle of fears and insecurities.

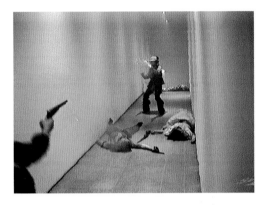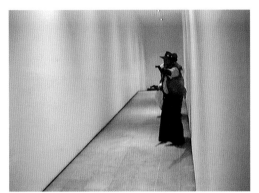

Wearing's videos are usually shown in a loop, so that any sense of beginning and ending is greatly diminished. Perhaps this is most striking in *(Slight reprise)* (1994–95), in which the looped (non)progression emphasizes the spectacular futility of playing 'air guitar' while at the same time sustaining the players' evident pleasure in a permanently unresolved state. The title of the piece itself evokes not only the virtuoso guitar of Jimi Hendrix but also the eternal return of the expressive fantasy. The barely-veiled masturbatory aspect of air guitar-playing is denied any climax, as each concluding series of power chords is abruptly replaced by the next flurry of fingering. The mime offers its participants the opportunity to express themselves without making any new statement; it allows them to speak noisily while in fact remaining silent. Wearing takes an evident pleasure in this semi-underground but pervasive form of self-expression through the appropriated work of others. ('Eric Clapton played this solo and I play this solo'.) She herself, after all, is in turn appropriating their performances for her own ends, making public this normally private form of fantasy.

Wearing pushes past the conventional

boundaries that separate privately indulged fantasy from publicly controlled self-preservation. Cowboys can run through the Hayward gallery, guns blazing (*Western Security*, 1995). Even Wearing's apparently most private works, such as *Confess all ...*, are in the end acts of public exposure, simply because everyone involved understands that Wearing will show them publicly. This is clear in *The Regulators' Vision* (1995–96), the companion piece to *Western Security*, as the 'cowboys' who have been playing out their childish fantasies in the museum gather round to enjoy watching themselves on video.

When we see Wearing herself lurching silently in a Peckham arcade or walking the streets swathed in bandages, one part of us might recall Joe Orton's sardonic aphorism, 'With madness as with vomit, it is the passer-by who receives the inconvenience'.[17] But the other side of Orton's vision is if anything even more relevant: the unbridled rejection of convention, especially the

above and following pages,
Western Security
1995
Video installation
10 monitors, 30 mins., colour, sound
Dimensions variable
Video stills

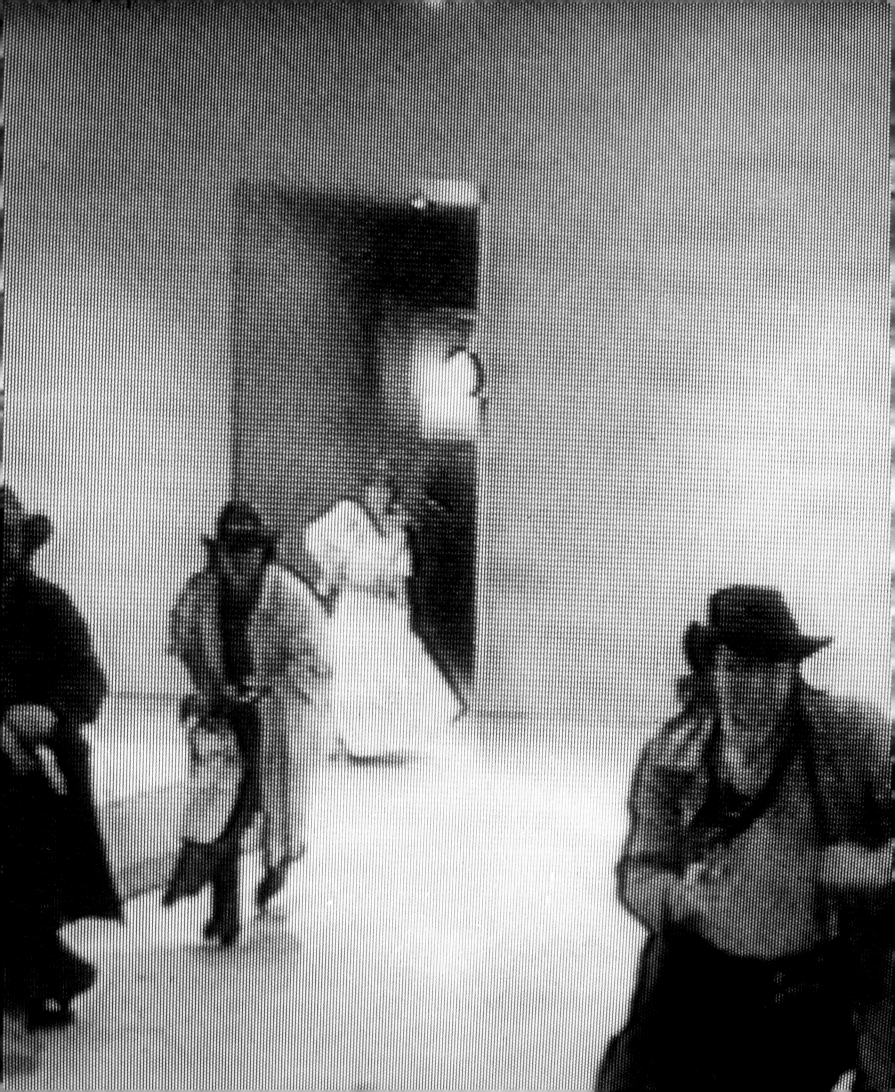

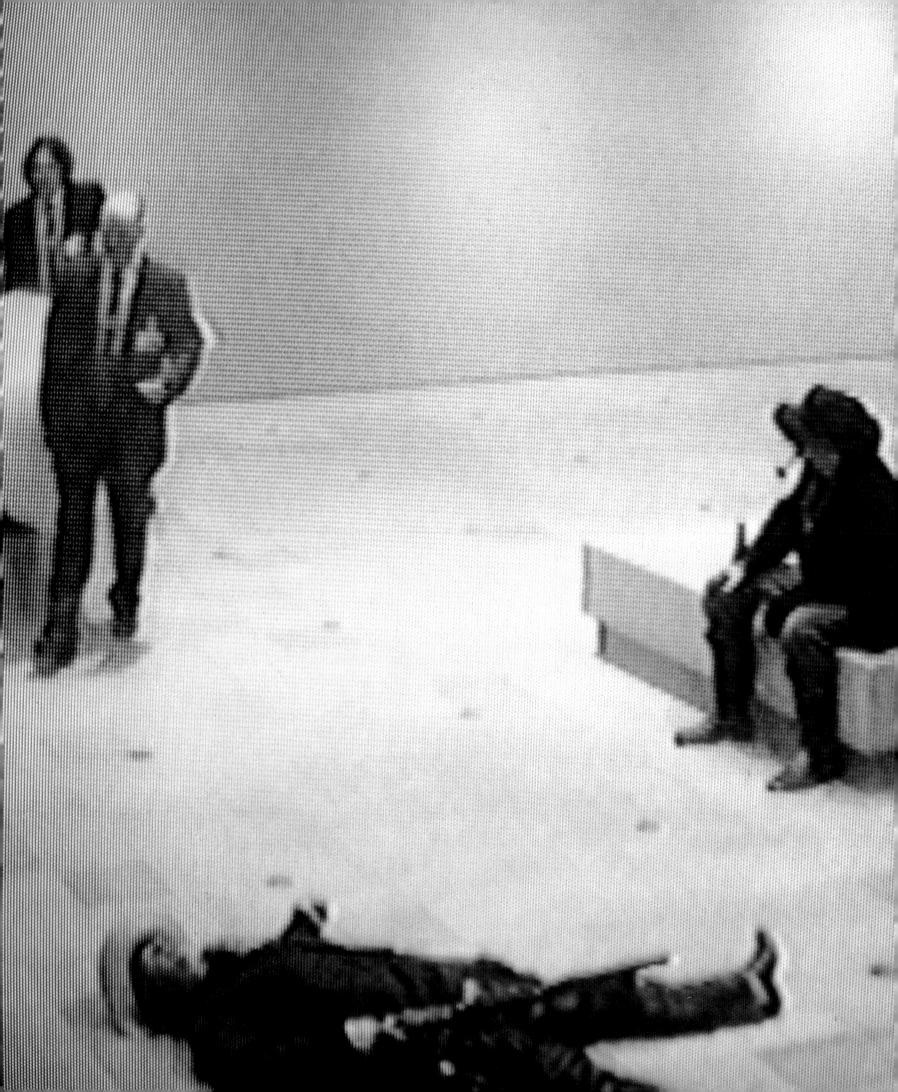

opposite and following pages,
Untitled
1997–
Work in progress
Video stills

glacial weight of repression that is the special preserve of the English middle class. As the monstrous nurse in his farce *Loot* (1965) puts it, prophetically for English society: 'I'm not in favour of private grief. Show your emotions in public or not at all.'[18] The characters in Wearing's *The Unholy Three* (1995–96) display a decidedly Ortonesque set of obsessional, not to say perverse, behaviour, but only in private and alone. When they actually meet, their outlandish private fantasies are converted into the most banal pub chit-chat. No one connects. The effect is dismal, and one longs for the public expression of the hidden desires.

'Show your emotions in public' could be a subtitle for *Signs* ... , and indeed for almost all of Wearing's work. 'There's a lot of unknown territory still out there, I think, on the way we are', Wearing has said.[19] She herself remains the watcher and listener who encourages the emotional release, who accepts it all and makes it her own: the banal, the bizarre and the desperate, disguised and revealed.

1 Pascal, Blaise, *Pensées*, trans. Martin Turnell, Harper and Brothers, New York, 1962, p. 150

2 Barthes, Roland, 'The Death of the Author' (1967) in *Image-Music-Text*, Hill and Wang, New York, 1977, p. 147

3 Ensor, James, quoted in Paul Haesaerts, *James Ensor*, Abrams, New York, 1959, p. 163

4 Vernant, Jean-Pierre and Pierre Vidal-Naquet, *Myth and Tragedy in Ancient Greece*, Zone, New York, 1988, p. 396

5 Breton, Andre, *Nadja* (1928) Grove Press, New York, 1960, pp. 105, 106, 108

6 Wearing, Gillian, in Gianmarco Del Re, 'Confessions', *Flash Art*, Vol. 31, No. 199, Milan, March/April, 1998, p. 88

7 Wearing, Gillian, in conversation with Paul Graham, in Andrew Wilson et al., *Paul Graham*, Phaidon Press, London, 1996, p. 16

8 Cixous, Hélène, 'Castration or Decapitation', in Russell Ferguson, Martha Gever, Trinh T Minh-ha and Cornel West (eds.) *Out There: Marginalization and Contemporary Cultures*, MIT Press, Cambridge, Massachusetts, 1990, p. 348

9 Spinelli, Marcelo, 'Gillian Wearing', 'The British Art Show' website, Hayward Gallery and National Touring Exhibitions, London, 1995

10 Marx, Karl, 'The Eighteenth Brumaire of Louis Bonaparte' (1852) in Robert C. Tucker (ed.) *The Marx-Engels Reader*, Norton, New York, 1978, p. 608

11 Deleuze, Gilles, in dialogue with Michel Foucault on the latter's work, in 'Intellectuals and Power', Michel Foucault, *Language, Counter-Memory, Practice*, ed. Bouchard, Donald F., Cornell University Press, Ithaca, 1977, p. 209

12 Arbus, Diane, in *Diane Arbus*, Aperture, New York, 1972, p. 3

13 Images of Diane Arbus' work cited in the texts have not been illustrated, to respect the wishes of the Diane Arbus Estate.

14 Wearing, Gillian, in Gregor Muir, 'Sign Language', *Dazed & Confused*, No. 25, London, 1996, reprinted in this volume, pp.130–135

15 Wearing, Gillian, in Rachel Campbell-Johnson, 'Wearing Her Heart on Her Sleeve', *The Times*, London, 3–9 January, 1998

16 Larkin, Philip, 'This Be The Verse', in *High Windows*, Farrar, Straus & Giroux, New York, 1974, p. 30

17 Orton, Joe, *The Orton Diaries*, John Lahr, ed., Harper & Row, New York, 1986, p. 14

18 Orton, Joe, *Loot*, Grove Press, New York, 1967, p. 10

19 Wearing, Gillian, in Gianmarco Del Re, op. cit., p. 88

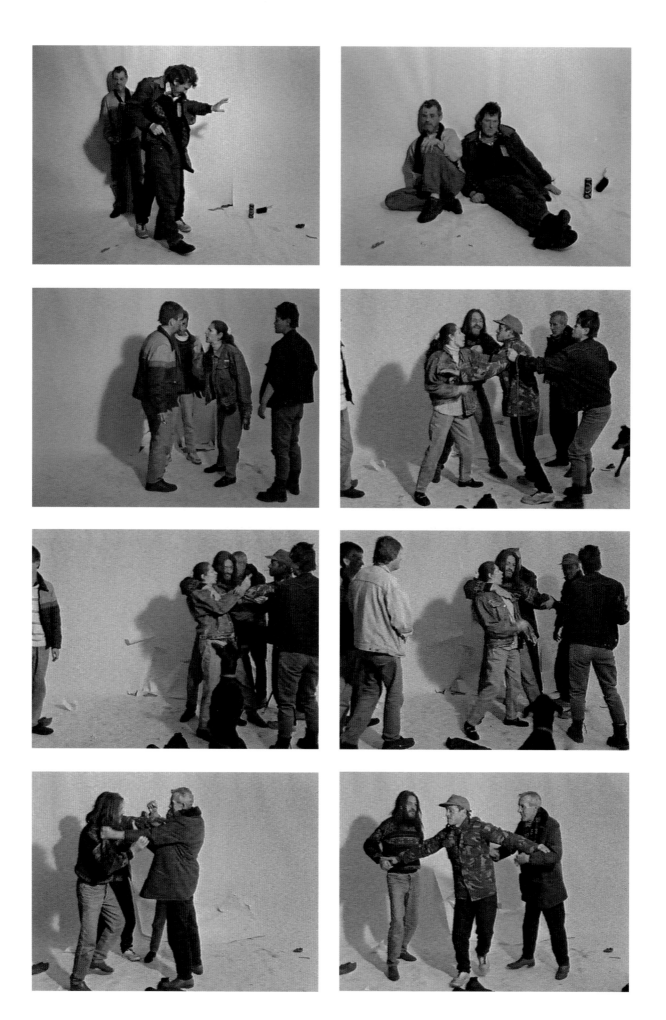

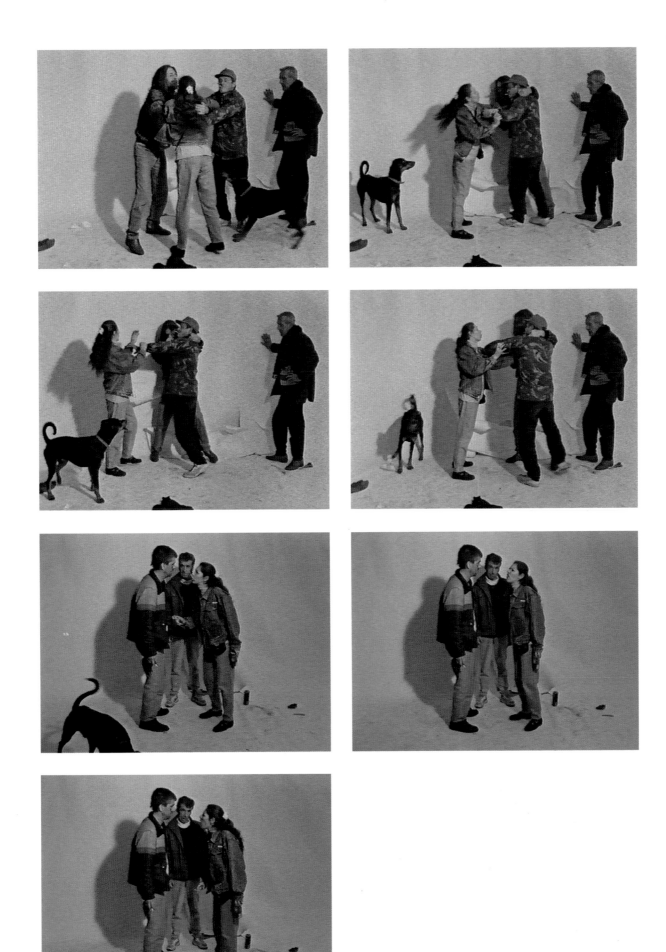

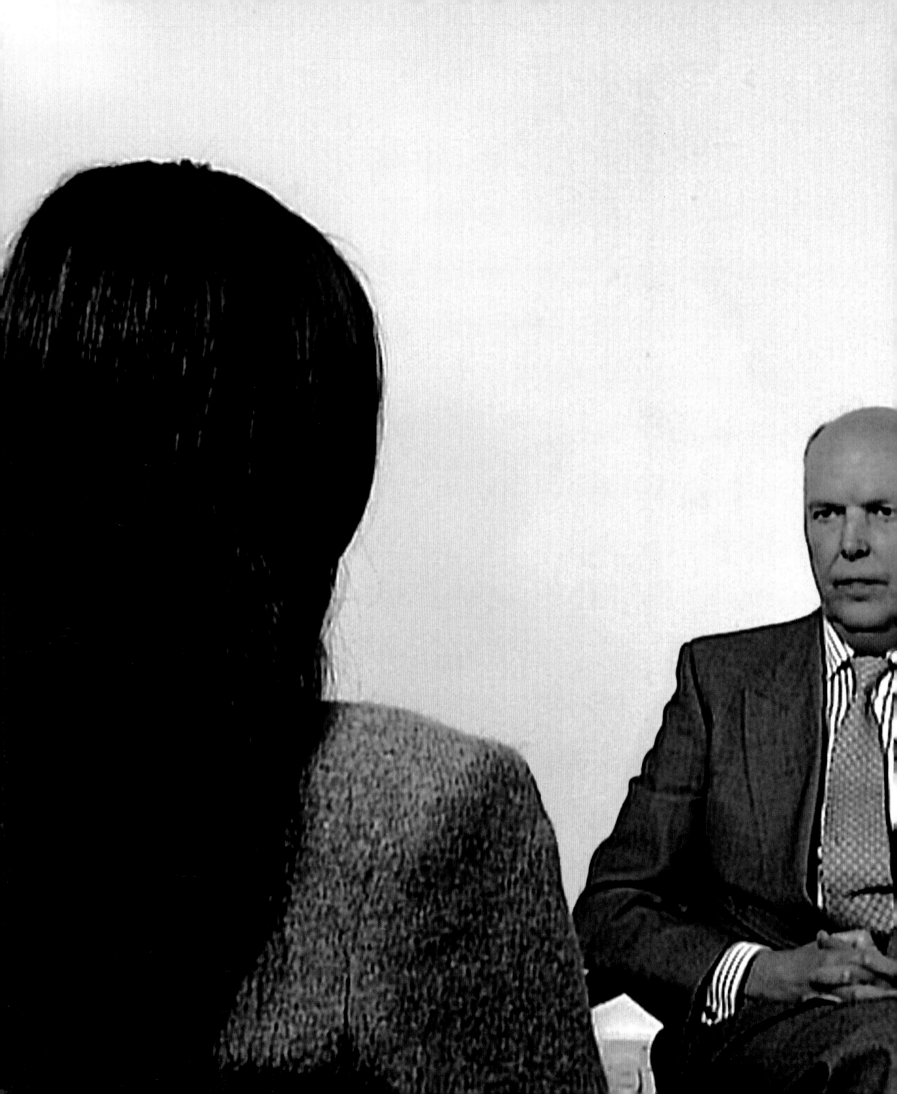

Contents

10–16
1997
Video projection
Approx. 15 mins., colour, sound
Dimensions variable
Video still

' "What does it matter who is speaking", someone said, "what does it matter who is speaking" '. Michel Foucault borrows these words from Samuel Beckett to frame the opening paragraphs of his essay 'What Is an Author?' The line sets a tone of indifference that silently flows through the essay, only to emerge fully formed in its final sentence: 'What difference does it make who is speaking?' This question, when coupled with its counterpart, 'What difference does it make who is listening?' forms the centre around which much of Gillian Wearing's art coheres.

In his essay, Foucault offers a notion of fiction released from the authorial hold of its producer. Such a text, no longer constrained by the regulatory figure of an author, is free to develop in what he calls the 'anonymity of a murmur'. This renders the tired and rehearsed questions that we routinely bring to a work (Who really spoke? Was it really this person and not someone else? With what authenticity or originality? And what part of this person's deepest self was expressed in this discourse?) inaudible beneath the anonymous drone of the text. New questions then emanate from this aural absence. These questions are limited only by the flexible boundaries of the receiver's experience of the text, set in the wider context of his or her life: What are its modes of existence? How is it presented? Where has it been used? How can it circulate? Who can appropriate it for themselves? What space is there left in the text for a productive subject? And who can occupy these positions in the text? Questions belonging to the first group are tied up with concerns of form and mannerism in a work that refers principally to itself. The second group of questions reach out beyond the formal or expressive qualities of a text and into the space it shares with life.

10–16 is a signature piece that communicates a strong personal statement by its author and thus could easily be lost in a mire of questions relating to mannerist self-expression and form. Yet, as a videotext grounded in the everyday cadences of language and identity, *10–16* resists this fate and insistently elicits questions akin to those of the second group, i.e., beyond formalism and expressionism. As with much of Wearing's work, *10–16* is split between these seemingly contradictory poles – the piece occupies our attention as an objective document of the symbolic in search of the real, while at the same time never vacating the position it holds as an expressive statement of the artist's own subjective experience.

This paradoxical split is potentially a feature of works of a documentary nature.

In *10–16*, the rigorously nonfictive language of video magnifies these split tendencies, following the medium's propensity to de-centre the subject and dissolve the author and spectator alike in the wake of its total flow. It is along these cleavages that Gillian Wearing's art interacts with various documentary traditions and means of representing the self alongside the Other. This same conjuncture serves as the source for many of the rhythmic tensions that one can grasp in her work: those between an interior feeling self and the external display of a mask, between private identifications and their public expression, and ultimately, that area between thought and expression over which is spread a lifetime. It is the slippage back and forth between these states that fascinates Wearing. To chart these fault lines and trace such movement leads in her work to an intense involvement with identity and its embodiment in language.

As the named author of *10–16*, Gillian Wearing maintains a position both inside and outside the frame of this piece. As in much of her lens-based art that includes collaborators and co-authors from the streets of London, Wearing frames herself as she frames the Other. This builds a reflexivity into the work which helps her negotiate the contradictory status of otherness as both given and constructed, real and fantasmatic. In turn, this reflexive aspect of Wearing's art allows her to retain a fragile, yet tangible, sense of critical distance as she weaves threads from her own biography into the fabric of her subjects' biographies.

The Other remains other and is neither subsumed by the whole nor lost in a cloud of over-identification, which leaves ample space in her work for the Othering inherent to representation. This is not to say that her representations are not problematic; they are, deeply.

But rather than brushing aside the problems that arise in representing the Other, Wearing reaches out to the frustrations and the traumas that we each experience in attempting to represent that which we feel to be real, and part of ourselves. These adversities – that amount to a crisis of representation which we all can relate to personally – then become the matter out of which she makes her art.

In a way, the authors of *10–16* are both resoundingly present and conspicuously absent. This videotext emerges eloquently out of the anonymous and sometimes painfully awkward murmurs of language and identity that unfurl in childhood. As such, *10–16* strikes at the centre of Wearing's person and practice. Perhaps more than any other, this piece shows her art to be not so much about human language and humane communication as material examples of just that. From the start, Wearing aimed to construct a narrative that would recount the rites of passage that take place from ten to sixteen years of age. Seven film segments mark the expansive development and maturation of language and identity that is compressed into those seven short years. In order to construct the piece, Wearing collected audio recordings from children aged ten to sixteen. She found her subjects in school yards and on playgrounds, on the street, by way of friends and finally through an advert posted in a listings magazine. She then filmed adult actors mimicking edited versions of individual texts. At each turn, she nearly gave up on the project – either due to difficulties in finding the right material, or because the actors she cast found the process of lip-synching to the texts too counter-intuitive to adapt to. Finally, Wearing collaged the audio texts with the video images in a computer-assisted digital re-sync. This editing process – one mediated in part by a monitor, a machine and a 'mouse' – allowed Wearing to place the body of an idea before her on a screen. Intuition played a greater role in this process than technology, with much of the work of editing taking place live and in the real time shared between Wearing and her collaborators.

The rites of passage that are elaborated in *10–16* follow the insertion of the subject into the symbolic order and codes of language and identity. The story that Wearing tells here is one of the birth of a speaking subject. It is, consequently, as much about discovery as it is about loss. *10–16* begins with a subject on a couch and ends with an establishing two-shot that recreates a therapist's consulting room as the camera pans over Wearing's own shoulder to focus on the 'client' sitting opposite. However, it is not so much the visual aspects of the

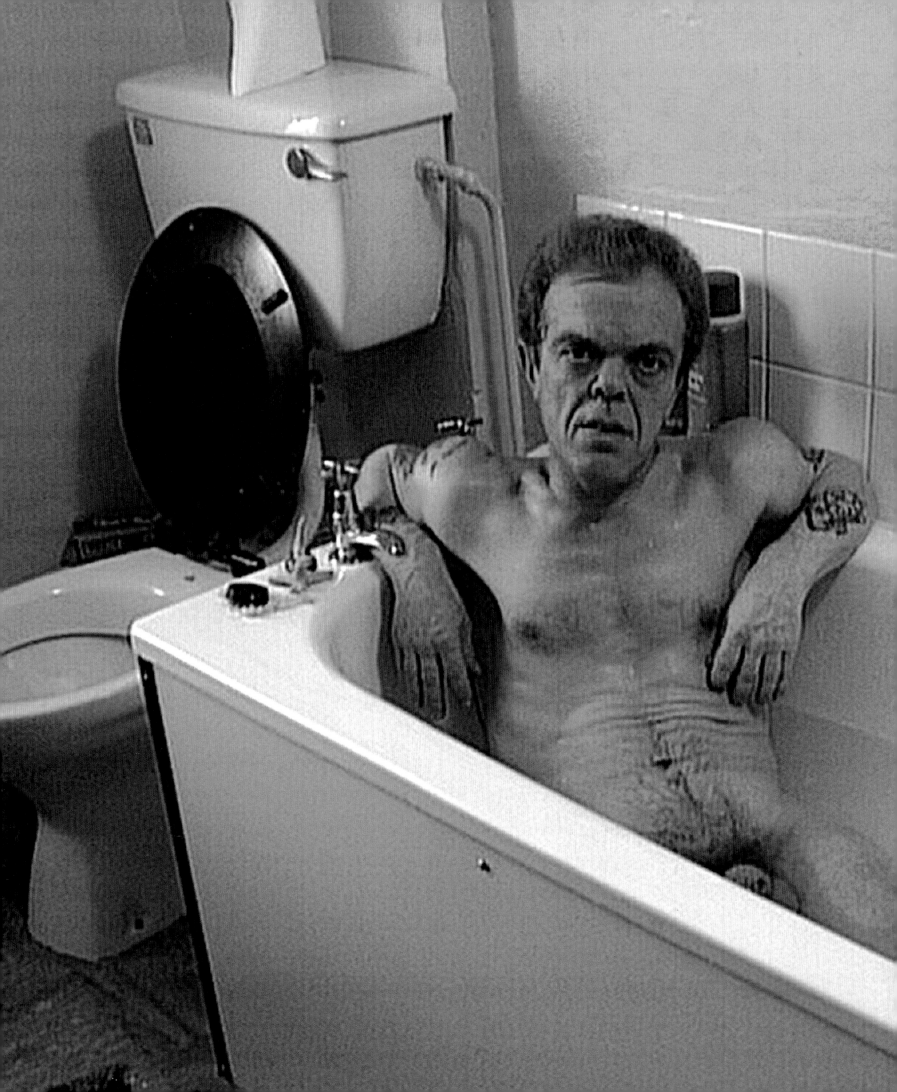

piece that lend it its therapeutic feel. It is the development and deployment of language that produces something like the 'affect' of a therapeutic experience, just as a major part of analysis consists precisely in getting the subject to speak.

10–16 follows a narrative structure native to childhood and as such amounts to a collection of assembled fictions. The texts that Wearing collected are firmly located in the imaginary realm of a child's ordinary experience. These texts document the linguistically shaped process of weighing and assigning meaning to everyday experience. In putting these parts together to form a whole, Wearing makes use of an assumed narrative flow present in childhood – we were all there once and we know how the chapters are numbered and generally how the story goes. A purely visual example of a similar project is found in a work by French artist Christian Boltanski, *10 Portraits Photographiques de Christian Boltanski 1946–1964* (1972). Boltanski's piece, like *10–16*, relies on the informational exchange between text and image – ten photos, each captioned with a date when the image was taken and the age of the sitter, mark the artist's passage to maturity. The final frame shows

left, **Christian Boltanski**
10 Portraits Photographiques de
Christian Boltanski 1946–1964
1972
10 black and white photographs
mounted on board, frames,
handwritten text
30 × 60 cm

Boltanski, listed at twenty years of age, in the same spot in a leafy park where the other photos had been taken. We easily buy into this developmental display and even willfully overlook the disjointed permutations that occasionally take place between panels, given the overall narrative fit with childhood. Only the final panel actually shows us an image of Boltanski (and not at twenty, but when he actually made this fictional piece at twenty-eight years of age). This does not, however, interfere with our ability to let the disparate parts stand for the whole, or to allow the metaphor to re-describe our shared experience of growth in childhood. It is impossible to illustrate before you in fragments of either word or picture, but the contiguity that is demonstrated by Boltanski's piece here on the page is equally present in *10–16*. As disparate as the individual texts of *10–16* are – spanning different classes, genders, ages and contexts – one can and does recombine them to form an overarching story. That we are able to hold the narrative together, given the surreal vessels

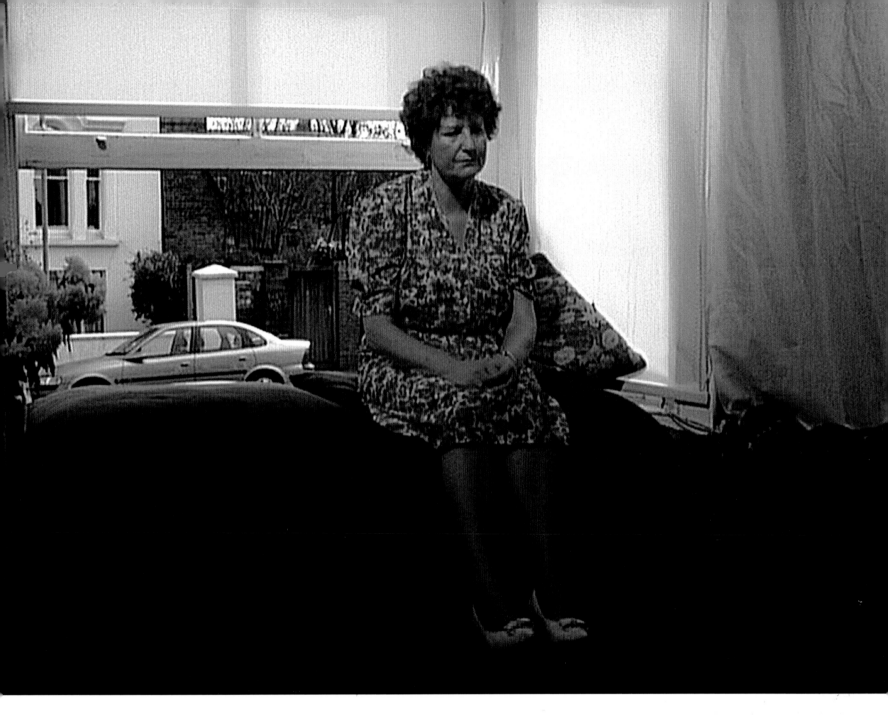

that carry these metaphorical segments, underscores Wearing's command of metaphor.

Wearing's psychoanalytic framings of herself and the Other are very real, but they do not need to be so in order to function – either as art or, even more significantly, as documentary. In *Sixty Minute Silence* Wearing exploits video's insistent nonfictive framings to present a study in photographic portraiture and control. That the police officers assembled before the camera are hired actors and stand-ins does not change the way they function as signs. To say that *10–16* is an allegorical fiction may undermine its proximity to what we conventionally understand as documentary, but what is lost with the label is outweighed by what can be gained in understanding. Metaphor itself can be described as the reassignment of a label. Metaphor mines hidden resemblance, it explores linkages and

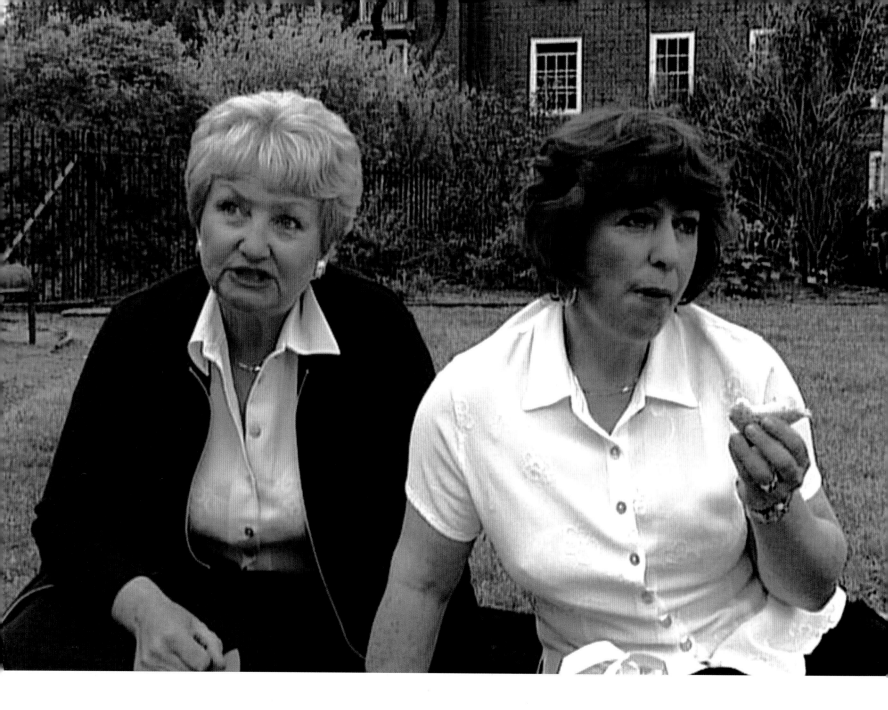

makes reconnections between disparate ideas. Language – both literal and allegorical – is the product of such metaphoric substitutions and reversals. In placing the child's voice in the adult's body Wearing entered into a play of presence and absence. This relationship between presence and absence is mirrored in both the body and language of the parent and offspring. American artist William Wegman's *Family Combinations* explores this type of likeness as a relation that takes place through metaphor. Combining an image of himself with those, first, of his mother, then of his father, and finally of his mother and father alone together, Wegman metaphorically draws a picture of the breeding, familiarity, and compression that takes place between generations in a family. In *10–16* such physical overlaps and overlays are expressed in language. It is through language that we can find the

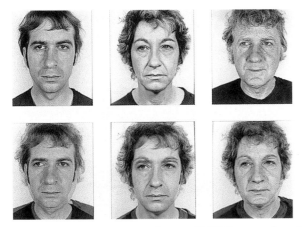

above, **William Wegman**
Family Combinations
1972
6 silver gelatin prints
31 × 26 cm each

opposite, **10–16**
1997
Video still

kind of material evidence of social relations that lies embedded in communicative relations. For Wearing this is a crucial factor, since in the cultural context in which her consciousness was formed, language and identity are inseparable – your destiny is defined by the shape, cadence and pronunciation of your words, even more than by your anatomy.

Wearing's employment of video allows us to witness the full range of possibilities and potentialities of the medium in a way that illuminates its more restricted uses. She comes to video through the television screen. Wearing is more a product of British documentaries – broadcast into her home and family life as a young teen in the mid-1970s – than the offspring of early video artists working in the same period. Franc Roddam and Paul Watson's *The Family,* broadcast in 1974, and Michael Apted's *Seven Up* (1964) and ongoing sequels, helped to show Wearing that features of her immediate environment were shared by others. More significantly, she realized that the issues the participants spoke of – the hopes, traumas, fears and family dramas – could circulate openly and outside the confines of the home. By working in video, Gillian Wearing focuses our attention on the neglected relation-ship between video art and television broadcasts. In her work, video functions as a theatre of the self. Her pieces are full of electronic intimacy, and yet Wearing consistently pushes this inherently self-referential and narcissistic device, to take stock of and respond to the structural conceits and codes upon which the amassed media of electronic broadcasts rely.

Culture today is wholly a matter of media. Technology and the machine not only govern the mechanization of culture, but increasingly these regimes regulate the flow of private feelings between individuals. Even when saturated by their electronic glow, Wearing's video pieces caution us that meaningful communication, hazardous and imperfect as it may be, takes place in the space between two or more humans and is only mediated by the analogue features of language. The words in her work always take precedence over and above any prized production values. Presentation is in fact only a recent concern – for Wearing, the collusive relationship she forms with her collaborators is still essentially the primary end product of her art.

Conceptually as well as chronologically, *10–16* sits between *Confess all …* and *2 into 1*. The latter work is the fullest realization of the idea that led Wearing to *10–16*:

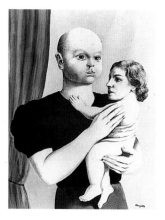

the re-synching of voice and image. With *2 into 1* the metaphor is more transparent. Here the re-sync demonstrates the mirroring, or reflecting-back, of words belonging to another, that amounts to evidence of listening. We hear with our ears, but show others we have heard with our mouths. This powerful performance by a mother and her twin sons aged eleven was broadcast by the BBC in November, 1997. The reflection of words that belong to another – the sons receiving those of the mother, and the mother returning their own in kind – recreates a narrative based in family therapy. *2 into 1* became possible as a result of the re-sync technique developed by Wearing for *10–16*. In part, the re-sync in *10–16* aims to protect the child and is a structural technique that equals the masks in *Confess all...* Like most of Britain, Wearing has watched the participants in the *Seven Up* series growing up in public. The camera and the eyes of a nation continue to shape their lives when, at each seven-year interval, we tune-in to discover what's happened to Symon or John. *10–16* fosters its subjects' anonymity.

Working with audio recordings also suited the source: audiotape recording works better than video with children, allowing their unregulated stream of language to flow without distraction. Transcriptions of *10–16* and *2 into 1* attempt to tame the raw spoken speech of these videotexts through the written word. But such taming then strips these texts of their force – one is left with disembodied words neatly trapped on the page while their meaning has escaped. These words need their vessels – those bodies shaped by a metaphorical juxtaposition and the kind of absurdity found in Magritte's painting *L'esprit de géométrie* (The mathematical mind, c.1936). It is the synching of voice and vessel – the joining of vehicle with tenor upon which metaphor relies – that enables us to temporalize

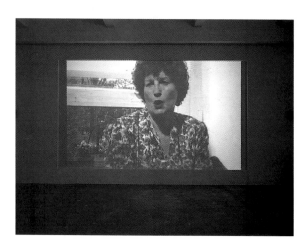

those rites of passage experienced in language and project the vocalized traumas of the child into the hardened adult scar. Theory, it seems, also acts to tame Wearing's work, but here her pieces prove to be equally elusive. The work escapes and returns to where it is centred on the purely human acts of speaking and listening.

Even if they appear to originate from a

left, **René Magritte**
L'esprit de géométrie (The mathematical mind)
c. 1936
Gouache on paper
37.5 × 29 cm

opposite, **10–16**
1997
Video still

left, **10–16**
1997
Video projection
Approx. 15 mins., colour, sound
Dimensions variable
Installation, Chisenhale Gallery, London, 1997

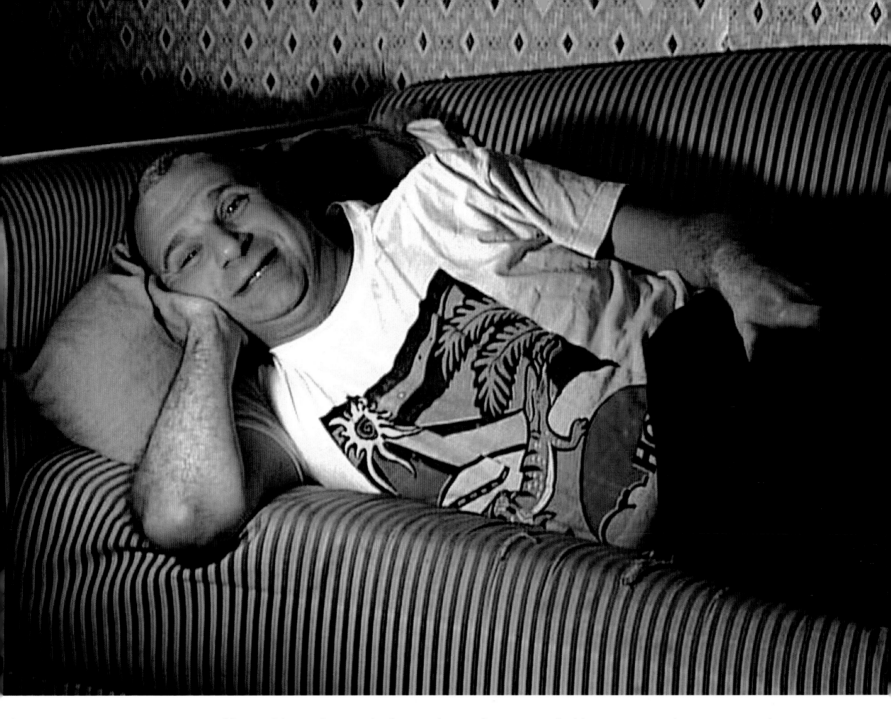

speaking subject, the words that make up these remarkable texts constitute a poem that has been written. That the author remains anonymous is what makes their having been written an ethical act. Gillian Wearing does not suffer the indignity of speaking for others. She listens with an empathy beyond that of language while bringing voices into frame that speak to us all. That one can identify on a humane level with these unconstrained voices means that, in the end, the question that really matters is not: *Who* is speaking? The question is rather: *who* is willing to enter the space Gillian Wearing leaves for us in these very human discourses, and, in so doing, become a subject that speaks, but more importantly, one who also listens.

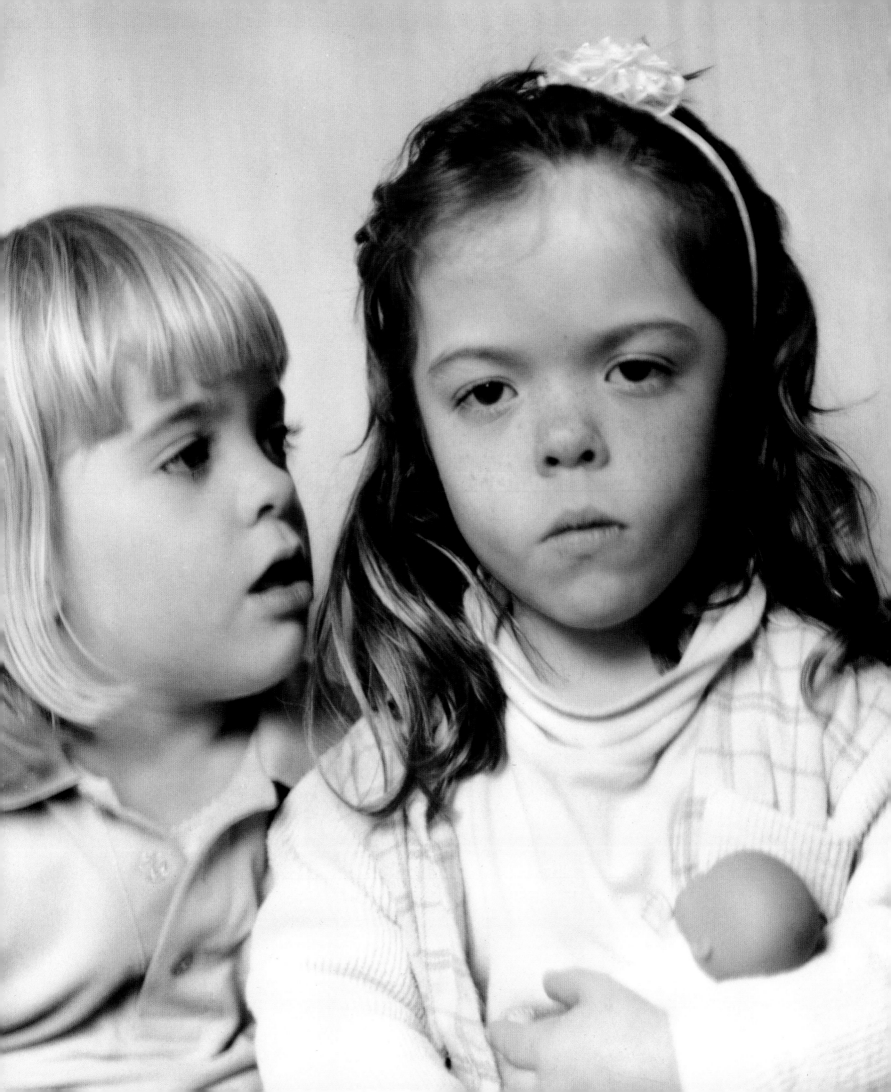

Contents

Symon

7

'I had one dream and everything flew up in the air and it all landed on my head.'

14

'They say, where's your father? Then, you know, when your mum's out at work, yeah, your father, and I just tell them I ain't got one.'

'Well, I don't think it's had any effect on me because what you don't have you don't miss, you know, as far as I can see.'

21

'I can get on well with my mother sometimes. Well, that's good because a lot of young children can't get on with their parents at all at this time of the year, their life, and I get on pretty well with my mum. We talk very well with each other, but it's sometimes not quite as mother and son, more like friends … '

'She's always been nervous. Not all the time, but she has periods of depression, or deep depression, or whatever they call it, and it sort of makes me think: well, what happened there?'

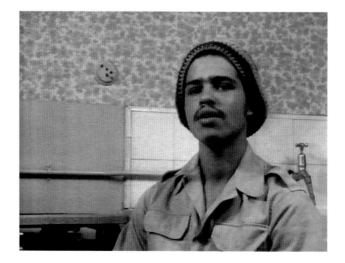

Michael Apted
top left, Seven Up
1964
Documentary for television broadcast, 60 mins., black and white, BBC/Granada Television
Film still
Symon at 7 years

centre left, Fourteen Up
1970
Documentary for television broadcast, 60 mins., colour, BBC/Granada Television
Film still
Symon at 14 years

bottom left, Twenty-one Up
1977
Documentary for television broadcast, 60 mins., colour, BBC/Granada Television
Film still
Symon at 21 years

Michael Apted

top right, Seven Up
1964
Documentary for television broadcast, 60 mins., black and white, BBC/Granada Television
Film still
John at 7 years

centre right, Fourteen Up
1970
Documentary for television broadcast, 60 mins., colour, BBC/Granada Television
Film still
John at 14 years

bottom right, Twenty-one Up
1977
Documentary for television broadcast, 60 mins., colour, BBC/Granada Television
Film still
John at 21 years

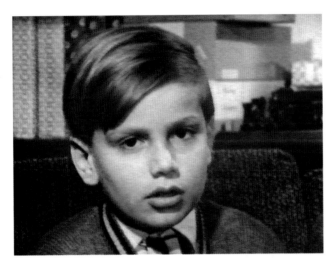

John

7

'When I leave school I'm going to Colet Court and then I will go to Westminster boarding school if I pass their exam and then I think I'm going to Cambridge and Trinity Hall.'

14

'When you board on a weekly basis you have the best of both worlds, so to speak. One sees one's parents at the weekend, and one gets all the benefits from an English boarding school.'

21

'I do believe parents have a right to educate their children as they think best. I think someone who works on an assembly line in some of these car factories, earning huge wages, could well afford to send their children to private school if they wanted to. Just because some sorts of people perhaps don't put that as high on their priorities as, you know, as having a smart car or something, I don't think that's any reason for abolishing public schools. I think an awful lot more people could afford to send their sons to school, but they don't choose to. That's their choice.'

Theresa
1998
5 colour photographs, 5 text
panels
Work in progress

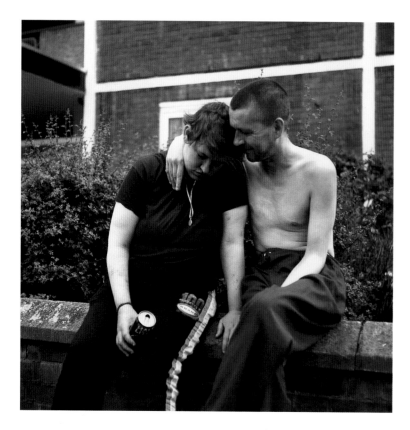

I LOVE YOU THERESA BECAUSE YOU ARE SO WONDERFUL BECAUSE YOU ARE SO MEANINGFUL YOU ARE SO SINCERE YOU ALWAYS MAKE ME HAPPY WHEN I'M DOWN. THERESA YOU ARE ONE IN A MILLION. I'VE ASKED YOU TO SORT KYM OUT AND YOU SAID YOU WOULD BECAUSE YOU DIDN'T LIKE THE WAY KYM TREATED ME. KYM COULD PUT HER ARMS ROUND ME KISS ME TOUCH ME BUT WHEN I PUT MY ARMS ROUND HER I WAS LIKE THE DEVIL INCARNATE. I WOULDN'T HIT WOMEN BECAUSE I THINK IT'S MORALLY WRONG. I HOPE WHEN YOU HIT KYM SHE REALLY HURTS THE WAY SHE ABUSED ME THAT MY BE A LESSON FOR HER NOT TO TAKE THE PISS OUT OF OTHER GUYS IN THE FUTURE THERESA I ENJOYED MAKING LOVE WITH YOU RECENTLY. IT WAS ONE OF THE MOST PLEASURABLE EXPERIENCES I'VE ENDURED I KNOW I MESSED UP BY GOING WITH PAULINE. SHE CAME ROUND ONE NIGHT AND ONE THING LED TO ANOTHER.

I HOPE THAT WE CAN PUT THIS BEHIND US AND START AGAIN IF POSSIBLE BUT THAT IS ENTIRELY UP TO YOU. BECAUSE I WILL NEVER FORGET THE FEELINGS I HAVE FOR YOU.

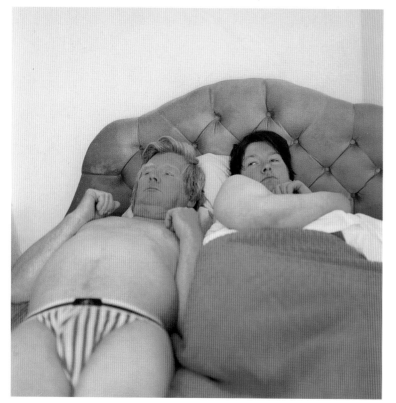

FORM MY POINT OF VIEW SHE IS ABSOLRUTELY STUPID. SHE DOSE NOT RESPECT HERSELF. I MEAN ANYONE WHO SELLS THEMSELVES FOR A CAN OF BEER HAS GOT TO STUPID AND FOR A START NOT APPERING IN CORT WHEN DUE SHE THINKS SHE ABOVE THE LAW. NOW SHE IS SEEING NICK AND NOW SHA IS GOING TO GET HER FINGERS BURNED HE EVEN SAID LAST NIGHT HE WANTED TO DUMP HER AT MY PLACE YET LAST WEEK HE ASKED HER TO MARRY HER IF SHE WANTED A CAN OF BEER THATS IT. I TOLD HER YOU CANT KEEP DOING THIS AS YOU WILL GET A DISEASE BUT AS LONG AS SHE HAS GOT A CAN OF BEER IN HER HAND SHE COULDENT CARE LESS. WE HAVE SEXUAL RELATIONSHIPS AS SHE HAS A GOOD HART AND A GOOD SENCE OF HUMOUR

BUT SHE IS OVERWEIGHT. AND HAS NO SENCE OF DRESS AS LONG AS YOU ARE WITH TRESA YOU ARE NEVE SHORT OF PILLOW YOU CAN USE HER BRESTS

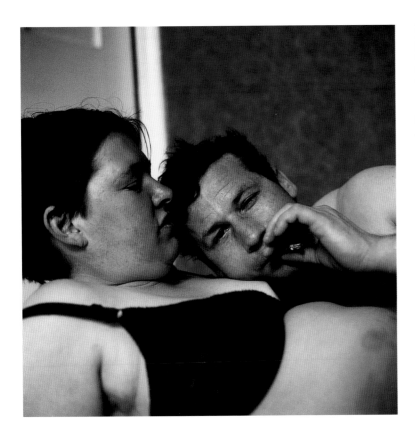

SHE' IS A VERY SERIOUS WOMAN BUT WHEN SHE HAVE DRINK SHE CAN BE CHANGE HER PERSONALITY WHEN PEOPLE LEAVE HER ALONE SHE CAN BE VERY UNDERSTANDING. I CAN BE VERY ARGERMENTIVE, SHARP TEMPER AND I THROW HER OUT OFF BED SHE CANT GET A WORD IN EDGWAYS I DONT KNOW THE ANSWERS TO MY OWN PROBLEMS SO I CANT CURE HERS. I THINK SHE IS USHAMED OF HER BODY SHE NEVER WASHS I HAVE TO BATH HER WHEN SHE COMES HERE AND SHE DOESNT KNOW WHAT TO DO WITH SOAP SO SHE PUTS IT UP HER PUSSY SHE SWALLOWS IT UP

AND MAKES ME FISH IT OUT. WHEN SHE LOVES HERESOME ALL BLACK AND BLUE I CANT TOUCH HER THE SMELL IS SO BAD IM THE BEST PERSON TO GET ON WITH IN WORLD BUT THERASA KNOWS HOW TO GET ME JELOUS. WHEN I WANT HER SHE WONT BUDGE FROM SEAMUSS SOFA IT CAN MAKE VERY MOODY AND VUNRABLE BUT IF SHE WANTS SEX IT SO VIOLENT SHE CAN

BE BLOODY PAINFUL

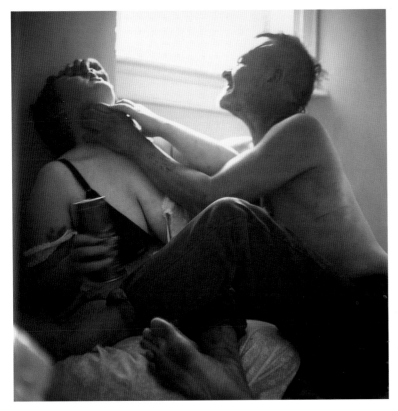

I
What she is is a speed freak evil witch She needs her head sorted out it can get full of shit. We done some personal stuff I wont say what as I know it wont sound too good witchs can be evil remember its not good looking

maybe to some other watcher she is... I like small blonde hair girls (less trouble) she can be a drunken diamond when she is in a good mood She has a beautiful daughter called Kathleen who is my friend too...

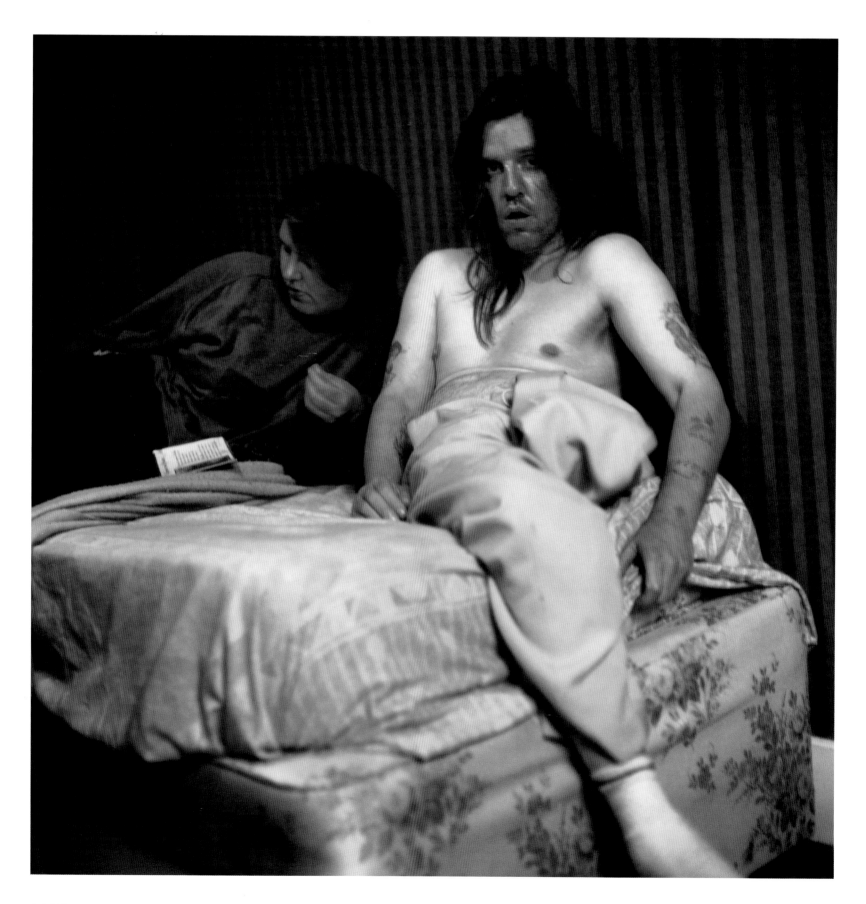

OUT TO THEM SHES STRAIGHT
FORWARD THE WAY
SHE SPEAKS TO YOU
i WOULD BE LOST WITH OUT
HER BECAUSE WEN PEAPLE
GATHER ROUND AND
ARE NOSEY AND LOOK
ME UP AND DOWN THINK
IM A BIT THICK THERESA
TELLS THEM OFF

THRESAS OK SHES GOT A
QUICK TEMPER i COME TO SEE
HER A LOT AND PEAPLE TRY
TO INTERSFERE WITH US SHE SEEM
TO BE DOING TOO WELL WITH
MICK AND WE GO TO PUBS TO GET
AWAY AND GET A BIT OF TIME
ONLY TIME i DARE FREEDOM
IS WITH THERESA SHES VERY
STRICK V SHE IS HAS AND CAN SLAP
ON BACK VISCOUSLY SHES
SES VERRY PROTECTIVE
TWOARDS ME PEAPLE
TAKE A DVANTAGE
OF ME i HIDE BEHIND
THERESA AND SHE TELLS
THEM OF AND GIVES

Cor blimey I think you should know what its possibly all about.
cos it ain't no lark like shut up you got — — — — —
— — — — — — and stuff. You what
I got to be myself aint I alright — oh blimey
how do you talk like that oh yeah it hurts
— and stuff. I've been through a lot
ain't I You what — No she never
She said — — — — — — mine here
bleed...

You what You're off your face mate I/we
what Go on then and show me where
Shall we go now then Well to start with its
we like we're pisshoads and were like pissed ain't
— — pissed there is — — —
Jokes (cigarette) thats what happens
— — — — — People You what — — —
Some pisshead can't talk Do what I want. No it don't matter
— — pissheads — — — — — I forgot
again — — Well you can attache thet to your
bloody Jacksee Noanyway.
— — — — for a start — we have — —
— — — leave that (it) Yeah — —
talk — — — — — — — that why
I talk proper and everyone here talks
proper and yeah she does ME FRIEND

Contents

Signs that say what you want
them to say and not Signs that
say what someone else wants
you to say
Italian series
1994
C-type colour photographs
mounted on aluminium
40.5 × 30.5 cm
Series of approx. 250 photographs

top right, l. to r., 'I hope that
everyone can one day be as happy
as we are now.'

'We want peace of the senses.'

'See Naples and die of boredom.'

bottom right, l. to r., 'Those who
work don't earn; those who earn
don't work.'

'Two years ago I was on drugs.
Drugs no good. I hope all kids get
themselves off drugs.'

'Transmit to all of you! This is
what I want to do. Not to write
but to transmit.' (signature)

opposite, 'I admire you for your
ability to be so open.' (signature)

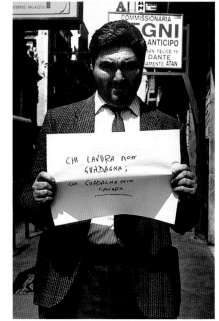
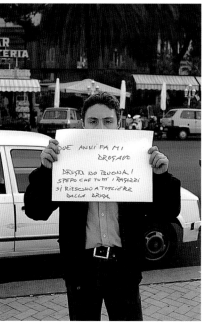
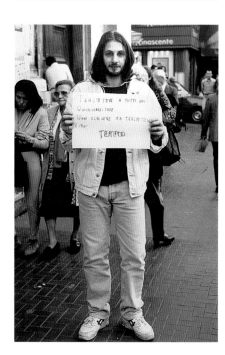

When most people are stopped in the street they expect to be asked questions usually
concerned with either a product, money, a survey, a personality test or directions.

To be asked only to write something, anything, presents a challenge and creates
a totally different relationship to the person posing the question. The bizarre request
to be 'captured' on film by a complete stranger is compounded by a non-specific space:
the blank piece of paper, which almost replicates an unexposed film.

Perhaps the fascination in the relationship between the person and their slogan
is in the confidence or diffidence of the people being 'imaged' in the first place.

This image interrupts the logic of photo-documentary and snapshot photography,
through the subjects' clear collusion and engineering of their own representation.

Vi ammiro per la Vostra
capacità di essere così disponibili

(signature)

Interviews with people in the street 1993

Gillian Wearing **Is there anything that you have regretted buying?**

City Gent The only thing I bought which I wished I hadn't bought is the house in Spain.

Wearing **Why's that?**

City Gent Because, had I invested the money elsewhere, the interest would have paid for annual holidays for me and my family – luxurious holidays for me and my family. Ad infinitum.

Wearing **So it's become a bit of a burden?**

City Gent It's not a burden, it's just a folly.

Wearing **Is there anything you would like to have that you can't afford?**

City Gent Yes, more time.

Wearing **Leisure time, would that be?**

City Gent Just more time in general.

Wearing **Immortality, would that come in somewhere?**

City Gent Wonderful.

Wearing **Would you like that? What do you like about yourself?**

City Gent I don't like anything particularly about myself.

Wearing **I don't believe that**.

City Gent It's true.

Wearing **There must be something; everyone likes something about themselves.**

City Gent No.

Wearing **A small thing you like about yourself?**

City Gent No.

Wearing **Nothing at all?**

City Gent No.

Wearing **Have you reached down into your soul and found something – say, personality – that you like?**

City Gent Yes, quite satisfied. But nothing especially different.

Wearing **You think you're just average?**

City Gent Yes, just average. It's very enthusiastic to be keen about being average.

Wearing **It's very … ?**

City Gent It's very different – it's very difficult to be keen about being average.

Wearing **So, you're not keen about being average?**

City Gent No, but no one is.

Wearing **How do you know that? Average to what?**

City Gent Average to the mass.

Interviews with people in the street
1993
Audio recording
Production still

Wearing **You think you are. I don't think so.**

City Gent Oh yes, I'm dressed very similarly to you.

Wearing **But this is my superb coat.**

City Gent [*laughs*]

Wearing **What do you dislike about yourself?**

City Gent I'm getting old.

Wearing **That's it? Just age?**

City Gent Age, deterioration.

Wearing **Is there anything you wished you had done when you were younger?**

City Gent Oh, many things.

Wearing **But you like being alive?**

City Gent Love being alive. Can't think of anything better than being alive.

Wearing **What about physically … is there anything you dislike about yourself physically?**

City Gent Yes, each year gets harder than the previous year.

Wearing **So it's age, then?**

City Gent Yes.

Transcript from interview in the audio recording series, *Interviews with people in the street*, a project of the artist during 1993.

What do you like about London?
1990
Video, destroyed
Duration unknown, colour, sound
35 mm documentation slides

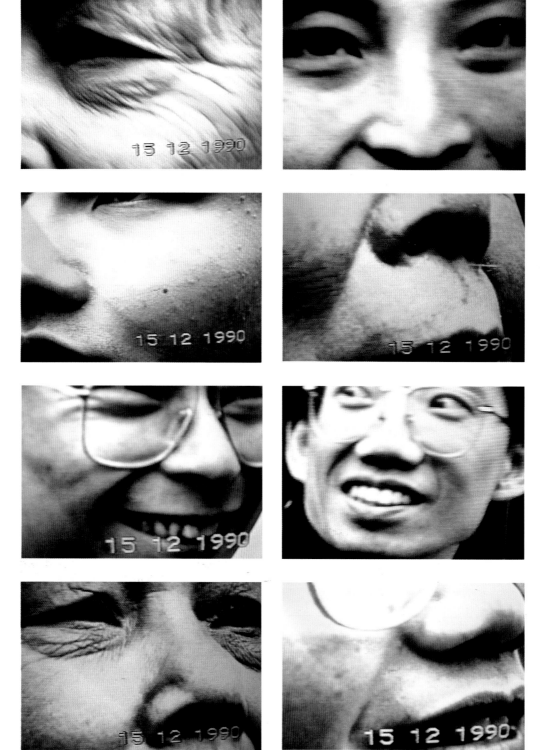

Artist's Writings

Confess all on video. Don't worry, you will be in disguise. Intrigued?
Call Gillian 1994

Confession 1

This particular company – one of the biggest companies for pizzas – they don't give a shit about discrimination, and I was humiliated in this company. So I did seek revenge. There were two people who really pissed me off, my boss particularly, and on my last couple of days there he asked for a pizza, a nice thin and crispy pizza, so I said fine and I got this scab growing on my hand and I picked it off and put it on his pizza. And he did actually remark about how nice and crispy the pizza was. And then there was this woman who had a problem with me being gay and I sat down and tried to reason with her and she was fine for a couple of hours but after that she continued to undermine me and make rude remarks about my sexuality. So I put the bitch's telephone number in a phone box marked 'Busty lady wants to give men a good time' so then she was harassed by dirty old men phoning her up in the middle of the night wanting sex. But I'm afraid that's the way it goes, we as gay people can not afford to be dumped on by society. Especially now that Parliament has just underlined the fact that we can be discriminated against. And if that's the case we're going to fight back.

Confession 2

When I was twenty I was involved with a group of people who were making pornography. It was good money at the time. There was also a lot of drugs available but I kept away from that and concentrated more on drink. I saw a lot of people get killed through the drugs and I saw a lot of women get beaten up, which was a terrible thing. I have never done that to a woman and I never would. But there were a lot of nasty people out there that would kick, beat and whip a woman to get her to do things. But even though I was against this I could not speak out else I would be beaten up too. It was only when I managed to get out of pornography I managed to report these people to the police. But this is part of life that still continues. At the moment I'm not involved with crime and hopefully I won't ever be again.

Confession 3

My confession is drugging a man, robbing his house and stealing his credit card. A girl approached me at a train station and told me this man had been two-timing us, sleeping with both of us, not using any contraception apart from the pill. But we decided to get him back. He went on holiday to Greece and he phoned both of us up and told us if we loved him or wanted him to come back we should tell him. So we both told him to come back, so he came back early from Greece. And for four nights we both

Confess all on video. Don't worry, you will be in disguise. Intrigued? Call Gillian
1994
Video
30 mins., colour, sound
Video still
Collections, Arts Council, London;
Tate Gallery, London; Kunsthaus, Zurich

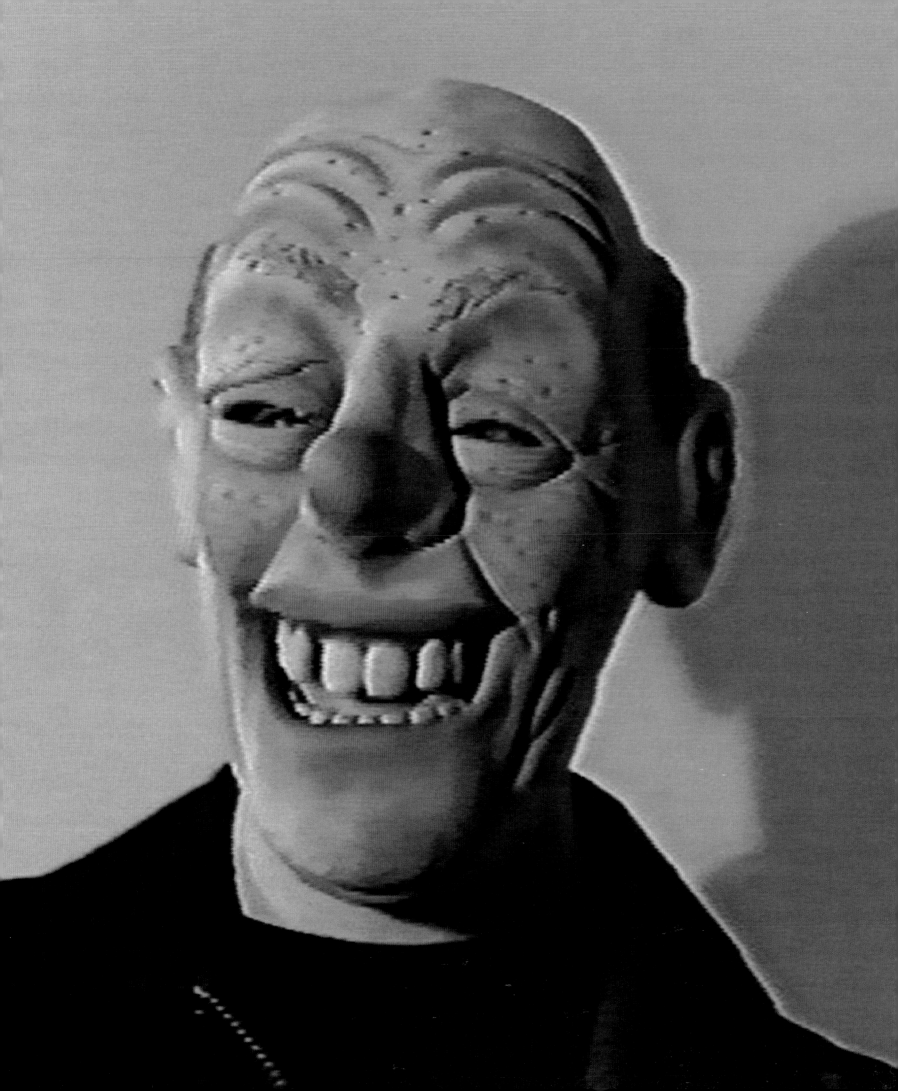

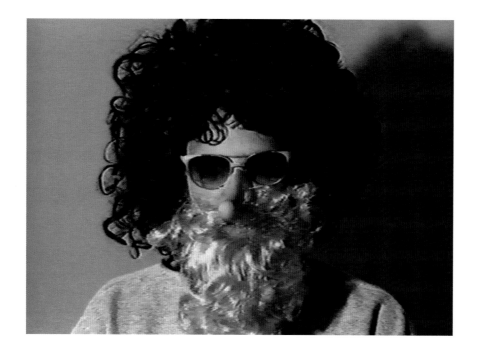

saw him on alternate nights then on the fifth night we had our plan all set up. She was going to book a hotel room with a four-poster bed. When she picked him up in all his smart clothes she took him to the hotel and they had a magnum of champagne, which we had put sleeping tablets in. In the meantime I had gone around to his parents and told them that me and him were moving out and so I started packing away all the gifts I had bought him and took them back to my car where I waited for a call from the other girl. Back at the hotel they had finished their champagne and were now having a three course dinner with wine. After that she took him upstairs to the bedroom, at which point he collapsed because of all the alcohol and sleeping tablets. At this point I got a phone call and drove over to the hotel to meet my girlfriend and partner in crime. We took all his clothes, plus all the sheets and towels from the room so he couldn't get away. And we left a message saying 'This is what you get for fucking two girls'. We then took a photograph of him naked so he couldn't bribe us. We then went downstairs and handed his credit card over the counter to pay for the bill, which came to £200. So this is my confession for drugging someone, stealing their credit card, and costing them quite a lot of money.

Confession 4

I went with a prostitute. I went first and left my friends behind. She directed me to a backstreet nearby and just had sex there. I was eighteen at the time.

Confession 5

Hello, my confession is about a subject dear to us all: sex. When people think about sex, they think about sex in a loving relationship; they think about pain, humiliation, disgrace, disgust. For some people it's a filthy act to be done as quickly as possible. When I think about sex I think about strangers and the total thrill of having sex with a stranger. Not knowing their name and not even wanting to know their name. Just being with them for sex. Let me explain when this first started for me. Around about the age of fourteen to fifteen, when a boy starts turning to sex, I decided I had a high sex drive. But I was too shy to ask girls out, so what was I going to do? I had to masturbate. I don't like the word masturbate, I don't like the words handyshandy or J. Arthur Rank so from now on I shall say wank. I started buying soft porn magazines at the age of seventeen. Then when I got a job at eighteen I started to go to prostitutes. All in all in the last eleven years I've been to fifty different prostitutes. I didn't think it was embarrassing or degrading to pay for sex. I'm not ugly, not handsome, just average

Confess all on video. Don't worry, you will be in disguise. Intrigued? Call Gillian
1994
Video
30 mins., colour, sound
Video stills
Collections, Arts Council, London; Tate Gallery, London; Kunsthaus, Zurich

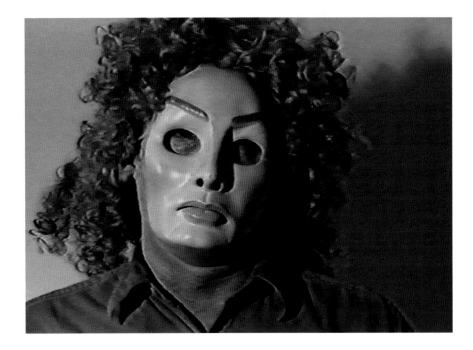

looking and I suppose I could get a girlfriend if I really tried. But I don't want to sleep with the same person all the time because it's boring. So, anyway, I was reading soft porn magazines and I graduated to blue movies. And on top of this I was making obscene phone calls. This first started when I was sixteen. I fancied the girl who delivered newspapers and one day I rang her up and said 'What colour knickers are you wearing today?' She said, 'Who's this?' and put the phone down. I was incredibly turned on by this and now whenever I feel horny I sometimes just have a wank or I have a wank and watch a film. But most times I need to make a phone call, have some photographs in front of me, watch a movie and have a wank. I didn't make many phone calls until the age of twenty because I was living with my parents. But as soon as I got my own place I could obviously make as many calls as I wanted, whenever I wanted. And nobody would find out because I was paying the bill. I've got various sources for obtaining numbers. I look through the classified adverts sections in newspapers, I ring up numbers in the wedding dress section, the flatshare section like 'Female flatmate wanted', the sunbed section, because they tend to be used by women, and the childrens' wear section. I don't want to talk to children, anyway they're usually at school and I can get their mothers at home. Sometimes I ring up and say, 'You've got a really sexy voice, I'm feeling really turned on', or, 'Hello sexy, what colour knickers you wearing?' It might be childish but it usually gets the reaction, 'Green with pink spots on', or 'None at all', or 'Fuck off you dirty pervert'. Pervert. What is a pervert? According to the Concise Oxford Dictionary it is a person showing perversion of sexual instincts, and perversion is defined as 'a preference for sexual activity other than sexual intercourse'. Well, I wouldn't call myself a pervert because my preferred form is sexual intercourse. Obviously I've got certain preferences for that, like oral sex – both giving and receiving – and I prefer the woman to be on top. If you can't get that either because you're too shy or can't afford prostitutes what are you going to do? I find that black women talk more than white women. And one woman I called (I think she was from the West Indies) asked what oral sex was. And I said, 'I would like to lick your pussy', and she said that had never happened to her and that it sounded quite interesting. She said I should phone her again tomorrow and when I rang back the next day she said, 'Sorry, I can't talk to you any more because my husband may find out'.

Confession 6
A friend of mine has a brother that goes to school in South London and in this school they have just bought an Apple Mac computer. So me and my friend decided to break

into the school, which we knew would be pretty easy because it was the design block and the walls there are made of thin board. So one night at about eleven o'clock we climbed over the fence and ran up to the design block and kicked-in the wall. Inside, we knew there was motion sensors so we managed to steer around those and get to the computer. At this point we were feeling really high. We knew it was too difficult to take everything so we took the main bits – the scanner and the computer. At this point time was getting short and we had to do everything quickly. I had the scanner under my arms and my friend had the computer. As soon as we managed to get out of the building the alarm bells went and when he saw us he started to chase us. We ran like crazy and managed to get over the fence and hide in a bush. We could hear police sirens come whizzing down the road so we had to wait about an hour before we moved. Eventually we got the stuff home and have heard nothing since.

Confession 7
The other day I turned up at her house fifteen minutes late and she was very annoyed and she said she would punish me again, and so she told me to put on a basque and suspenders, which I did, and then she gave me a pair of black stretch trousers with a loop underneath the feet and she gave me all her blouses plus a pair of black shoes with two-inch heels and then she gave me my jacket to put on and then she said we were going out. I then realized the trousers were so tight you could see the stockings and suspenders underneath. We went out and drove five to six miles and went to a pub, and went in for a drink, and it was very embarrassing: everyone was looking at me and that's where we are now. She's got me, I can't do anything to resist her, else she'll send off letters to my boss at work. She was the one who told me to come along to do this session today and said if I didn't she would punish me. And that's my story.

Confession 8
She has big breasts, dark hair, not awfully attractive but still a nice girl. But it was the usual story: money was all she wanted. So she started to massage me, took my clothes off, put on a condom. I would say make love but that's hardly the word. The whole situation was designed to make me come as quickly as possible. So she could just get up and go out, which she did, leaving me naked in bed with a condom on. I didn't feel happy, sad or guilty. I didn't feel any of the usual feelings you have after sex, especially with my girlfriend. I didn't feel elated or overjoyed. I didn't feel like I wanted to get up and run six times around the room. I just felt pathetic. So the next morning I tried to

Confess all on video. Don't worry, you will be in disguise. Intrigued? Call Gillian
1994
Video
30 mins., colour, sound
Video still
Collections, Arts Council, London; Tate Gallery, London; Kunsthaus, Zurich

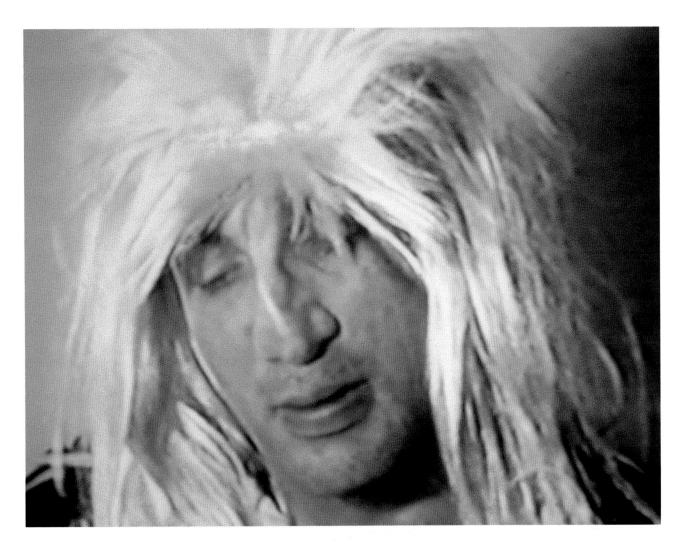

take on life where it had left off. She will never guess, she will never know. But if she does ever hear, I am sorry – truly I am.

Confession 9

Hi, I am a transvestite. I dress in women's clothes which is something I enjoy doing. But unfortunately it causes distress and unhappiness to myself and those around me. Since I confessed all I have been through counselling and an awful lot of heartache, but have learnt a lot in the process. I would like to offer words of advice and comfort to people who have found themselves in my situation. Or those who are partners of people who have a fetish, something they enjoy but which unfortunately can destroy a relationship.

Confession 10

The story is this, I am one of four siblings – two boys and two girls – and we had a very happy family, and I regret to say my father died of cancer when we were pretty young. My mum did not remarry or start another relationship. The confession I have to make is this. My brother developed a sexual relationship with his sister and this involved snogging/necking, but not sexual intercourse. I haven't been able to come to terms with this because I used to watch my brother and sister and I haven't been able to come to terms with brother/sister snogging. It wasn't a one-off, it went on for years about once every couple of weeks. It's something I haven't been able to categorize. I can't discover if it's a common or rare thing. When you have an experience you file it away and put it under such and such a category. But I've never been able to categorize what brother and sister kissing means. It was quite passionate kissing and cuddling between brother and sister. It started when my brother was nine and my sister was ten and about eighteen months later I realized my other sister was involved, and it went on

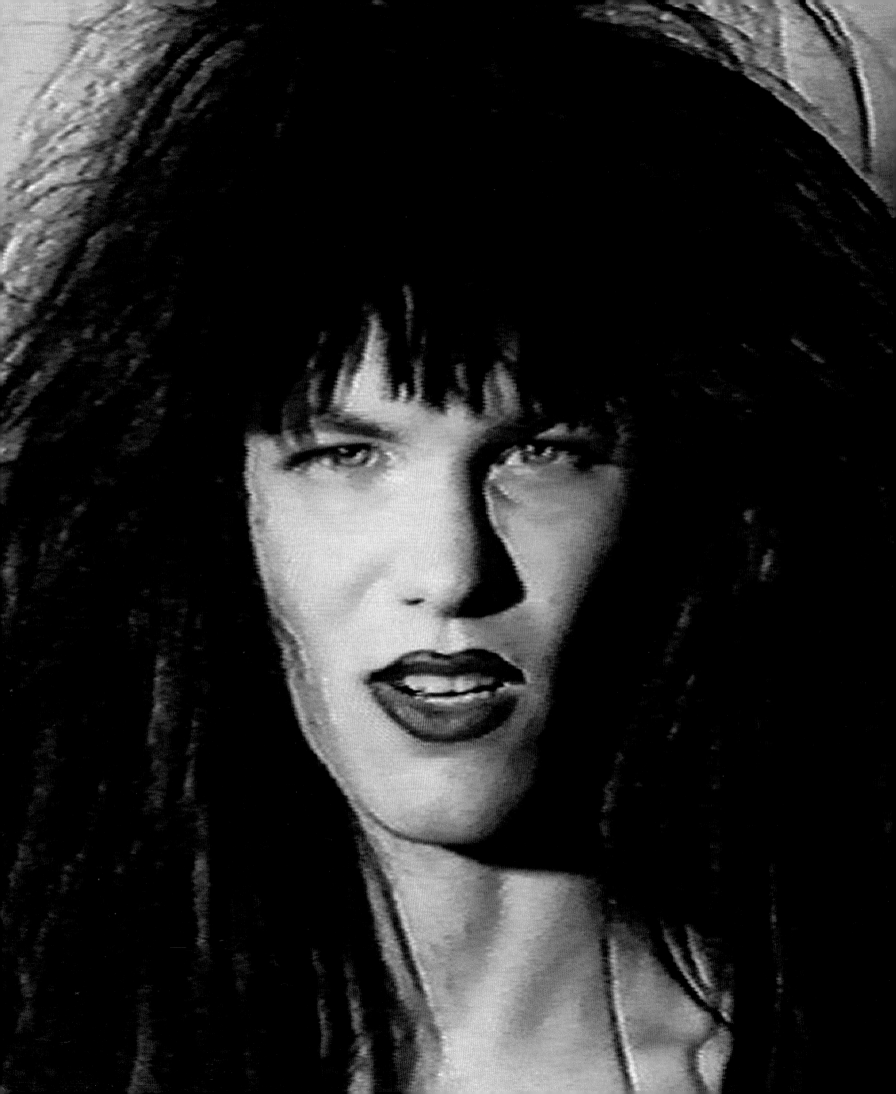

Confess all on video. Don't
worry, you will be in disguise.
Intrigued? Call Gillian
1994
Video
30 mins., colour, sound
Video still
Collections, Arts Council, London;
Tate Gallery, London; Kunsthaus,
Zurich

until one of my sisters was seventeen. I've never been able to work out if this is
a common or rare thing. It's not as if it involves sexual intercourse. It's a question
of whether brothers and sisters normally kiss in this way and I can't figure it out.
And it's led to enormous trouble in my life, because I've got a photographic memory
and these images of brother and sister snogging are branded onto my mind. It's meant
that my own sexuality has been completely destroyed by this thing, because my
sexuality has been completely caught up in a tight spiral. I'm heterosexual, but as soon
as my sexuality builds up over two to three days, I get these white hot images in my
mind and my sexuality dissipates because of those images. Because of this thing
I haven't been able to have relationships with women. I'm thirty-six and still a virgin.
I've never kissed a woman but I've put my arms around one twice in my life. It's led to
a lot of emotional pain. I've got this whole thing constantly in my mind, like when I go
into the office and there's something in my 'in' try, I file it away. But this is in the 'in' tray
of my mind and I don't know where to put it. Now about a year ago I decided I couldn't
take any more of these images in my mind and the fact of never having a relationship
with a woman. So I went into a police station the day I was supposed to be at a confer-
ence with my company I work for, and I said, 'I demand to be arrested', and they said,
'How can we help you, what's the problem?' And I said, 'If you don't arrest me there's
going to be trouble.' And then I picked up a metal litter bin and flung it with all my force
across the floor, being careful not to hit anyone; I did not want to hurt anyone. I threw it
in a desperate bid to get some attention and bring this thing to a complete head. When
the bin hit the deck it made an almighty clatter and these police officers came rushing
from the back and immediately put my arms behind my back and arrested me. They
then put me in a police cell for a couple of hours to cool off. Now the company I worked
for found out about it and I was lucky not to get fired. But they did give me a warning
and told me to undergo psychiatric treatment which I have been doing for just over
a year and it's still going on. But this thing has still led to a total suppression of my
character. It has become an obsession with me. As soon as I have sexual thoughts
they're just about this thing, and I've also developed my own fantasies about kissing
and cuddling with my sisters. But my sisters wouldn't come near me when I was young
because I was having emotional trouble after my father had died. This is a true confes-
sion and I don't think I can add any more than this. I can only hope that this is part of
a therapeutic process which I'm seeking to undergo.

Transcripts from video, *Confess all on video. Don't worry, you will be in disguise. Intrigued? Call Gillian*, 1994.

Homage to the woman with the bandaged face who I saw
yesterday down Walworth Road 1995

**Homage to the woman with the
bandaged face who I saw
yesterday down Walworth Road**
1995
Video projection
7 mins., black and white/colour,
subtitles
Video stills

Homage to the woman with the
bandaged face who I saw yesterday
down Walworth Road

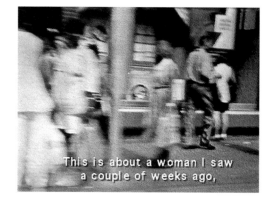

This is about a woman I saw
a couple of weeks ago,

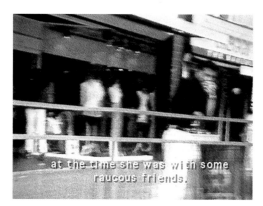

at the time she was with some
raucous friends.

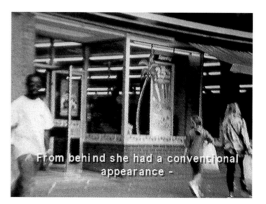

From behind she had a conventional
appearance –

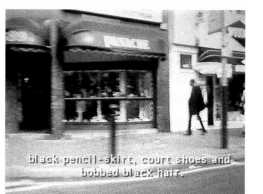

black pencil-skirt, court shoes and
bobbed black hair.

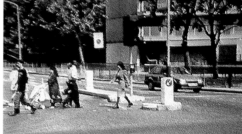

Her profile was the first thing
that struck me.

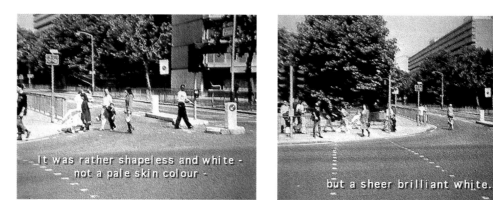

It was rather shapeless and white –
– not a pale skin colour –

but a sheer brilliant white.

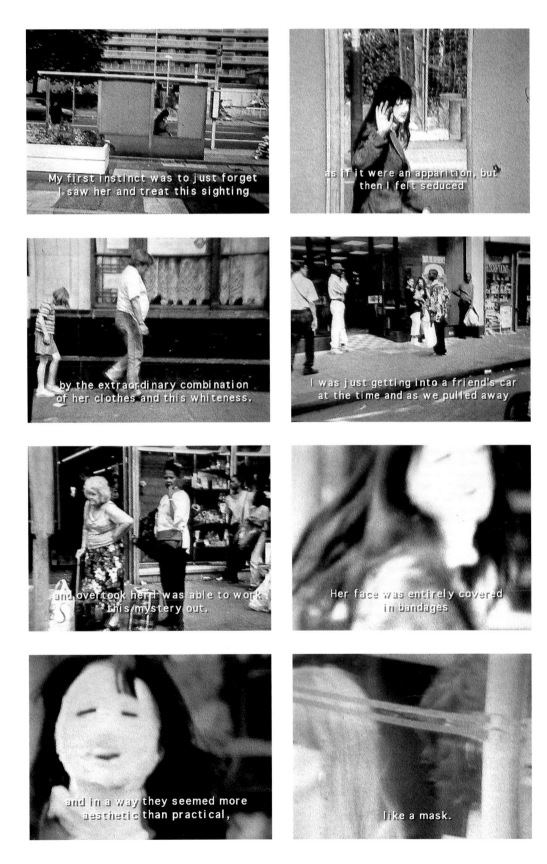

My first instinct was to just forget I saw her and treat this sighting

as if it were an apparition, but then I felt seduced

by the extraordinary combination of her clothes and this whiteness.

I was just getting into a friend's car at the time and as we pulled away

and overtook her I was able to work this mystery out.

Her face was entirely covered in bandages

and in a way they seemed more aesthetic than practical,

like a mask.

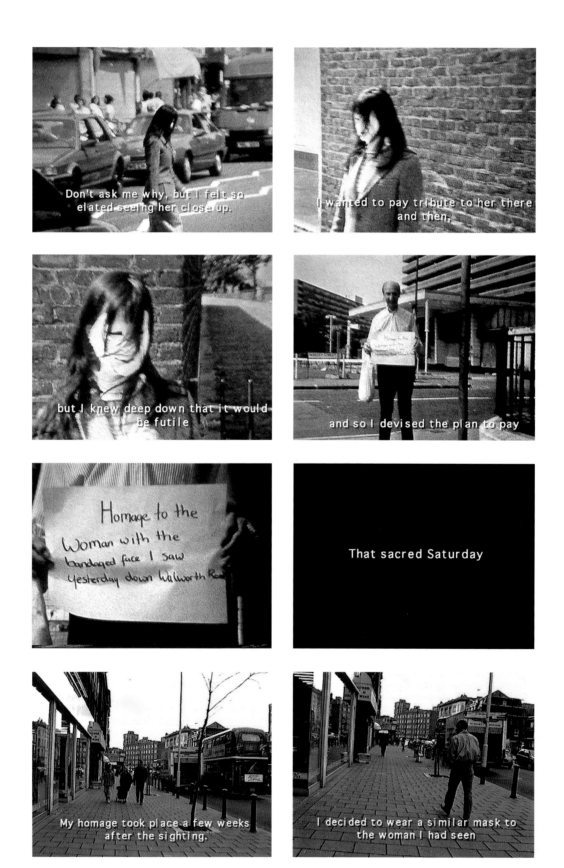

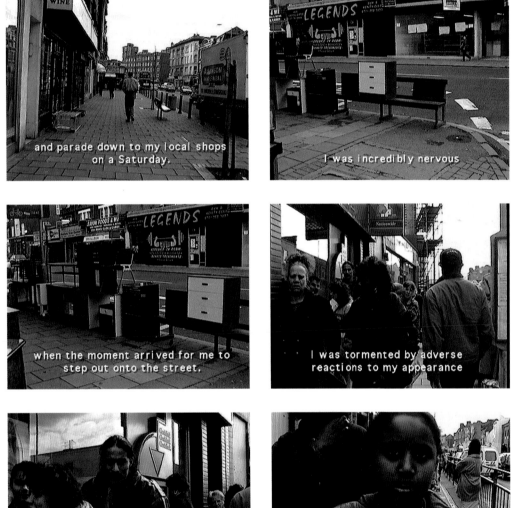

and parade down to my local shops on a Saturday.

I was incredibly nervous

when the moment arrived for me to step out onto the street.

I was tormented by adverse reactions to my appearance

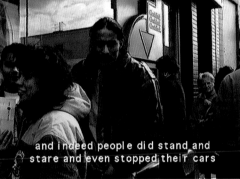

and indeed people did stand and stare and even stopped their cars

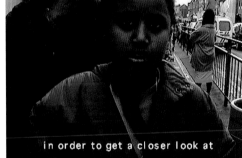

in order to get a closer look at

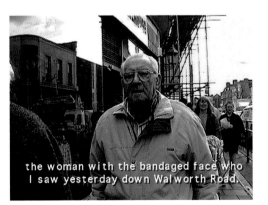

the woman with the bandaged face who I saw yesterday down Walworth Road.

On meeting the

Kwik-Fit Fitters

After a while I felt dejected.

No one had the nerve to confront me.

Then I heard a chorus of heckles.

I immediately turned around

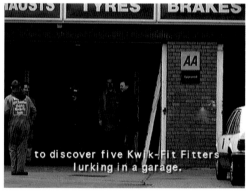

to discover five Kwik-Fit Fitters lurking in a garage.

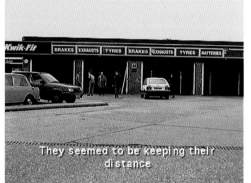

They seemed to be keeping their distance

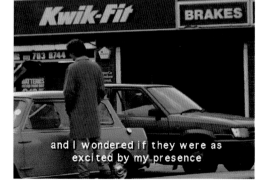

and I wondered if they were as excited by my presence

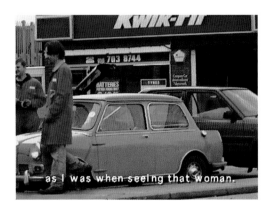

as I was when seeing that woman.

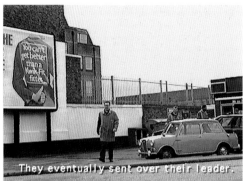

They eventually sent over their leader.

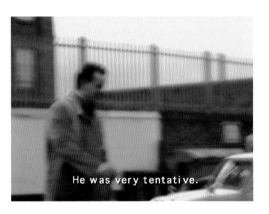

He was very tentative.

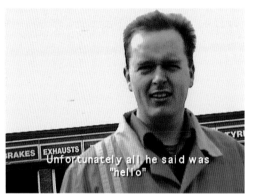

Unfortunately all he said was
"hello"

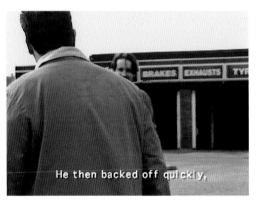

He then backed off quickly,

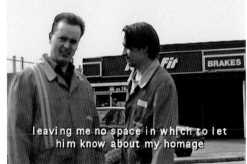

leaving me no space in which to let
him know about my homage

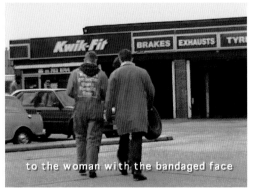

to the woman with the bandaged face

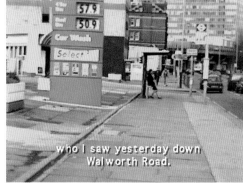

who I saw yesterday down
Walworth Road.

It's a Question of Choosing Those Moments …
Interview with Ben Judd 1995

Gillian Wearing started talking about a woman she had seen in South London, who had appeared completely normal except for one disturbing aspect: she had a completely bandaged face. The face seemed like a white mask, over which hung the woman's fringe. The seductiveness of such a freakish, inexplicable sight prompted her 1995 video *Homage to the woman with the bandaged face who I saw yesterday down Walworth Road*. This led to a conversation about other people that Wearing is drawn towards:

Gillian Wearing **Some of them you get to categorize, but there's always one odd person who acts in an extraordinary way, who's got there through a route that you're not sure about – which makes that person more fascinating than others. The bandaged woman was one of the first people who completely fascinated me, because she wasn't a bag lady or anything like that. Subtly being on the outside, or being different, is the most interesting, because the person looks like he or she has access to both worlds.**

Ben Judd I was thinking that your *Dancing in Peckham* video could almost deal with the same sort of thing. On the surface it could appear to deal with mental illness, or how people react to the mentally ill.

Wearing **That's what I was thinking of as well. I'd seen this woman in the Royal Festival Hall who was dancing completely out of sync. She was just going for it in a way that had nothing to do with the music, and it was hysterical. And I wanted to say 'Can I have your name and address and put you in my video?' You just realize you've got to stop yourself because it would be so patronizing. Maybe I was recognizing nuances in myself as well, because I can be like that – I do actually dance quite maniacally. I had to take it one step further. Even if I'd been just videoing her there, in the Royal Festival Hall, it wouldn't have been interesting. You see things where you feel you could be like that, but you can't, you're scared, or you feel that you could slip into that mode. For me to be interested, it's got to be something about me.**

Judd There's a part of you that can do that, and did do it.

Wearing **It's trying to then orchestrate it into something that people can understand.**

Judd Does that understanding come from you changing the context, and is it you

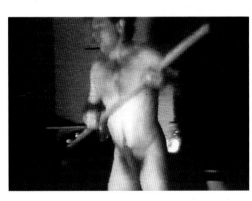 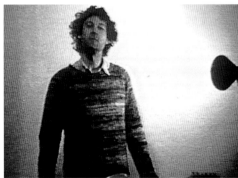 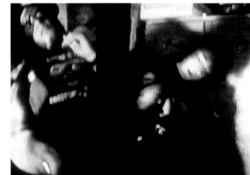

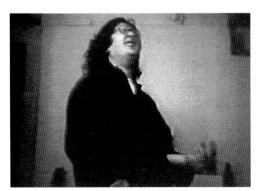 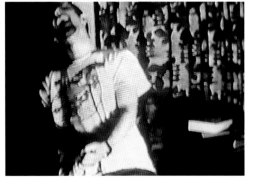

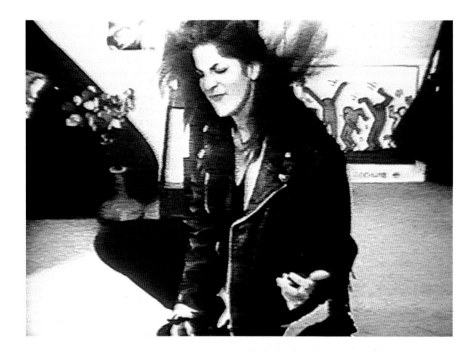

changing the context that determines how successful the piece is? You dancing in your bedroom would obviously have had a very different feel.

Wearing **In the *Video Diary* or *Video Nation* TV spots, you see people acting silly in their own homes – and that's since camcorders have come out. People have wanted to record themselves being wacky; this is the 'true' them. But they're doing it in private. I'm sure that many people have done a lot of dancing in their bedrooms, but taking that fantasy and putting it somewhere that's alien – that's where you can start questioning.**

Judd As in some of these 'fly on the wall' documentaries, your work seems to be a mixture of a certain amount of controlled elements and aspects that are left down to chance.

Wearing **You'd be very lucky if you went to a park on a Sunday and saw a streaker. You know those things are there; it's just a question of choosing those moments. It's like editing life. Nothing would ever be interesting in its real state. A film director's work can be completely contrived, and yet look as if it's just an improvisation.**

Judd In the videos which feature yourself, there seems to be an interest in your personal endurance of a situation, or even your humiliation.

Wearing **I suppose I'm interested in that tragi-comic element. A lot of documentaries are hysterical, because that's what life is like. There's elements of humour and then there's humility as well. I'm interested in every emotion being part of the work. Some of my work is very depressing, and then there's other stuff that's funny – like the air guitarists in (*Slight reprise*). People know, when they do it, that it's a ridiculous**

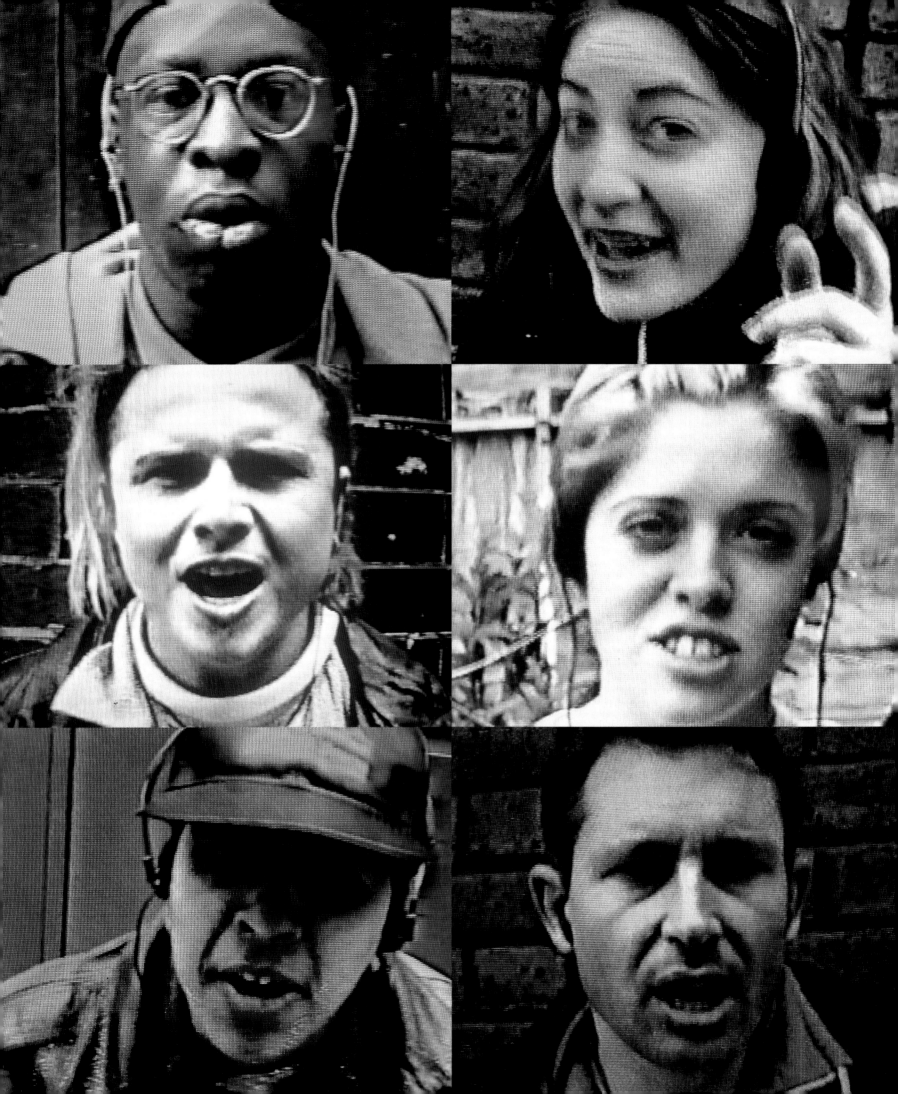

My Favourite Track (details)
1994
Video installation
5 monitors, approx. 90 mins.,
colour, sound
Dimensions variable
Video stills
Collection Tate Gallery, London

scenario, but they enjoy it. But I will actually humiliate myself – the only person who
can actually invoke ridicule has to be me, at the end of the day.

Judd Isn't there a certain amount of ridiculing of the other people, like the air guitarists,
or the people singing on *My Favourite Track*?

Wearing **My Favourite Track is very funny because the subject matter is funny – it's
not as if I'm asking them to say something about their family life. If you hear it from
a distance, it actually sounds very tragic, as if they're lambs going to slaughter. It's
meant to be humorous, and the participants know that. The Walkman means you can
sing a record that's not there – it's an imaginary space.**

Judd Imaginary space is quite close to individual space, and they both encompass the
notion that although everyone might be together in a public space, we're essentially alone
and separate, caught up in our own worlds. In your work, this idea is accentuated by you
asking people to do very absorbing, private acts in public. It maybe only works within
a city.

Wearing **In London you get everything, and you'll always feel that this is a place where
you can disappear. I like that, because I don't want to keep bumping into the same thing
every day, the same attitude, the same feeling. Or the idea that I'm being watched.**

Judd Your work has been described as 'Mass Observation for the 1990s' – or as a kind of
Orwellian overview.

Wearing **The fact that people are watched doesn't worry me. We need some form of
protection. I don't find it sinister at all; I've grown up with it. It's more intimidating
being watched by someone in person than by someone you can't see (behind a security
camera). We need some kind of security.**

Judd Which leads us neatly to *Western Security* and *The Regulators' Vision*. Why did you
want to film the cowboys' and security guards' reactions?

Wearing **To see them together. The cowboys have their own group problems. I was
trying to find that essence. If they all talked about the video, which I knew they'd all have**

strong opinions on, it was a good way of seeing how that dynamic worked, or didn't.

Judd *Western Security* was very mischievous, as it disrupted the sacred space of the gallery. Especially with paranoia over security and guns, you went completely the other way and staged a gunfight.

Wearing **It also questioned our behaviour within that space; our etiquette. Those white spaces usually command such respect, and I like the complete disrespect of it. How many times have you been to a gallery and had pure fun? It's always very contrived fun. Maybe a private view is lots of fun, and then you see the after-effects of someone who is on the inside, and you feel like you're very much not part of it. Galleries will always do that; there's no way you can actually break that down. I understand the gallery space, and I can enjoy work in it. It's when people think they can have this participation, get into the work … I don't like this idea that you're implied somehow, because if someone tries to put you in, it's quite intimidating. Galleries weren't created to forward this idea of mass participation.**

Judd In *Signs* … I was surprised at how willing people were to allow such an invasion of their own privacy to occur. It made me feel uncomfortable, but maybe this was an acknowledgement of our fascination with people who are 'on the edge'. There is perhaps a fine line between that fascination and actually finding it funny.

Wearing **As a series, I don't find it humorous at all, that's just the one that covers everything. What might make it uncomfortable is people being so honest. Especially within the art world, you can get very guarded. That's why I ask strangers, because people are much more honest to someone they're not going to see again.**

Judd *Signs* … has such a wide breadth, from homelessness to homosexuality to insanity, and it is this scope that separates it from social commentary.

Wearing **It leaves a lot to the imagination – that's what art should do. It leaves you something to go away with, something to think about. It doesn't say: this is a story, completely, and this is my take on it.**

Judd So it's that gap between what we expect from something, and what you deliver.

I'd Like to Teach the World to Sing
1995
Video projection
1 min. 49 secs., colour, sound
Dimensions variable
Video still

I'd Like to Teach the World to Sing
1995
Video projection
1 min. 49 secs., colour, sound
Dimensions variable
Video still

Wearing **I actually like to think there's something left of that person. Who wants to know every little thing that's going on in someone's brain? There's got to be some sort of editing going on.**

Judd We were talking earlier, in relation to your *I'd Like to Teach the World to Sing* video, about Coke™ as a big corporate power. It could lead us back to ideas about Mass Observation, or of us being watched or controlled in some way.

Wearing **Yes, there's no idea of free will any longer, which is ridiculous. The idea of humanism was initially about knowledge giving you power and giving you access to freedom. Now we feel we have access to all these things, but they're all completely controlled, because they have to be.**

Judd Like the internet.

Wearing **Yes, the internet. People think that all of a sudden they're going to be ten times more powerful or knowledgeable. We're much less free. Even with the cowboys appreciation society in *Western Security*, they've notched up something that, to a certain extent society would frown upon, and yet they've done it. I like people who go outside of what we perceive to be normal. Because we've all got an opinion now of what we should and shouldn't do. We all control each other in a way, we all control each other's patterns and we all have ideas of ethics and morals and PC. But then that gets exploited, and everyone exploits each other, and that creates limitations to what we feel we can do. So it goes across everything, really.**

Judd It takes away that paranoia, to think that there's not one controlling force or body.

Wearing **Which makes it harder to chip away at. When a person does have an individual opinion they then look mad, because we've all been so softened. Those people are usually the most interesting. I have always been interested in people, even when I was a young kid. So it seems, for me, quite a natural thing that I'm interested in. I'd like to find out as many facets as possible about people. I'm interested in people more than I am in myself. Maybe that's what it is.**

Judd In *I'd Like to Teach the World to Sing*, there was the duality of the participants singing a brainwashing song, but then there's also something liberating about it. Not only did they agree to do the video, but it also has a positive feel, by it being shot in a park on a sunny day.

Wearing It's the way advertising can come up with this successful song, there's that positive thing in there as well as a negative thing.

Judd Advertising pushes across that idea that you can be individual but like everyone else at the same time.

Wearing Especially when the adverts are about family life, and they all look very homogeneous. It makes you feel that's the way it is, and that's where you've come from. Some idea of your family life comes from advertisements, so you feel in a way that even your own history seems to have been altered.

Judd Everyone does want those moments that you can associate with, as well as their own individuality.

Wearing The three characters in *The Unholy Three* all share one thing: their self-obsession. That is their common ground. But then if you take it to its extreme, that is what creates isolation.

Judd That separateness. It seems that the three characters can't fit into a collective; they're too far removed. And to prove that is to put them all together.

Wearing You're not seen in a very good light if you don't fit in. We don't have that much time for these people. I was always thought of as weird at school. I had a slight complex, feeling slightly 'out'. Like when I've temped over the years for different record companies, and again you're made to feel weird because you don't fit in. So you realize at the end of day that there's different little collectives, and it's the individuals that are seen as being weird somehow. But at least artists have found a grouping that we feel comfortable with, to a certain extent.

First published in *Untitled*, No. 12, London, Winter 1996/97, n.p. Revised 1998.

opposite, **The Unholy Three**
1995–96
Video projection
3 screens, 10 mins., colour, sound
Dimensions variable
Video stills

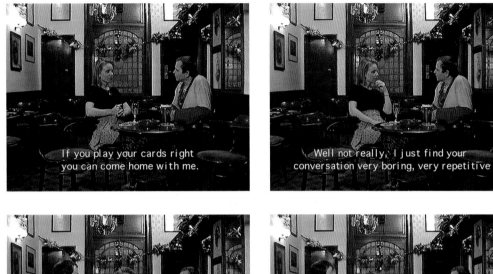

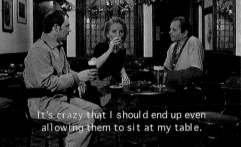

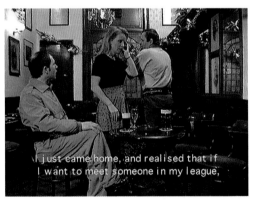

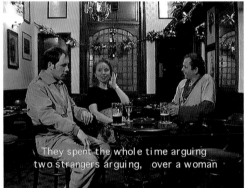

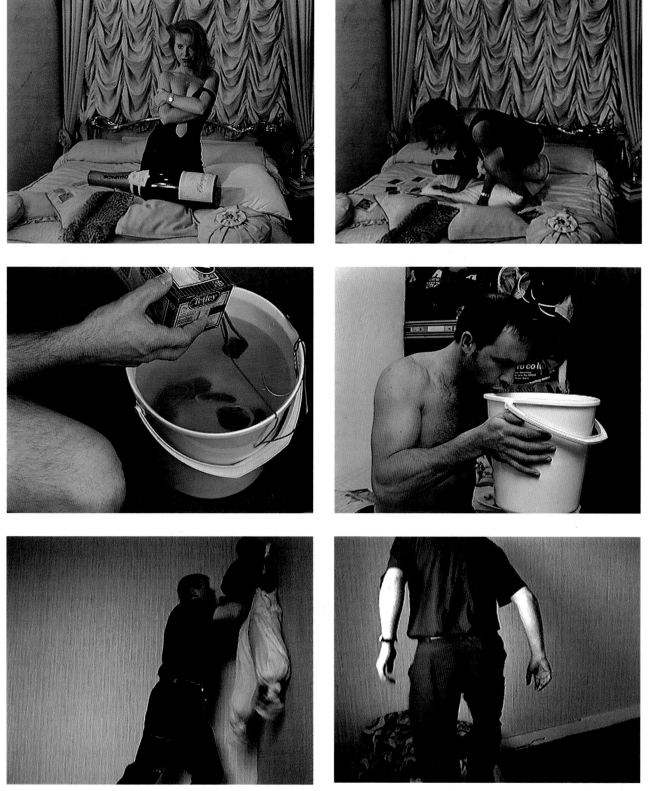

The Unholy Three
1995–96
Video projection
3 screens, 10 mins., colour, sound
Dimensions variable
Video stills

Sign Language
Interview with Gregor Muir 1996

Gregor Muir When you made the *Signs* ... photographs, how did people react when you approached them?

Gillian Wearing **A lot of people told me to fuck off, especially in South London. The hardest thing about the *Signs* ... photographs was gaining people's attention. At first I felt a bit of an idiot approaching people with my clipboard and camera, but when people actually stopped and listened, they took it quite seriously. They thought it was a good idea and wanted to collaborate.**

I was actually surprised that the *Signs* ... photographs worked out. People gave so much of themselves, which is unexpected in the British public, generally perceived as being reserved. Homeless people were the most generous. Some ended up writing stories about themselves which took up page after page, while the one-liners usually came from business people or people out shopping.

Muir Tell me about the businessman who wrote 'I'm desperate'?

Wearing **People are still surprised that someone in a suit could actually admit to anything, especially in the early 1990s, just after the crash. I literally had to chase him down the street. He only had time for one photograph and what he scrawled down was really spontaneous. I think he was actually shocked by what he had written, which suggests it must have been true. Then he got a bit angry, handed back the piece of paper, and stormed off.**

Muir Have you considered what *Signs* ... will look like in a hundred years?

Wearing **Besides their nostalgic and anthropological value, I think the language will appear more violent. Especially the ones that say 'Fuck Off' or 'Fuck the Tories'.**

Muir Do you intend to take more *Signs* ... photographs?

Wearing **I've been put off taking more, partly because people know what to expect.**

Muir How do you think your work has changed since the *Signs* ... photographs?

Wearing **Initially I wanted to find out what makes people tick. A great deal of my work**

From **Signs that say what you want them to say and not Signs that say what someone else wants you to say** (detail)
1992–93
C-type colour photograph, aluminium
40.5 × 30.5 cm
Series of approx. 600 photographs

is about questioning handed-down truths without being force-fed in front of the TV. I'm always trying to find ways of discovering things about people, and in the process discover more about myself. More recently, the work has undergone a shift of emphasis. Whereas before it was about asking people what they thought, I've started to produce scripted videos which are heavily structured.

Muir Do you script everything now?

Wearing **There are some things you can't ask of the public. For instance, the original idea for *Dancing in Peckham* stemmed from seeing this woman dancing wildly in the Royal Festival Hall. She was completely unaware that people were mocking her: either that, or she just simply didn't care. Asking her to be in one of my videos would have been patronizing, so I decided to do it myself.**

Muir What inspires you to document other people?

Wearing **Years ago I used to be really impressed by fly-on-the-wall documentaries such as Franc Roddam and Paul Watson's *The Family* which was first screened in 1974 and followed the life of a working class family in Reading. Watching it for the first time I couldn't believe how revealing it was. The film crew, the presenter, and the whole Wilkins family were so naive in front of camera. Brought to the screen, even the most normal scenarios suddenly seemed horrific. Everything about their lives was exposed. It was as if the whole thing were an experiment where no one knew what was going on. Nowadays, people get all nervous when you stick a camera up their nose. They want to look their best or come across as being witty and clever rather than just being themselves, which is far more interesting. I'm intrigued by nuances which aren't stereotyped yet. That's what I like about comedy: it reveals stereotypes which are right in front of your eyes.**

Muir How would you like to see documentaries being developed?

Wearing **I get a real kick from documentaries that touch upon art as well as cinema. Recently I saw one about a South American football player, which was so well orchestrated it was as though he had colluded with the production company. At one point, they filmed him naked having a shower. His life was going downhill because he couldn't score any goals. It was so close to being a film, with hardly any narrative, just**

music. There was this beautiful footage where you just followed him around. That's where I would like to see documentaries go. Not just sitting someone in front of a camera and asking them to justify themselves, but actually approaching their life as though it were a more interesting concept.

Muir Tell me about your work with the police force.

Wearing **After *Western Security* – which had a fantasy element of dressing up and being an outlaw – I became interested in costumes such as police uniforms. Everyone has a relationship with the police. For instance, some people fear the law because they feel guilty of committing a crime.**

My installation, *Sixty Minute Silence,* confronts the viewer with all these police officers in such a way that it's difficult to know where you stand. My own feelings, looking at them all, are that I'm half with them, half against. Clearly, it's hard to accept something that has authority over your life, so I ended up using the police as ciphers to question how our personal freedom is restricted.

The thing is, with the police you don't have to do much to them, because they're already loaded with significance. On the one hand they're merely civil servants, on the other they're synonymous with repression. Simply by using the police, people project much larger issues onto the work such as what's right and wrong, what constitutes acceptable social behaviour, and so on. So the idea was to place these people, who normally control us, in a controlled situation.

Muir At the end of the day, what kind of characters are you attracted to?

Wearing **Being an artist, I have to go through life accepting certain situations and making a lot of compromises. I'm attracted to all sorts of people, average as well as extreme. But above all, I really love people who go through life without compromise and stick to their character, even when it means they remain unemployed, or they don't have any friends or relationships.**

In a world which is willing to be elastic, they stick resolutely to this one path, this fixed belief in themselves. We all have a certain madness about us and these people don't mind showing it. Which leads me to believe that the most insane thing you can ever do is try to be sane.

Dazed & Confused, Issue 25, London, 1996, n.p. Revised 1998.

Franc Roddam, Paul Watson
The Family
1974
Documentary film series for
television broadcast
60 mins., colour
Film stills
Scenes from the Sunday Lunch
episode

overleaf, **Sixty Minute Silence**
1996
Video projection
60 mins., colour, sound
Dimensions variable
Video still
Collection Arts Council, London

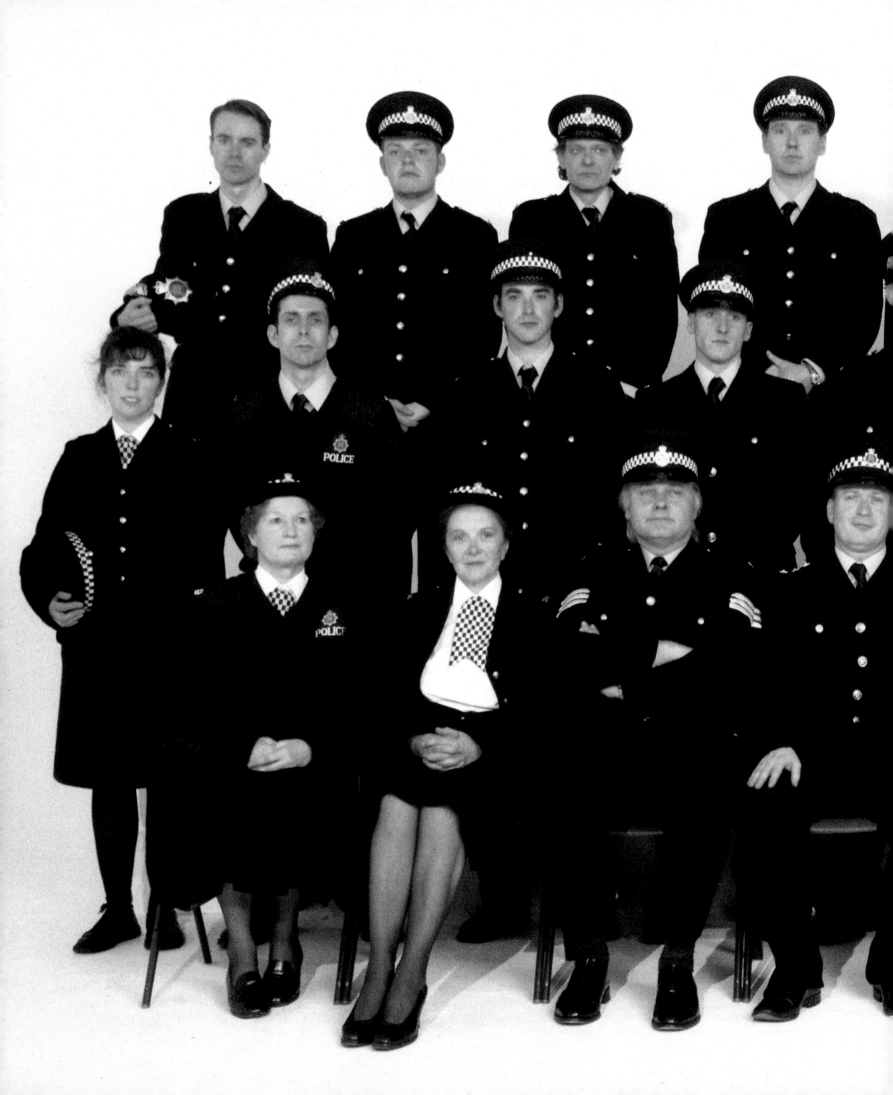

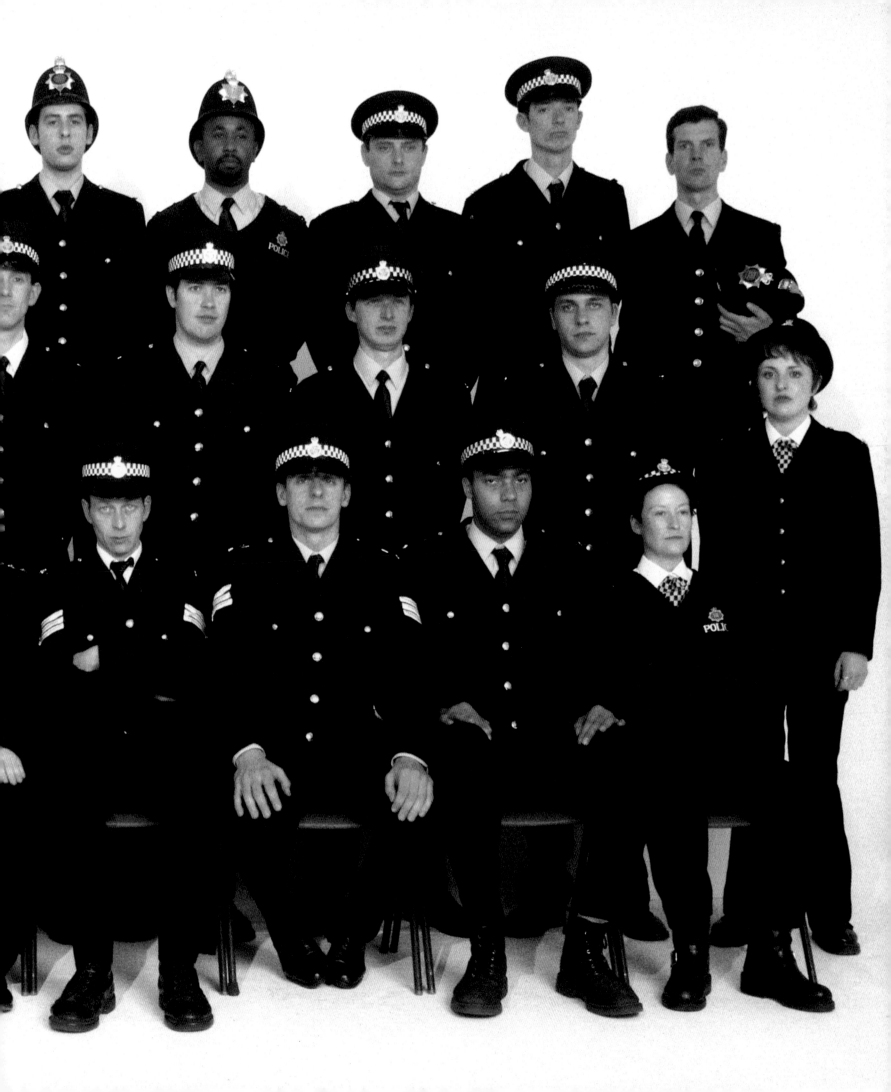

10–16
1997
Video projection
Approx. 15 mins., colour, sound
Dimensions variable
Video stills

10

Well, I have a tree house and it's out the back. And I use wood, metal, plastic and things like that. It's fun and joyful and … and my seat's right at the top, so I got a good view. It's quite good when you're up there 'cause like, when you're bored, when you're up right at the top, and my seat, it's quite good 'cause, like you can't see over the buildings, but there's like a fence, lots of gardens and you can see over them and see what people do in their gardens if you're bored. And you can … you see like … sometimes you see squirrels in the tree and birds and there's a big bird's nest up right at the top, but I don't … I just leave that.

I play games, I play army up there and trying to hide from the baddy. When I am up there by myself I think I am home alone and … it's quite good 'cause no one's there with you, you get to do loads of stuff. And um, read books sometimes and play with their things. And when I am up there I dream that I'm like a character and it's um, quite fun 'cause I act I'm all rich, like I imagine that I'm a professional footballer and gymnastic. I think sometimes I got a happy life, a fun life, an exciting life. And I think what I'm gonna do with my future.

11

It's important to be tough, but every time I hit someone I think, 'Ow, why did I do that?' At first I hit people in the arm and then I kick 'em in the legs and then I punch them in the belly and I'd like to hit 'em harder, but then we get separated.

I don't think many people like me that much, 'cause I had to move schools. Well, at my last school I was friends with Victoria, Antoinette and Louise. Now I am friends with Adam, Jason, Victoria, Antoinette and Louise. Antoinette doesn't always like to play with me, but when she does want to play with me, I don't want to play with Antoinette. In fact, one day I'm gonna kill Antoinette – I'm gonna punch her in the gob.

Everyone says I'm tough – just like my mum. But I think, 'No.' Me and my mum, I think we're more like our cat Rebecca, 'cause neither me or my mum change our clothes that much and we like sleeping lots and lots.

[*Second actor's voice*:] Me and my cat climb scaffoldings and when we get to the top we look down and look at all the people. When we're looking down we see some funny people and I throw stones off at 'em and Rebecca just sits there watching.

12

Um, I don't … I don't usually have any worries really. Um, I don't really have any worries, I just … because … um … I suppose, um … I am happy and I don't really need worries and I am a bit laid back really. Um, because I am at a lovely school, um, where I have lots of friends and, um, and I'm in a lovely home and, um, that's all.

I think, um, most of it's, um, fine, but I do actually, um, get upset when I, um, hear about, um, how many tigers there are left in the world and, um, how little of this and how little of that there are left in the world. And, um, people are extincting them and, um, hurting them. And also I get upset about the way people have abortions now, a lot. Because, um, in science at the moment our science teacher is teaching us about babies and so now we know exactly what they look like and they're really lovely and then when they get aborted they're being murdered, really, by human society.

13

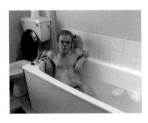

One of the things I do feel anxious about is my mother. And I'd love to kill her very much, as I found out she is a lesbian. I first found out when she came to my garden shed to tell me the exciting news that she'd been to a meeting and had met a big white swan. And the big white swan had floated across the room to her and now they're in love. So I told her I was delighted, but wasn't really delighted about her being a lesbian – in the house, especially.

And the next day I was sent to meet her by the station. And I waited for two hours for the big white swan and the big white swan didn't ever arrive and it was snowing and my duffle coat wasn't that warm really.

So I went home and found the big white swan was already there. And she had gone to a different station and hadn't bothered to tell me. Then she was sitting on the sofa and her fat was oozing all over the sofa and then off the sofa and all across the floor. And she didn't look like a swan to me. And she was guzzling cakes. And she looked revolting, and my mother was in love with this lump of lard. And I was appalled really. And I'd love them both to be dead very much, especially the big white swan, but my mother as well really.

And I do know how to kill people, 'cause my mum told me. She said what you have to do is freeze some peas and then defreeze 'em and do it a few times and you make pea soup. And apparently when they die they can't tell what's killed 'em. So I'd like to try that one on – since I do most of the cooking anyway.

10–16
1997
Video projection
Approx. 15 mins., colour, sound
Dimensions variable
Installation, Chisenhale Gallery,
London, 1997

10–16
1997
Video projection
Approx. 15 mins., colour, sound
Dimensions variable
Video stills

14

I feel like I'm a man in a boy's body and I like drinking and I like getting beer into my stomach so I can get buzzing. Where I get my money from is sometimes, when I ask my mum for the money and she goes, 'Alright then.' Then I go out onto the street and get one of my bigger mates to get me a beer. Also if there's money lying around in my house on the mantle piece or on the side or on the fridge or somewhere like that, I just take it, like 'cause when I'm playing out most of my mates have money and I don't have no money. And when I say to my mum and she goes, like 'cause she's already given me money but I want more, so I just pick it up from the side. And when she asks me, 'Where's the money?' I just say, 'I haven't seen it – I've already had money, why am I gonna take more?' I just say that.

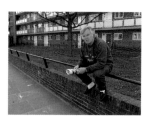

Sometimes when I go into McDonald's there is a man sitting outside and I go in and get what I want. And then I buy him something 'cause like he looks like as if he's poor. I buy him something and when he's sitting down I offer him a can of Coke or some chips or something and when he takes it off me I just bend down and take his money 'cause he puts it in a hat. So then I just run off and wait for the bus around the corner where he can't see me and when the bus comes I get on in and come home.

Sometimes when I wake up in the morning, say I've been drinking the night before, when I wake up I have a hangover and I take some tablets and I drink it with beer. And 'cause it makes me shiver if I ain't had a drink or something and then I have a drink of beer and then it makes me feel better and I feel alright. I lay down for another hour or something and when I get up, I feel alright, like better than I was.

15

I like taking bus rides. The longer journey I do, the more times I enjoy it. I've been places like Bromley, Orpington, Croydon, Bexley, Dartford. See, I like to tour, tour places, and I have friends there and I go and see them sometimes. Or if, if I am not doing a lot or if I am at home and not working.

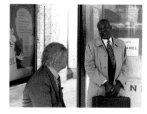

Well I've been doing that ever since I was a child. When I was young my dad used to take me out on bus rides. He used to take me down Vauxhall, Victoria, even Westminster. And I've inherited that. Ya know, that's how I like bus rides. Ya know I've always liked it and I enjoy it, I really enjoy it. Mostly I travel alone. I like to travel on my own – at the same time it gives me time to think and at the end of it I feel better.

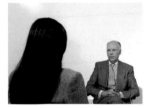

16

My anxiety stems really I guess from my whole life and the point I am at now. I've always had this inferiority complex which stems back … six years? Yeah, ten years old, when I developed chronic acne – only now has it recently cleared up. What also made matters worse was my weight. At the age of fourteen and a half I peaked at seventeen and a half stone.[1] And I wasn't particularly a loner, but I wasn't really amazingly popular either. I didn't want people to pay me much attention. I didn't want anyone to look at me. I didn't really know who *me* was. It was like I'd been given this horrible mask to wear, some kind of clown's body. The whole thing resulted in some sort of clinical depression. This might all sound paranoid, but I remember these builders, I was just walking down the road and they would shout, 'Oi, ya fat cunt – shed it!' So people who see you do comment on it. I am kind of okay physically now. As you can see, at some point I chose to do something about it, but when you carry that much flab around with you, you tend to get stretch marks. And while I was losing a lot of weight I got stretch marks. Now fifty percent of my body is covered in stretch marks, therefore I still feel overweight.

In regard to my sexuality there's a certain amount of ambivalence attached to that. I mean I'm not really split either way. I am attracted to girls – if I see them walking down the street then of course, you know I am going to get excited. With men it's not like that, it's a different sort of attraction. I just think about the cock – an erect cock really turns me on. And I think about fucking and being fucked. It was about a year ago I was in the bath and I was masturbating and I thought, I wondered what it would be like to put my fingers up inside myself. So I did and I started to play with myself as if I were doing it to myself and it was pretty pleasurable, but I am still not getting any feelings about men. I started to play with fruit and stuff and if I am in the bathroom I like to look at my cock in the mirror. It's the only part of my body that I don't feel a sense of shame about.

1. 245 lbs; 111 kg

Transcripts from the video *10–16*, 1997.

Contents

Chronology Gillian Wearing Born 1963, Birmingham, England. Lives and works in London

Selected exhibitions and projects
1985-93

1985-87
Studies Art and Design, B. Tech., Chelsea School of Art,
London

1987-90
Studies Fine Art, B.A. (Hons.), Goldsmiths' College,
University of London

1991
'Clove 1',
Clove Building, London (group)

'Empty Gestures',
Diorama Art Centre, London (group)

'Piece Talks',
Diorama Art Centre, London (group)

1992
'British Art Group Show',
Musée des Beaux-Arts, Le Havre, France (group)

'Instruction',
Giò Marconi, Milan (group)

1993
City Racing, London (solo)

'BT New Contemporaries',
Cornerhouse, Manchester; **Orchard Gallery**, Derry;
Maplin Art Gallery, Sheffield; **City Museum and Art
Gallery**, Stoke-on-Trent; **Centre for Contemporary
Art**, Glasgow (group)
Cat. *BT New Contemporaries*, BT New Contemporaries,
Manchester, texts David Manley, Stuart Morgan, et al.

Receives BT New Contemporaries Award

'Okay Behaviour',
303 Gallery, New York (group)

'2 into 1',
Centre 181 Gallery, London (group)

'Vox Pop',
Laure Genillard Gallery, London (group)

'Mandy Loves Declan 100%',
Mark Boote Gallery, New York (group)

Selected articles and interviews
1985-93

1992

Raphael, Amy, 'Hype: Write to Reply', *The Face*, No 51,
London, December

1993
Guha, Tania, 'Gillian Wearing: City Racing', *Time Out*,
London, 24/31 March

Graham-Dixon, Andrew, 'That Way Madness Lies', *The
Independent*, London, 22 June

Bush, Kate, 'Vox Pop', *Untitled*, No 4, London, Spring,
1994
Searle, Adrian, 'Vox Pop', *Time Out*, London, 5/12
January, 1994

Archer, Michael, 'O Camera O Mores', *Art Monthly*, No
166, London, May
Feaver, William, 'Treasures in the Wendy House of the
Lost Boys', *The Observer*, London, 4 July
Milner, Catherine, 'Positive Exposure for New Talent',
The Times, London, 27 February
Stallabrass, Julian, 'Power to the People', *Art Monthly*,
No 165, London, April

Selected exhibitions and projects
1994-95

1994
'Rien à signaler',
Galerie Analix B & L Polla, Geneva (group)
Cat. *Rien à signaler*, Galerie Analix B & L Polla, Geneva,
A&MBookstore, Milan, texts Barbara S. Polla, Gianni
Romano, Gillian Wearing, et al.

'Le Shuttle',
Künstlerhaus Bethanien, Berlin (group)
Cat. *Le Shuttle*, Künstlerhaus Bethanien, Berlin, text
Christoph Tannert

'Videoportrait IV – Gillian Wearing',
Rooseum Centre for Contemporary Art, Malmö (solo)

Maureen Paley/Interim Art, London (solo)

'Not Self-Portrait',
Karsten Schubert, London (group)

'Domestic Violence',
Giò Marconi, Milan (group)

'incertaine identité',
Galerie Analix B & L Polla, Geneva (group)
Cat. *incertaine identité*, Galerie Analix B & L Polla,
Geneva, Georg Éditeur, Geneva, texts Barbara S. Polla,
Olivier Zham, et al.

'3.016.026',
Theoretical Events, Naples (group)

'Fuori Fase',
Viafarini, Milan (group)

1995
'Möbius Strip',
Basilico Fine Arts, New York (group)
Cat. *Möbius Strip*, Basilico Fine Arts, New York, texts
Stephano Basilico, Liam Gillick, Matthew Ritchie

'Make Believe',
Royal College of Art, London (group)
Cat. *Make Believe*, Royal College of Art, London, Arts
Council of England, London, text Maurits Sillem

'Sage',
Galerie Michel Rien, Tours, France (group)

Invitation card, 'Sage', Galerie Michel Rien, Tours, France

'Hotel Mama',
Kunstraum, Vienna (group)

Selected articles and interviews
1994-95

1994

Craddock, Sacha, 'Gillian Wearing: Interim Art', *The
Times*, London, 14 June
Currah, Mark, 'Gillian Wearing: Interim Art', *Time Out*,
London, 29 June/6 July
Searle, Adrian, 'Gillian Wearing', *frieze*, No 18, London,
September/October

Vettese, Angela, 'Domestic Violence', *frieze*, No 18,
London, September/October

Craddock, Sacha, 'Great British Hopes: Rising Stars in
the Arts Firmament', *The Sunday Times*, London, 19
November
Jaio, Miren, 'Construyendo la identidad', *Lapiz*, Vol 12,
No 106, Madrid, October/November
Lillington, David, 'Real Life in London', *Paletten*, No
219, Gothenburg, April
Savage, John, 'Vital Signs', *Artforum*, Vol 32, No 7, New
York, March

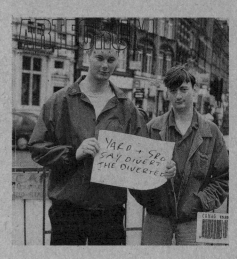

1995

Kent, Sarah, 'Make Believe', *Time Out*, London, 22/29
February

Selected exhibitions and projects

1995

'Western Security',
Hayward Gallery, London (solo)

Maureen Paley/Interim Art, London (group)

'Aperto '95',
Le Nouveau Musée, Villeurbanne, France (group)

Publication of text, 'A Short Love Story by Gillian
Wearing', *Nummer*, No 3, Cologne, September

'Brilliant! New Art from London',
Walker Art Center, Minneapolis, toured to
Contemporary Arts Museum, Houston (group)
cat. *Brilliant! New Art from London*, Walker Art Center,
Minneapolis, text Douglas Fogle

'Brill: Works on Paper by Brilliant Artists',
Montgomerie Glasgoe Fine Art, Minneapolis (group)

'Mysterium Alltag',
Kampnagel, Hamburg (group)

'The British Art Show 4',
organized by National Touring Exhibitions, The
Hayward Gallery, London
Upper Campfield Market, Manchester; **Collective
Gallery**, Edinburgh; **Ffotogallery**, Cardiff (group)
Cat. *The British Art Show 4*, South Bank Centre, London,
texts Richard Cork, Rose Finn-Kelcey, Thomas Lawson

'Gone',
Blum and Poe, Los Angeles (group)

'Hello!',
Andréhn-Schiptjenko, Stockholm (group)

Project, Holly Street Estate Art Project, London

'It's Not a Picture',
Galleria Emi Fontana, Milan (group)

Selected articles and interviews

1995

Barratt, David, 'Gillian Wearing: Hayward Gallery', *Art
Monthly*, No 191, London, November
Cavendish, Dominic, 'Gallery Gunslingers on a Shoot to
Thrill', *The Independent*, London, 11 September
Currah, Mark, 'Action Replayed', *Time Out*, London, 20/
27 September
Hall, James, 'Western Security', *The Guardian*, London,
21 September
Patrizio, Andrew, 'Hayward Shoot-Out', *Galleries*,
London, September

Barratt, David, 'Jean Baptiste Burant/Sharon
Lockhart/Paul Noble/Giorgio Sadotti/Gillian Wearing',
Art Monthly, No 191, London, November
Bonaventura, Paul, 'Profile: Wearing Well', *Art
Monthly*, No 184, London, March
Currah, Mark, 'Interim Art', *Time Out*, London, 11/18
October

Collings, Matthew, 'Welcome to Our Repartee', Vol 8,
No 4, *Modern Painters*, London, Winter
Kastner, Jeffrey, 'Brilliant', *Art Monthly*, No 192,
London, December/January
MacRitchie, Lynn, 'Their Brilliant Careers', *Art in
America*, Vol 84, No 4, New York, April, 1996
Smith, Roberta, 'Some British Moderns Seeking to
Shock', *The New York Times*, New York, December
Tomkins, Calvin, 'London Calling', *The New Yorker*, 11
December

Corrigan, Susan, 'Get the Picture, British Art's Next
Superstars', *i-D*, London, December
Feaver, William, 'Where There's a Wilt ... ', *The Observer*,
London, 19 November
Gayford, Martin, 'Youth, Formaldehyde and the Spirit
of the Age', *The Daily Telegraph*, London, 11 November
Hall, James, 'Butterfly Ball', *The Guardian*, London, 14
November
MacRitchie, Lynn, 'Shock Artists', *The Financial Times*,
London, 17 November
Searle, Adrian, 'British Art with Attitude', *The
Independent*, London, 14 November

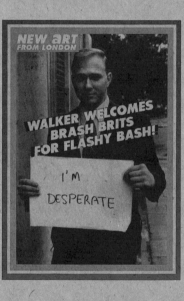

BAS JAN ADER

SAM DURANT

RAINER GANAHL

GILLIAN WEARING

Selected exhibitions and projects
1995-96

Publication of text, 'Hommage à la femme au visage
couvert de bandages, que j'ai vue hier sur la Walworth
Road', *Blocnotes*, No 9, Paris

'Campo',
XLVI Venice Biennale (group)

'X/Y',
Musée national d'art moderne, Centre Georges
Pompidou, Paris (group)

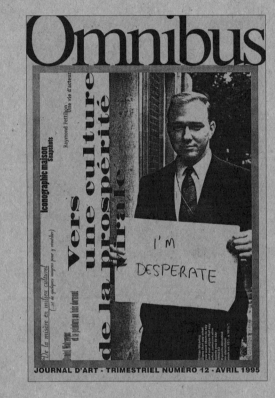

1996
'Traffic',
capc Musée d'art contemporain, Bordeaux, France
(group)
Cat. *Traffic*, capc Musée d'art contemporain, Bordeaux,
France, text Nicholas Bourriaud

'Pandæmonium: The London Festival of Moving
Images',
organized in collaboration with London Electronic Arts
Institute of Contemporary Arts, London (group)

'Gillian Wearing. City Projects – Prague, Part II',
organized by The British Council, Prague
Cat. *Gillian Wearing. City Projects – Prague, Part II*, The
British Council, Prague, text Michael Bracewell

'NowHere',
Louisiana Museum of Modern Art, Humblebæk,
Denmark (group)
Cat. *NowHere*, Louisiana Museum of Modern Art,
Humblebæk, Denmark, texts Iwona Blazwick, Laura
Cottingham, Bruce Ferguson, Lars Nittve

Interviews Paul Graham, text published in Andrew
Wilson, et al., *Paul Graham*, Phaidon Press, London

Selected articles and interviews
1995-96

Ardenne, Paul, 'Vers une culture de la prospérité
virale', *Omnibus: Journal d'Art*, No 12, Paris, April
Benedict, David, 'These Are the Rising Stars of 1996,
Which Names Will You Hear Everywhere in the Year
Ahead?', *The Independent*, London, 30 December
Buck, Louisa, 'British Art: Don't Knock It', *The
Independent*, London, 24 June
Cork, Richard, 'Forthcoming Attractions', *The Times*,
London, 18 November
Harvey, Will, 'Bodies of Work', *The Observer*, London, 9
September
Januzczak, Waldemar, 'Cool Britannia', *The Sunday
Times*, London, 3 December
Landesman, Cosmo; Rogers, Simon, 'Talking Pictures',
The Big Issue, No 116, London, 6/12 February
Leturcq, Armelle, 'Fluidite deplacements, liquidie',
Blocnotes, No 9, Paris, Summer
Lind, Maria, 'Inventing the Ordinary', *Material*,
Stockholm, No 26
Lloyd, Fran, 'Bad Girls: In Bed with Madonna?',
Contemporary Art, Vol 3, No 1, London, Winter
Morrish, John, 'Wildlife, Martyrs to Their Art', *The Daily
Telegraph*, London, 7 October
Searle, Adrian, 'Faces to Watch in the Art World, 8:
Gillian Wearing', *The Independent*, London, 26
September
Walker, Caryn Faure, 'Signs of the Times', *Creative
Camera*, No 332, London, February/March

1996
Bang Larsen, Lars, 'Traffic', *Flash Art*, No 189, Milan,
Summer

Darke, Chris, 'The Shape of Things to Come', *Artists
Newsletter*, London, June

Bauer, Ute Meta; Blazwick, Iwona; Cottingham, Laura;
Ferguson, Bruce; Fuchs, Anneli; Grambye, Lars; Nittve,
Lars, 'NowHere', *Louisiana Revy*, Vol 36, No 3,
Humblebæk, Denmark, May
Reitmaier, Heidi, 'Cando', *Women's Art Magazine*, No
70, London, June/July

Selected exhibitions and projects

1996

'The Fifth New York Video Festival',
organized by the Film Society of Lincoln Center, New
York

'Private View: Contemporary Art at the Bowes Museum',
The Bowes Museum, Barnard Castle, County Durham
(group)
organized by the Henry Moore Sculpture Trust, Leeds
Cat. *Private View: Contemporary Art at the Bowes
Museum*, Henry Moore Sculpture Trust, Leeds, texts
Elizabeth Conrad, Penelope Curtis, Veit Görner, Robert
Hopper

'Artisti Britannici a Roma',
Valentina Moncada, Rome (group)
organized by The British Council, Rome
Cat. *Artisti Britannici a Roma*, Umberto Allemandi & C.,
Turin, text Mario Codognato

'The Cauldron',
Henry Moore Studio, Dean Clough, Yorkshire (group)
organized by the Henry Moore Sculpture Trust, Leeds
Cat. *The Cauldron*, Henry Moore Sculpture Trust, Leeds,
texts Robert Hopper, Gregor Muir

'Toyama Now '96',
The Museum of Modern Art, Toyama, Japan (group)
Cat. *Toyama Now '96*, The Museum of Modern Art,
Toyama, Japan, text Iwona Blazwick

'Electronic Undercurrents – Art and Video in Europe',
Statens Museum for Kunst, Copenhagen (group)
Cat. *Electronic Undercurrents – Art and Video in Europe*,
Statens Museum for Kunst, Copenhagen, texts Torben
Christensen, Lars Movin

'The Aggression of Beauty',
Galerie Arndt and Partner, Berlin (group)

'Life/Live',
ARC, Musée d'Art Moderne de la Ville de Paris (group)
Cat. *Life/Live*, ARC, Musée d'Art Moderne de la Ville de
Paris, texts Laurence Bossé, Hans Ulrich Obrist,
Suzanne Pagé

'English Rose', (with Tracy Emin and Georgina Starr,
curated by Carl Freedman), *frieze*, No 31, London,
November/December

'a/drift: Scenes from the Penetrable Culture',
Center for Curatorial Studies, Bard College,
Annandale-on-Hudson, New York (group)
Cat. *a/drift: Scenes from the Penetrable Culture*, Center
for Curatorial Studies, Bard College, Annandale-on-
Hudson, New York, texts Joshua Decter, et al.

'Gillian Wearing: New Work',
Maureen Paley/Interim Art, London (solo)

'Wish You Were Here,'
De Appel, Amsterdam (solo)

Selected articles and interviews

1996

Garner, Lesley, 'Cops on Top in the Cauldron', *The Daily
Express*, London, 2 August
Usherwood, Paul, 'The Cauldron', *Art Monthly*, No 198,
London, July/August

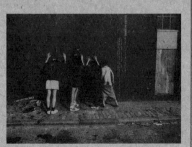

Feldman, Melissa E., 'Gillian Wearing at Interim Art',
Art in America, Vol 85, No 7, New York, July, 1997
Higgie, Jennifer, 'Gillian Wearing', *frieze*, No 33,
London, March/April, 1997
Kent, Sarah, 'Gillian Wearing, Interim Art', *Time Out*,
London, 11/18 December
Williams, Gilda, 'Gillian Wearing, Interim Art', *Art
Monthly*, No 203, London, February, 1997

Gillian Wearing |

Selected exhibitions and projects
1996

Le Consortium, Dijon, France (solo)

'ID – An International Survey on the Notion of Identity
in Contemporary Art',
Stedelijk Van Abbemuseum, Eindhoven, The
Netherlands (group)
Cat. *ID – An International Survey on the Notion of
Identity in Contemporary Art*, Stedelijk Van
Abbemuseum, Eindhoven, The Netherlands, texts Jan
Debbaut, Jaap Guldemond, Gregor Muir, Olivier Sacks,
Mats Sternstedt, et al.

Guest Editor, *Documents sur l'Art*, Paris

'Imagined Communities',
organized by The Arts Council of England, London, and
National Touring Exhibitions, Hayward Gallery,
London, in collaboration with Oldham Art Gallery
Oldham Art Gallery, touring to **John Hansard Gallery**,
Southampton; **Firstsite**, Colchester; **Walsall Museum
and Art Gallery**; **Royal Festival Hall**, London; **Glasgow
Gallery of Modern Art** (group)
Cat. *Imagined Communities*, The Arts Council of
England, London, text Richard Hylton

'Auto-Reverse 2',
Centre National d'Art Contemporain, Grenoble,
France (group)

'Playpen & Corpus Delirium',
Kunsthalle, Zurich (group)
Cat. *Playpen & Corpus Delirium*, Kunsthalle, Zurich, text
Bernhard Bürgi

'Full House – Junge Britische Kunst',
Kunstmuseum, Wolfsburg, Germany (group)
Cat. *Full House – Junge Britische Kunst*, Kunstmuseum,
Wolfsburg, Germany, texts Gregor Muir, et al.

Models for Wolfgang Tillmans,
images reprinted in *Süddeutsche Zeitung Magazin*, No
16, Munich, 19 April, and *Switch*, Vol 14, No 3, Tokyo,
April

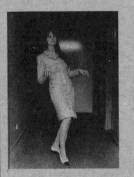
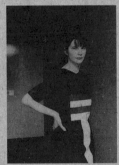

Selected articles and interviews
1996

Gibbs, Michael, 'ID – An International Survey on the
Notion of Identity in Contemporary Art', *Art Monthly*,
No 203, London, February, 1997

Masterson, Piers, 'Imagined Communities', *Art
Monthly*, No 194, London, March

Bickers, Patricia, 'The Young Devils', *Art Press*, No 214,
Paris, June
Buck, Louisa, 'Silver Scene', *Artforum*, Vol 34, No 10,
New York, Summer
Hall, James, 'Letter from London – Towers of London',
Artforum, Vol 34, No 7, New York, Summer
Judd, Ben, 'Interview with Gillian Wearing', *Untitled*,
No 12, London, Winter
Maloney, Martin; Del Re, Gianmarco; Davies, Peter,
'Ghosts of Celluloid: A New Generation "X" of Film-
makers Shows up in Britain', *Flash Art*, Vol 29, No 190,
Milan, October
Muir, Gregor, 'Sign Language', *Dazed & Confused*, No
25, London
Roberts, John, 'Mad For It! Philistinism, The Everyday
and the New British Art', *Third Text*, No 35, London,
Summer
Jacobson, Paul, 'The Emperor's New Pose', *Art Review*,
Vol 48, London, November
Leturcq, Armell, 'Let's Dance', *Blocnotes*, No 13, Paris,
September/October
Walters, Guy, 'State of the Art', *The Times Magazine*,
London, 20 July

Selected exhibitions and projects
1997

1997
'Gillian Wearing/Barbara Visser',
Bloom Gallery, Amsterdam (solo)

'Gillian Wearing: Vox populi',
Kunsthaus, Zurich (solo)
Cat. *Gillian Wearing*, Kunsthaus, Zurich, texts Bernhard
Fibicher, Gillian Wearing

Galleria Emi Fontana, Milan (solo)

'In Visible Light: Photography and Classification in
Art, Science and the Everyday',
Museum of Modern Art, Oxford
Cat. *In Visible Light: Photography and Classification in
Art, Science and the Everyday*, Museum of Modern Art,
Oxford, texts Kerry Browgher, Elizabeth Edwards,
David Elliot, Abigail Solomon Godeau, Russell Robert

'Città natura mostra internazionale di arte
contemporanea',
organized by Assessorato alle politiche culturi, Rome
Villa Mazzanti, Rome (group)
Cat. *Città natura mostra internazionale di arte
contemporanea*, Fratelli Palombi, Rome, texts Carolyn
Christov-Bakargiev, et al.

'10–16',
Chisenhale Gallery, London (solo)

S.L. Simpson Gallery, Toronto (group)

On selection panel for 'Becks New Contemporaries'
(with Sarat Maharaj and Hans Ulrich Obrist)
Cornerhouse, Manchester; **Camden Arts Centre**,
London; **Centre for Contemporary Art**, Glasgow

'Projects',
Irish Museum of Modern Art, Dublin (group)
Cat. *Projects*, Irish Museum of Modern Art, Dublin,
texts Sarah Glennie, Brenda McParland, Stephen Fahy

'Pictura Britannica: New Art from Britain',
Museum of Contemporary Art, Sydney, toured to **Art
Gallery of South Australia**, Adelaide; **City Gallery**,
Wellington (group)
Cat. *Pictura Britannica: New Art from Britain*, Museum of
Contemporary Art, Sydney, texts David Barrett, Tony
Bennett, Patricia Bickers, Patrick J. Boylan, Kobena
Mercer, Bernice Murphy, Nikos Papastergiadis,
Stephen Snoddy, John A. Walker

'Strange Days: British Contemporary Photography',
Claudia Gian Ferrari Arte Contemporanea, Milan
(group)
Cat. *Strange Days: British Contemporary Photography*,
Claudia Gian Ferrari Arte Contemporanea, Milan,
Edizioni Charta, Milan, text Gilda Williams

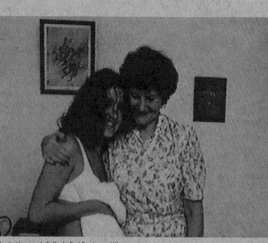

Selected articles and interviews
1997

1997

Invitation card, Galleria Emi Fontana, Milan

Coomer, Martin, 'Gillian Wearing, Chisenhale', *Time
Out*, London, 21/28 May
Lyttleton, Celia, 'Indecent Exposures', *Esquire*, New
York, May
Searle, Adrian, 'Bring on the Naked Dwarf', *The
Guardian*, London, 6 May
Dorment, Richard, 'Out of the Mouths of Babes', *The
Daily Telegraph*, London, 21 May

Clancy, Luke, 'The Lost Tribes of Peckham', *The Irish
Times*, Dublin, 10 September

Selected exhibitions and projects
1997

'Package Holiday – New British Art in the Ophiuchus Collection',
The Hydra Workshop, Hydra, Greece (group)

Jay Gorney Modern Art, New York (solo)

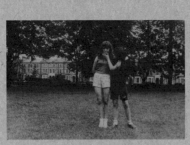

Invitation card, Jay Gorney Modern Art, New York

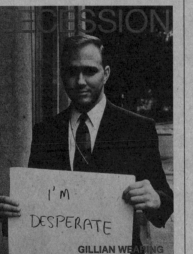

'Sensation: Young British Artists from the Saatchi Collection',
Royal Academy of Arts, London (group)
Cat. *Sensation: Young British Artists from the Saatchi Collection*, Royal Academy of Arts, London, Thames & Hudson, London, texts Adam Brooks, Lisa Jardine, Martin Maloney, Norman Rosenthal, Richard Shone

Television broadcast, *2 into 1*, in 'Expanding Pictures' series, BBC 2

'Gillian Wearing',
Wiener Secession, Vienna (solo)
Cat. *Gillian Wearing*, Wiener Secession, Vienna, texts Ben Judd, Gillian Wearing

'Tales from the City',
Stills Gallery, Edinburgh (group)
Cat. *Tales from The City*, Stills Gallery, Edinburgh, texts Charles Esche

'Turner Prize Shortlist',
Tate Gallery, London (group)
Cat. *The Turner Prize*, Tate Gallery, London, text Virginia Button

Selected articles and interviews
1997

Goldberg, Vicki, 'The Artist Becomes a Storyteller Again', *The New York Times*, New York, 9 November
Greene, David A., 'Kids', *The Village Voice*, New York, 21 October
Hegarty, Laurence, 'Gillian Wearing, Lorna Simpson, Rosemarie Trockel', *Art Papers*, No 22, Atlanta, January/February, 1998
Hoge, William, 'Arriving in New York After Taking off in London, Video Maker with a Taste for Secrets', *The New York Times*, New York, 14 September
Israel, Nico, 'Gillian Wearing', *Artforum*, Vol 36, No 5, New York, January, 1998
Kastner, Jeffrey, 'Gillian Wearing', *ARTnews*, Vol 96, New York, December
Kimmelman, Michael, 'Gillian Wearing at Jay Gorney', *The New York Times*, New York, 26 September
Kimmelman, Michael, 'Gillian Wearing', *The New York Times*, New York, 24 October
Kino, Carol, 'True Confessions', *Time Out*, New York, 9/16 October
Princenthal, Nancy, 'Gillian Wearing', *Art in America*, Vol 86, No1, New York, January, 1998

Murphy, Fiona, 'A Shopping Sensation', *The Guardian Weekend*, London, 27 September

Lewis-Smith, Victor, 'Kylie at Arm's Length As She Hits Topless C', *The Evening Standard*, London, 14 November

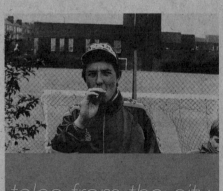

Alberge, Dalya, 'All-Women Shortlist Takes Turner by Surprise', *The Times*, London, 18 June
Bernard, Kate, 'The Woman Who Won't Win the Turner Prize', *The Evening Standard*, London, 30 October
Buck, Louisa, 'Life, Art and the Turner Women', *The Evening Standard*, London, 28 October
Coomer, Martin, 'Prized Apart', *Time Out*, London, 5/12 November
Feaver, William, 'Something In the Air', *The Observer*, London, 2 November
Glaister, Dan, 'A Woman's Place – in the Gallery', *The Guardian*, London, 18 June
Hussey, Margret, 'If You Take a Good Look You Might Even Like It', *The Express*, London, 29 October
Januszczak, Waldemar, 'Women on the Verge', *The Sunday Times*, 2 November
Laws, Roz, 'The Art of Making a £10,000 Video. The "Failure" from Brum Who Made It to the Top', *The Sunday Mercury*, Birmingham, 13 July

Reynolds, Nigel, 'The Turner Shortlist Is For Women Only', *The Daily Telegraph*, London, 18 June
Slyce, John, 'Art For Our Sake', *The Times Higher Education Supplement*, 28 November
Slyce, John, 'The Odds on the Turner Prize', *Flash Art*, No 196, Milan, October
Stringer, Robin, 'Women Only and Not a Painting in Sight', *The Evening Standard*, London, 17 June
Withers, R. L., 'On the Gallop', *Make*, No 77, London, September/October

Alberge, Dalya, 'Moving Pictures Take Turner Prize', *The Times*, London, 3 December
Fuller, Wendy, 'Modern Art? This Is Worthy of Constable', *The Express*, London, 3 December
Ginn, Kate; Terri Judd, 'Constable Picture Wins the Turner (No, Not That Constable)', *The Daily Mail*, London, 3 December
Glaister, Dan, 'Silence Is Golden for Turner Winner', *The Guardian*, London, 3 December
Johnson, Boris, 'Portrait of the Artist of Silent Nuances', *The Daily Telegraph*, London, 8 December
Lister, David, 'Uproar As Video Entry Snaps up the Turner', *The Independent*, London, 3 December
Littlejohn, Bel, 'How We Chose the Turner Prize Winner', *The Guardian*, 5 December
McEwen, John, 'Video Becomes Wearing', *The Sunday Telegraph*, 6 December
Packer, William, 'This Fly on the Wrong Wall', *The Financial Times*, 6 December
Reynolds, Nigel, '"Frozen Policemen" Video Wins Turner Prize', *The Telegraph*, London, 3 December
Riding, Alan, 'No Sexism, Please; They're British', *The New York Times*, New York, 29 December
Searle, Adrian; Serota, Nicholas, 'Turner Prize: Gillian Wearing's Arresting Image', *The Guardian*, London, 3 December
Thorncroft, Anthony, 'Artist Brushes Paint Aside to Win Turner Prize', *The Financial Times*, London, 3 December

Receives the Turner Prize

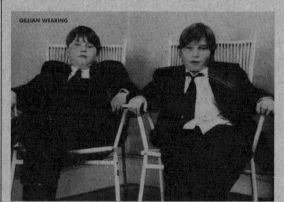

Invitation card, Galerie Drantmann, Brussels

Galerie Drantmann, Brussels (solo)

'history: the mag collection',
Ferens Art Gallery, Hull, toured to **Fruitmarket Gallery**, Edinburgh; **Cartwright Hall**, Bradford; **Orleans House**, Twickenham; **Towner Art Gallery and Museum**, Eastbourne; **City Art Gallery**, York; **Laing Art Gallery**, Newcastle; **Rogaland Kunstmuseum**, Stavanger, Norway (group)
Cat. *history: the mag collection*, Ferens Art Gallery, Hull, texts Gill Hedley, Paul Wilson, Rosemary Betterton, Jane Beckett, Maude Saulter

Book, *Signs that say what you want them to say and not Signs that say what someone else wants you to say*, Maureen Paley/Interim Art, London

Galerie Anne de Villepoix, Paris (group)

'Identité',
Le Nouveau Musée, Villeurbanne, France (group)

'Splash',
AAC Galerie, Weimar, Germany (group)

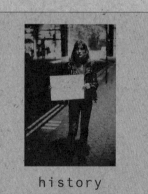

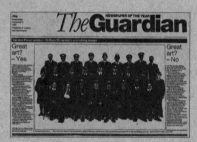

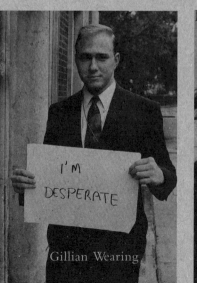

Selected exhibitions and projects
1997-98

'Private Face – Urban Space',
Hellenic Art Galleries Association, Athens; **Centre for Contemporary Art**, Rethymnon, Greece (group)

Spotlight

Gillian Wearing

Arts Council Collection

1998
'Spotlight on Gillian Wearing',
organized by National Touring Exhibitions, Hayward Gallery, London, for the Arts Council of England
Spacex Gallery, Exeter; **Quay Arts Centre**, Isle of Wight; **Towner Art Gallery**, Eastbourne; **Hatton Gallery**, Newcastle; **Graves Art Gallery**, Sheffield; **Ferens Art Gallery**, Hull; **Oriel Mostyn**, Llandudno (solo)
Cat. *Spotlight on Gillian Wearing*, South Bank Centre, London, texts Sacha Craddock

Television programme, *The South Bank Show: Young British Artists*, London Weekend Television

'School of the Museum of Fine Arts',
Grossman Gallery, Boston (group)

'English Rose in Japan',
Ginza Artspace, Tokyo (group)

'Real/Life: New British Art',
Prefectural Museum of Fine Arts, Tochigi, Japan; **City Art Museum**, Fukuoka, Japan; **Museum of Contemporary Art**, Hiroshima; **Museum of Contemporary Art**, Tokyo (group)
Cat. *Real/Life: New British Art*, Prefectural Museum of Fine Arts, Tochigi, Japan, texts Andrea Rose, James Roberts, et al.

'White Noise',
Kunsthalle, Bern, Switzerland (group)
Cat. *White Noise*, Kunsthalle, Bern, texts Bernhard Fibicher, Andreas Litmanowitch

Selected articles and interviews
1997-98

Blazwick, Iwona, 'City Nature', *Art Monthly*, No 207, London, June
Buck, Louisa, 'Three Cheers For Art That Shatters Complacency', *The Express*, London, 19 June
Buck, Louisa, 'Rising Stars: Gillian Wearing', *Moving Targets: A User's Guide To British Art Now*, Tate Gallery, London
Crichton-Miller, Emma, 'Art', *Frank*, London, December
Collings, Matthew, 'The New Establishment', *The Independent on Sunday*, London, 31 August
Dahan, Eric ; Lefort, Gerard, 'Par déla le corps gai et lesbien', *Libération*, Paris, 28/29 June
Decter, Joshua, 'Elastic Realities', *Flash Art*, No 195, Milan, Summer
Ebner, Jorn, 'Tramdeutung und Befragen', *neue bildende kunst*, Berlin, February/March
Elwes, Catherine, 'Worldwide Video Festival', *Art Monthly*, London, November
Jobey, Liz, 'A Rat Race?', *The Guardian*, London, 4 October
MacMillan, Ian, 'Sign of the Times', *Modern Painters*, Vol 10, No 3, London, Autumn
Ronson, Jon, 'Ordinarily So. Jon Ronson on Documentary Filmmaking and Gillian Wearing', *frieze*, No 36, London, September/October
Sanders, Mark, 'British Art Supplement', *Dazed & Confused*, No 34, London, September

1998

Sladen, Mark, 'The South Bank Show: Young British Artists', *Tate*, No 15, London, Summer

Gallery Koyanagi, Tokyo (solo)

'A Collection in the Making',
Irish Museum of Modern Art, Dublin (group)
Cat. *A Collection in the Making*, Irish Museum of Modern
Art, Dublin, text Declan McGonagle

Receives the Ministeriums für Stadtentwicklung, Kultur
und Sport des Landes Nordrhein-Westfalen Prize,
'44th International Short Film Festival', Oberhausen,
Germany

Centre d'Art Contemporain, Geneva (solo)

'La Sphere de l'Intime',
Le Printemps de Cahors, Saint-Cloud, France (group)

Musée du Rochechouart, Rochechouart, France
(group)

'Videorama',
Depot, Kunst und Diskussion, Vienna (group)

'Projected Allegories',
Contemporary Arts Museum, Houston (group)

'Made in London',
Musea de Electricidade, Lisbon (group)

'Internationale Foto Triennale: Photography as
Concept',
Galerien der Stadt Esslingen, Esslingen, Germany
(group)

'UK Maximum Diversity',
Galerie Krinzinger, Bregenz, Austria (group)

Galerija Dante Marino Cettina, Umag, Croatia (group)

'Distinctive Elements: British Art Exhibition',
organized by the British Council, Seoul, Korea
National Museum of Contempoary Art, Seoul, Korea
(group)
Cat. *Distinctive Elements: British Art Exhibition*,
National Museum of Contemporary Art, Seoul, Korea,
texts Michael Archer, John Slyce, Lee Sook-Kyung

'screen',
organized by National Touring Exhibitions, The
Hayward Gallery, London
Thelma Hulbert Gallery, Honiton, Devon; **Wishaw
Library and Chapelhall Library**, Glasgow; **The Waiting
Room**, School of Art and Design, University of
Wolverhampton, **Michael Tippett Centre**, University
College, Bath; **Maltings Gallery**, Farnham, Surrey;
MacRoberts Arts Centre, Stirling; **Wakefield Art,
Gallery** (group)

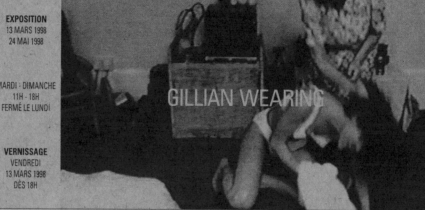

Buck, Louisa, 'VW bugs Wearing', *The Art Newspaper*,
London, July/August
Cameron, Dan, 'Gillian Wearing', *cream: contemporary
art in culture*, Phaidon Press, London
Campbell-Johnston, Rachel, 'Wearing: Her Heart on
Her Sleeve', *The Times*, London, 3/9 January
Coleman, Sarah, 'Interview with Gillian Wearing',
photo metro, Vol 16, No 149, San Francisco
Cork, Richard, 'Wearing Her Heart on the Sleeve', *The*

Selected exhibitions and projects
1998-99

1999
Maureen Paley/Interim Art, London (solo)

'The Museum of the Muse',
The Museum of Modern Art, New York (group)
Cat. *The Museum of the Muse*, The Museum of Modern
Art, New York, texts Kynaston McShine, et al.

6th Istanbul Biennial (group)

Selected articles and interviews
1998-99

Times, London, 13 January
Del Re, Gianmarco, 'Why Would a Businessman Say "I'm
Desperate"? A–Z of Gillian Wearing', *Flash Art*, Vol 31,
No 199, Milan, March/April
McGann, Paul, 'VW ad firm stole my ideas, claims
artist', *The Independent*, London, 12 June
Midgley, Carol, 'VW ad rips off my work, says artist', *The
Times*, London, 12 June
Miles, Anna, 'Picture Brittanica, Te Papa Museum,
Tongewara', *Artforum*, Vol 36, No 10, New York,
Summer
Slyce, John, 'Wearing a Mask', *Flash Art*, Vol 31, No
199, Milan, March/April
Smith, Roberta, 'Art of the Moment, Here to Stay', *The
New York Times*, New York, 15 February
Turner, Grady T., 'Gillian Wearing', *Bomb*, New York,
Spring
Williams, Gilda, 'Wahwah – The Sound of Crying or the
Sound of an Electric Guitar: The Art of Gillian Wearing',
Parkett, No 52, Zurich, May

Bibliography

Alberge, Dalya, 'All-Women Shortlist Takes Turner by Surprise', *The Times*, London, 18 June, 1997

Alberge, Dalya, 'Moving Pictures Take Turner Prize', *The Times*, London, 3 December, 1997

Archer, Michael, '0 Camera 0 Mores', *Art Monthly*, No 166, London, May, 1993

Ardenne, Paul, 'Vers une culture de la prospérité virale', *Omnibus: Journal d'Art*, No 12, Paris, April, 1995

Bang Larsen, Lars, 'Traffic', *Flash Art*, No 189, Milan, Summer, 1996

Barratt, David, 'Gillian Wearing: Hayward Gallery', *Art Monthly*, No 191, London, November, 1995

Barratt, David, 'Jean Baptiste Burant/Sharon Lockhart/Paul Noble/Giorgio Sadotti/Gillian Wearing', *Art Monthly*, No 191, London, November, 1995

Bauer, Ute Meta, 'NowHere', *Louisiana Revy*, Vol 36, No 3, Humblebæk, Denmark, May, 1996

Benedict, David, 'These Are the Rising Stars of 1996, Which Names Will You Hear Everywhere in the Year Ahead?', *The Independent*, London, 30 December, 1995

Bernard, Kate, 'The Woman Who Won't Win the Turner Prize', *The Evening Standard*, London, 30 October, 1997

Bickers, Patricia, 'The Young Devils', *Art Press*, No 214, Paris, June, 1996

Blazwick, Iwona, 'NowHere', *Louisiana Revy*, Vol 36, No 3, Humblebæk, Denmark, May, 1996

Blazwick, Iwona, 'City Nature', *Art Monthly*, No 207, London, June, 1997

Bonaventura, Paul, 'Profile: Wearing Well', *Art Monthly*, No 184, London, March, 1995

Bracewell, Michael, *Gillian Wearing. City Projects – Prague, Part II*, The British Council, Prague, 1996

Buck, Louisa, 'British Art: Don't Knock It', *The Independent*, London, 24 June, 1995

Buck, Louisa, 'Silver Scene', *Artforum*, Vol 34, No 10, New York, Summer, 1996

Buck, Louisa, 'Life, Art and the Turner Women', *The Evening Standard*, London, 28 October, 1997

Buck, Louisa, 'Three Cheers For Art That Shatters Complacency', *The Express*, London, 19 June, 1997

Buck, Louisa, 'Rising Stars: Gillian Wearing', *Moving Targets: A User's Guide To British Art Now*, Tate Gallery, London, 1997

Buck, Louisa, 'VW bugs Wearing', *The Art Newspaper*, London, July/August, 1998

Bush, Kate, 'Vox Pop', *Untitled*, No 4, London, Spring, 1994

Button, Virginia, *The Turner Prize*, Tate Gallery, London, 1997

Cameron, Dan, 'Gillian Wearing', *cream: contemporary art in culture*, Phaidon Press, London, 1998

Campbell-Johnston, Rachel, 'Wearing: Her Heart on Her Sleeve', *The Times*, London, 3/9 January, 1998

Cavendish, Dominic, 'Gallery Gunslingers on a Shoot to Thrill', *The Independent*, London, 11 September, 1995

Crichton-Miller, Emma, 'Art', *Frank*, London, December, 1997

Clancy, Luke, 'The Lost Tribes of Peckham', *The Irish Times*, Dublin, 10 September, 1997

Coleman, Sarah, 'Interview with Gillian Wearing', *photo metro*, Vol 16, No 149, San Francisco, 1998

Collings, Matthew, 'Welcome to Our Repartee', Vol 8, No 4, *Modern Painters*, London, Winter, 1995

Collings, Matthew, 'The New Establishment', *The Independent on Sunday*, London, 31 August, 1997

Coomer, Martin, 'Gillian Wearing, Chisenhale', *Time Out*, London, 21/28 May, 1997

Coomer, Martin, 'Prized Apart', *Time Out*, London, 5/12 November, 1997

Cork, Richard, 'Forthcoming Attractions', *The Times*, London, 18 November, 1995

Cork, Richard, 'Wearing Her Heart on the Sleeve', *The Times*, London, 13 January, 1998

Corrigan, Susan, 'Get the Picture, British Art's Next Superstars', *i-D*, London, December, 1995

Cottingham, Laura, 'NowHere', *Louisiana Revy*, Vol 36, No 3, Humblebæk, Denmark, May, 1996

Craddock, Sacha, 'Gillian Wearing: Interim Art', *The Times*, London, 14 June, 1994

Craddock, Sacha, 'Great British Hopes: Rising Stars in the Arts Firmament', *The Sunday Times*, London, 19 November, 1994

Craddock, Sacha, *Spotlight on Gillian Wearing*, South Bank Centre, London, 1998

Currah, Mark, 'Gillian Wearing: Interim Art', *Time Out*, London, 29 June/6 July, 1994

Currah, Mark, 'Action Replayed', *Time Out*, London, 20/27 September, 1995

Currah, Mark, 'Interim Art', *Time Out*, London, 11/18 October, 1995

Dahan, Eric, 'Par déla le corps gai et lesbien', *Libération*, Paris, 28/29 June, 1997

Darke, Chris, 'The Shape of Things to Come', *Artists Newsletter*, London, June, 1996

Davies, Peter, 'Ghosts of Celluloid: An New Generation "X" of Film-makers Shows up in Britain', *Flash Art*, Vol 29, No 190, Milan, October, 1996

Decter, Joshua, 'Elastic Realities', *Flash Art*, No 195, Milan, Summer, 1997

Del Re, Gianmarco, 'Ghosts of Celluloid: An New Generation "X" of Film-makers Shows up in Britain', *Flash Art*, Vol 29, No 190, Milan, October, 1996

Del Re, Gianmarco, 'Why Would a Businessman Say "I'm Desperate"? A–Z of Gillian Wearing', *Flash Art*, Vol 31, No 199, Milan, March/April, 1998

Dorment, Richard, 'Out of the Mouths of Babes', *The Daily Telegraph*, London, 21 May, 1997

Ebner, Jorn, 'Tramdeutung und Befragen', *neue bildende kunst*, Berlin, February/March, 1997

Elwes, Catherine, 'Worldwide Video Festival', *Art Monthly*, London, November, 1997

Feaver, William, 'Treasures in the Wendy House of the Lost Boys', *The Observer*, London, 4 July, 1993

Feaver, William, 'Where There's a Wilt …', *The Observer*, London, 19 November, 1995

Feaver, William, 'Something In the Air', *The Observer*, London, 2 November, 1997

Feldman, Melissa E., 'Gillian Wearing at Interim Art', *Art in America*, Vol 85, No 7, New York, July, 1997

Ferguson, Bruce, 'NowHere', *Louisiana Revy*, Vol 36, No 3, Humblebæk, Denmark, May, 1996

Fibicher, Berhard, *Gillian Wearing*, Kunsthaus, Zurich, 1997

Fuchs, Anneli, 'NowHere', *Louisiana Revy*, Vol 36, No 3, Humblebæk, Denmark, May, 1996

Fuller, Wendy, 'Modern Art? This Is Worthy of Constable', *The Express*, London, 3 December, 1997

Garner, Lesley, 'Cops on Top in the Cauldron', *The Daily Express*, London, 2 August, 1996

Gayford, Martin, 'Youth, Formaldehyde and the Spirit of the Age', *The Daily Telegraph*, London, 11 November, 1995

Gibbs, Michael, 'ID – An International Survey on the Notion of Identity in Contemporary Art', *Art Monthly*, No 203, London, February, 1997

Ginn, Kate, 'Constable Picture Wins the Turner (No, Not That Constable)', *The Daily Mail*, London, 3 December, 1997

Glaister, Dan, 'A Woman's Place – in the Gallery', *The Guardian*, London, 18 June, 1997

Glaister, Dan, 'Silence Is Golden for Turner Winner', *The Guardian*, London, 3 December, 1997

Goldberg, Vicki, 'The Artist Becomes a Storyteller Again', *The New York Times*, New York, 9 November, 1997

Graham-Dixon, Andrew, 'That Way Madness Lies', *The Independent*, London, 22 June, 1993

Grambye, Lars, 'NowHere', *Louisiana Revy*, Vol 36, No 3, Humblebæk, Denmark, May, 1996

Greene, David A., 'Kids', *The Village Voice*, New York, 21 October, 1997

Guha, Tania, 'Gillian Wearing: City Racing', *Time Out*, London, 24/31 March, 1993

Hall, James, 'Western Security', *The Guardian*, London, 21 September, 1995

Hall, James, 'Butterfly Ball', *The Guardian*, London, 14 November, 1995

Hall, James, 'Letter from London – Towers of London', *Artforum*, Vol 34, No 7, New York, Summer, 1996

Harvey, Will, 'Bodies of Work', *The Observer*, London, 9 September, 1995

Hegarty, Laurence, 'Gillian Wearing, Lorna Simpson, Rosemarie Trockel', *Art Papers*, No 22, Atlanta, January/February, 1998

Higgie, Jennifer, 'Gillian Wearing', *frieze*, No 33, London, March/April, 1997

Hoge, William, 'Arriving in New York After Taking off in London, Video Maker with a Taste for Secrets', *The New York Times*, New York, 14 September, 1997

Hussey, Margret, 'If You Take a Good Look You Might Even Like It', *The Express*, London, 29 October, 1997

Israel, Nico, 'Gillian Wearing', *Artforum*, Vol 36, No 5 New York, January, 1998

Jacobson, Paul, 'The Emperor's New Pose', *ArtsReview*, Vol 48, London, November, 1996

Jaio, Miren, 'Construyendo la identidad', *Lapiz*, Vol 12, No 106, Madrid, October/November, 1994

Januszczak, Waldemar, 'Cool Britannia', *The Sunday Times*, London, 3 December, 1995

Januszczak, Waldemar, 'Women on the Verge', *The Sunday Times*, London, 2 November, 1997

Jobey, Liz, 'A Rat Race?', *The Guardian*, London, 4 October, 1997

Johnson, Boris, 'Portrait of the Artist of Silent Nuances', *The Daily Telegraph*, London, 8 December, 1997

Judd, Ben, 'Interview with Gillian Wearing', *Untitled*, No 12, London, Winter, 1996

Judd, Ben, *Gillian Wearing*, Wiener Secession, Vienna, 1997

Judd, Terri, 'Constable Picture Wins the Turner (No, Not That Constable)', *The Daily Mail*, London, 3 December, 1997

Kastner, Jeffrey, 'Brilliant', *Art Monthly*, No 192, London, December/January, 1995

Kastner, Jeffrey, 'Gillian Wearing', *ARTnews*, Vol 96, New York, December, 1997

Kent, Sarah, 'Make Believe', *Time Out*, London, 22/29 February, 1995

Kent, Sarah, 'Gillian Wearing, Interim Art', *Time Out*, London, 11/18 December, 1996

Kimmelman, Michael, 'Gillian Wearing at Jay Gorney', *The New York Times*, New York, 26 September, 1997

Kimmelman, Michael, 'Gillian Wearing', *The New York Times*, New York, 24 October, 1997

Kino, Carol, 'True Confessions', *Time Out*, New York, 9/16 October, 1997

Landesman, Cosmo, 'Talking Pictures', *The Big Issue*, No 116, London, 6/12 February, 1995

Rogers, Simon, 'Talking Pictures', *The Big Issue*, No 116, London, 6/12 February, 1995

Laws, Roz, 'The Art of Making a £10,000 Video. The "Failure" from Brum Who Made It to the Top', *The Sunday Mercury*, Birmingham, 13 July, 1997

Lefort, Gerard, 'Par déla le corps gai et lesbien', *Libération*, Paris, 28/29 June, 1997

Leturcq, Armell, 'Let's Dance', *Blocnotes*, No 13, Paris, September/October, 1996

Leturcq, Armelle, 'Fluidite deplacements, liquidie', *Blocnotes*, No 9, Paris, Summer, 1995

Lewis-Smith, Victor, 'Kylie at Arm's Length As She Hits Topless C', *The Evening Standard*, London, 14 November, 1997

Lillington, David, 'Real Life in London', *Paletten*, No 219, Gothenburg, April, 1994

Lind, Maria, 'Inventing the Ordinary', *Material*, Stockholm, No 26, 1995

Lister, David, 'Uproar As Video Entry Snaps up the Turner', *The Independent*, London, 3 December, 1997

Littlejohn, Bel, 'How We Chose the Turner Prize Winner', *The Guardian*, 5 December, 1997

Lloyd, Fran, 'Bad Girls: In Bed with Madonna?', *Contemporary Art*, Vol 3, No 1, London, Winter, 1995

Lyttleton, Celia, 'Indecent Exposures', *Esquire*, New York, May, 1997

MacMillan, Ian, 'Sign of the Times', *Modern Painters*, Vol 10, London, Autumn, 1997

MacRitchie, Lynn, 'Shock Artists', *The Financial Times*, London, 17 November, 1995

MacRitchie, Lynn, 'Their Brilliant Careers', *Art in America*, Vol 84, No 4, New York, April, 1996

Maloney, Martin, 'Ghosts of Celluloid: An New Generation "X" of Film-makers Shows up in Britain', *Flash Art*, Vol 29, No 190, Milan, October, 1996

Masterson, Piers, 'Imagined Communities', *Art Monthly*, No 194, London, March, 1996

McEwen, John, 'Video Becomes Wearing', *The Sunday Telegraph*, 6 December, 1997

McGann, Paul, 'VW ad firm stole my ideas, claims artist', *The Independent*, London, 12 June, 1998

Midgley, Carol, 'VW ad rips off my work, says artist', *The Times*, London, 12 June, 1998

Miles, Anna, 'Picture Brittanica, Te Papa Museum, Tongewara', *Artforum*, Vol 36, No 10, New York, Summer, 1998

Milner, Catherine, 'Positive Exposure for New Talent', *The Times*, London, 27 February, 1993

Morrish, John, 'Wildlife, Martyrs to Their Art', *The Daily Telegraph*, London, 7 October, 1995

Muir, Gregor, 'Sign Language', *Dazed & Confused*, No 25, London, 1996

Muir, Gregor, 'Say What You Want', *ID – An International Survey on The Notion of Identity in Contemporary art*, Stedelijk Van Abbemuseum, Eindhoven, The Netherlands, 1996

Muir, Gregor, 'Winter 1996', *The Cauldron*, The Henry Moore Sculpture Trust, Leeds, 1996

Murphy, Fiona, 'A Shopping Sensation', *The Guardian Weekend*, London, 27 September, 1997

Nittve, Lars, 'NowHere', *Louisiana Revy*, Vol 36, No 3, Humblebæk, Denmark, May, 1996

Packer, William, 'This Fly on the Wrong Wall', *The Financial Times*, 6 December, 1997

Patrizio, Andrew, 'Hayward Shoot-Out', *Galleries*, London, September, 1995

Polla, Barbara S., 'Gillian Wearing: Ma vie', *incertaine identité*, Galerie Analix B & L Polla, Geneva, Georg Éditeur, Geneva, 1994

Princenthal, Nancy, 'Gillian Wearing', *Art in America*, Vol 86, No1, New York, January, 1998

Raphael, Amy, 'Hype: Write to Reply', *The Face*, No 51, London, December, 1992

Reitmaier, Heidi, 'Cando', *Women's Art Magazine*, No 70, London, June/July, 1996

Reynolds, Nigel, 'The Turner Shortlist Is For Women Only', *The Daily Telegraph*, London, 18 June, 1997

Reynolds, Nigel, '"Frozen Policemen" Video Wins Turner Prize', *The Telegraph*, London, 3 December, 1997

Riding, Alan, 'No Sexism, Please; They're British', *The New York Times*, New York, 29 December, 1997

Roberts, John, 'Mad For It! Philistinism, the Everyday and the New British Art', *Third Text*, No 35, London, Summer, 1996

Ronson, Jon, 'Ordinarily So. Jon Ronson on Documentary Filmmaking and Gillian Wearing', *frieze*, No 36, London, September/October, 1997

Sanders, Mark, 'British Art Supplement', *Dazed & Confused*, No 34, London, September, 1997

Savage, John, 'Vital Signs', *Artforum*, Vol 32, No 7, New York, March, 1994

Searle, Adrian, 'Vox Pop', *Time Out*, London, 5/12 January, 1994

Searle, Adrian, 'Gillian Wearing', *frieze*, No 18, London, September/October, 1994

Searle, Adrian, 'Faces to Watch in the Art World, 8: Gillian Wearing', *The Independent*, London, 26 September, 1995

Searle, Adrian, 'British Art with Attitude', *The Independent*, London, 14 November, 1995

Searle, Adrian, 'Bring on the Naked Dwarf', *The Guardian*, London, 6 May, 1997

Searle, Adrian, 'Turner Prize: Gillian Wearing's Arresting Image', *The Guardian*, London, 3 December, 1997

Serota, Nicholas, 'Turner Prize: Gillian Wearing's Arresting Image', *The Guardian*, London, 3 December, 1997

Sladen, Mark, 'The South Bank Show: Young British Artists', *Tate*, No 15, London, Summer, 1998

Slyce, John, 'The Odds on the Turner Prize', *Flash Art*, No 196, Milan, October, 1997

Slyce, John, 'Art For Our Sake', *The Times Higher Education Supplement*, 28 November, 1997

Slyce, John, 'Gillian Wearing', *Distinctive Elements: British Art Exhibition*, National Museum of Contempoary Art, Seoul, Korea, 1998

Slyce, John, 'Wearing a Mask', *Flash Art*, Vol 31, No 199, Milan, March/April, 1998

Smith, Roberta, 'Some British Moderns Seeking to Shock', *The New York Times*, New York, December, 1995

Smith, Roberta, 'Art of the Moment, Here to Stay', *The New York Times*, New York, 15 February, 1998

Stallabrass, Julian, 'Power to the People', *Art Monthly*, No 165, London, April, 1993

Stringer, Robin, 'Women Only and Not A Painting in Sight', *The Evening Standard*, London, 17 June, 1997

Thorncroft, Anthony, 'Artist Brushes Paint Aside to Win Turner Prize', *The Financial Times*, London, 3 December, 1997

Tomkins, Calvin, 'London Calling', *The New Yorker*, 11 December, 1995

Turner, Grady T., 'Gillian Wearing', *Bomb*, New York, Spring, 1998

Usherwood, Paul, 'The Cauldron', *Art Monthly*, No 198, London, July/August, 1996

Vettese, Angela, 'Domestic Violence', *frieze*, No 18, London, September/October, 1994

Walker, Caryn Faure, 'Signs of the Times', *Creative Camera*, No 332, London, February/March, 1995

Walters, Guy, 'State of the Art', *The Times Magazine*, London, 20 July, 1996

Wearing, Gillian, 'A Short Love Story by Gillian Wearing', *Nummer*, No 3, Cologne, September, 1995

Wearing, Gillian, 'Hommage à la femme au visage couvert de bandages, que j'ai vue hier sur la Wandsworth Road', *Blocnotes*, No 9, Paris, 1995

Wearing, Gillian, 'Interview', *Paul Graham*, Phaidon Press, London, 1996

Wearing, Gillian, *Signs that say what you want them to say and not Signs that say what someone else wants you to say*, Maureen Paley/ Interim Art, London, 1997

Williams, Gilda, 'Gillian Wearing, Interim Art', *Art Monthly*, No 203, London, February, 1997

Williams, Gilda, 'Picture This: Strange Days', *Strange Days: British Contemporary Photography*, Claudia Gian Ferrari Arte Contemporanea, Milan, Edizioni Charta, Milan, 1997

Williams, Gilda, 'Wahwah – The Sound of Crying or the Sound of an Electric Guitar: The Art of Gillian Wearing', *Parkett*, No 52, Zurich, May, 1998

Withers, R. L., 'On the Gallop', *Make*, No 77, London, September/ October, 1997

Public Collections

Irish Museum of Modern Art, Dublin

The Arts Council of England, London

The British Council, London

Contemporary Art Society, London

The Government Art Collection, London

South London Gallery, London

Tate Gallery, London

Solomon R. Guggenheim Museum, New York

Southampton City Council

Kunsthaus, Zürich

Comparative Images

pages 88, 89, **Michael Apted**
Seven Up

pages 88, 89, **Michael Apted**
Fourteen Up

pages 88, 89, **Michael Apted**
Twenty-one Up

page 44, **Hans Bellmer**
La Poupée (Doll)

page 44, **Jacques-André Boiffard**
Untitled
Centre Georges Pompidou, Paris

page 80, **Christian Boltanski**
10 Portraits Photographiques de Christian Boltanski 1946–1964

page 15, Diagram of clamp to facilitate the immobility of the subject while posing for a daguerreotype

page 39, **James Ensor**
Masks Confronting Death
Private collection, Brussels

page 40, **James Ensor**
Portrait of the Artist Surrounded by Masks
Private collection, Antwerp

page 8, **Walker Evans**
Young Girl
National Gallery of Art, Washington DC

page 62, **Jimi Hendrix**

page 48, **Douglas Huebler**
Variable Piece No. 70 (In Process) Global

page 34, **Sherrie Levine**
After Walker Evans (After Walker Evans' Portrait of Allie May Burroughs)
Metropolitan Museum of Art, New York

page 84, **René Magritte**
L'esprit de géométrie (The mathematical mind)
Museum Boijmans Van Beuningen, Rotterdam

page 31, **René Magritte**
La reproduction interdite (Not to be reproduced)
Tate Gallery, London

page 50, **Bruce Nauman**
Clown Torture

page 39, **Noh Mask**
University of Bristol Theatre Collection

page 14, **Photographer unknown**
Ferreotype studio

page 34, **Richard Prince**
Untitled (Girlfriend)

page 132, **Franc Roddam, Paul Watson**
The Family

page 45, **August Sander**
Anton Räderscheidt, Cologne
August Sander Archive, Cologne

page 39, **Cindy Sherman**
Untitled No. 96

page 83, **William Wegman**
Family Combinations

List of Illustrated Works

page 53, **Boytime 1**, 1996–98
page 53, **Boytime 2**, 1996–98
page 53, **Boytime 3**, 1996–98
pages 58, 59, **Brian**, 1996
pages 17, 37, 38, 103, 104, 105, 107, 108, **Confess all on video. Don't worry, you will be in disguise. Intrigued? Call Gillian,** 1994
page 35, **Dancing in Peckham,** 1994
page 54, **Girltime 1**, 1996–97
page 54, **Girltime 2**, 1996–97
pages 28-29, 43, 110, 111, 112, 113, 114, 115, **Homage to the woman with the bandaged face who I saw yesterday down Walworth Road,** 1995
pages 123, 124, **I'd Like to Teach the World to Sing,** 1995
page 99, **Interviews with people in the street,** 1993
page 31, **Kelly and Melanie,** 1997
pages 18, 19, **Masturbation,** 1991–92
pages 26, 51, 120, **My Favourite Track,** 1994
page 64, **The Regulators' Vision,** 1995–96
page 59, **Roger and Peter,** 1994–96
pages 24, 60, 61, **Sacha and Mum,** 1996
pages 9, 10, 46-47, 49, 131, **Signs that say what you want them to say and not Signs that say what someone else wants you to say,** 1992–93
pages 96, 97, **Signs that say what you want them to say and not Signs that say what someone else wants you to say** (Italian series), 1994
pages 13, 14, 134-135, **Sixty Minute Silence,** 1996
pages 63, 117, 118, 119, **(Slight reprise),** 1994–95
pages 56, 57, 59, **Steven, Danny, Daniel, Ryan,** 1996
pages 40, 41, **Take Your Top Off,** 1993
pages 42, 72, 75, 76, 79, 80, 82-83, 84, 85, 136, 137, 138-139, 140, 141, **10–16,** 1997
pages 90, 91, 92, 93, **Theresa,** 1998
pages 20, 142, 143, **2 into 1,** 1997
pages 22, 23, 127, 128, 129, **The Unholy Three,** 1995–96
pages 69, 70, 71, **Untitled,** 1997–
pages 100, 101, **What do you like about London?,** 1990
pages 65, 66, 67, **Western Security,** 1995